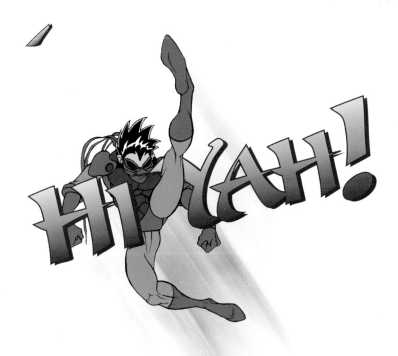

HOW TO DRAW FANTASTIC MARTIAL ARTS COMICS

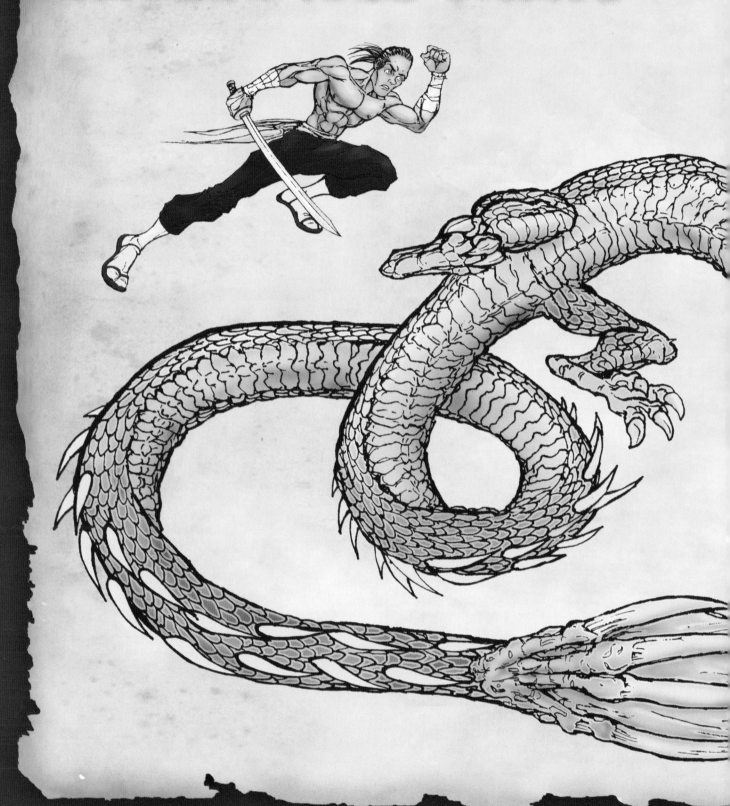

HI-YAH!

STEVE MILLER

WATSON-GUPTILL PUBLICATIONS
NEW YORK

THIS BOOK IS DEDICATED TO

Eric "Rick" Bupp, a black belt in tae kwon do and in how to live life in general,
and in loving memory of his son Leif (March 31, 1998–October 19, 2004).

ABOUT THE TITLE

Though I've taken great care in researching the martial arts, I'm not interested in presenting only that which is physically possible. I use the actual martial arts as a springboard into the realm of the extraordinary and even the superhuman—in other words, the "fantastic." Many of the martial arts moves presented in this book are one step beyond what you'd encounter at your local dojo, and many of the depictions presented here are possible only in video games or "wire-fu" cinema. Serious martial artists frequently use vocalizations to help them focus their attacks, but actually saying "Hi-Yah!" is a bit exaggerated and even flamboyant, which moves us into the fictitious world of martial arts as expressed in pop culture. *Hi-Yah!* is an expression of power and energy, qualities I want to teach you to instill in your drawings. So—if it helps you focus—feel free to exclaim, "Hi-Yah!" or "Banzai!" or even "Five-fingered pencil mark of death!" as you execute your powerful pencil strokes. But you may want to make sure your studio's door is securely shut, or you may find family members trembling with fear at the unleashing of your artistic energy.

© 2007 by Steve Miller

First published in 2007 by
Watson-Guptill Publications,
a division of VNU Business Media, Inc.,
770 Broadway, New York, N.Y. 10003
www.wgpub.com

Library of Congress Control Number: 2006937057

Senior Editor: Candace Raney
Editor: James Waller, Thumb Print
Senior Production Manager: Katherine Happ
Designer: Jay Anning, Thumb Print

ISBN: 0-8230-2246-3

Manufactured in Malaysia
First printing, 2007
1 2 3 4 5 6 7 8 9 / 10 09 08 07

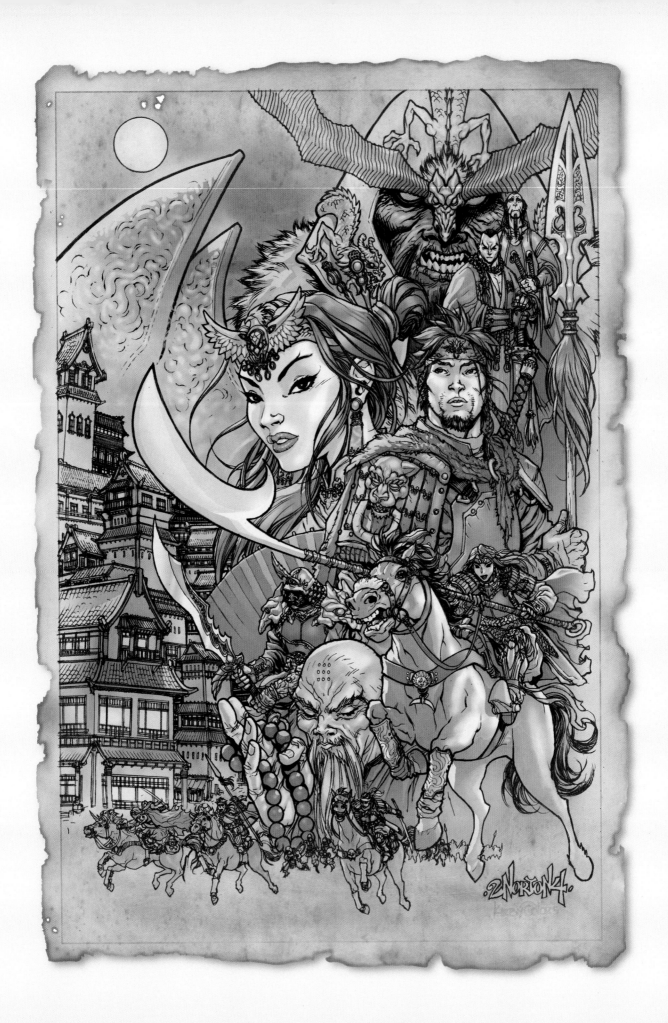

CONTENTS

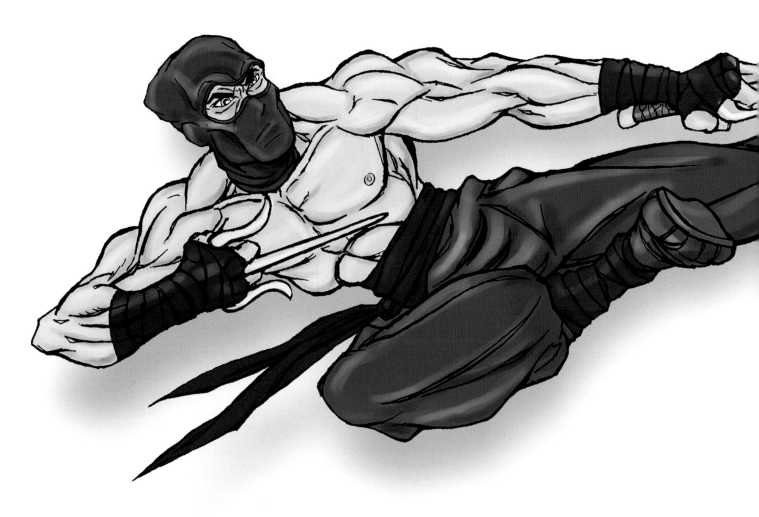

About the Artists

Carlo Barberi is one of the newest and brightest comic book stars to emerge in the last few years. His animated penciling style has graced numerous books for Image, Marvel, and DC Comics, including *Impulse, Young Justice, Ororo,* and *Justice League Unlimited.*

Brett Booth wrote and penciled Wildstorm Productions' *Kindred, Backlash, Wildcore,* and *Backlash/Spider-Man* comic books. He was also an artist on Wildstorm/DC's *Thundercats: Dogs of War* and *Extinction Event.* At Marvel Comics he penciled *Heroes Reborn: Fantastic Four, X-Men Unlimited,* and *X-Men.* Currently, Brett is drawing the *Anita Blake: Vampire Hunter* comic book for Dabel Brothers Productions (dabelbrothers.com). Check out Brett's own website at demonpuppy.com.

Bill Bronson is an accomplished artist and toy designer. He has previously contributed to *Scared!: How to Draw Fantastic Horror Comic Characters.* Bill can be visited at his website, billbronson.com.

Peter Caravette is the publisher of Samson Comics. The pages featured in the "Telling the Story" chapter of this book come from an upcoming issue of Samson's *Tool & Die.* Check out all of Peter's exciting projects at samsoncomics.com.

Andrew Dalhouse is an up-and-coming comic book colorist. He has numerous credits under his belt working on superhero and horror comics for companies like Alias, Avatar, and Samson Comics.

Steve Hamaker is Jeff Smith's hand-picked colorist for Cartoon Book's *Bone* series as well as for Jeff's upcoming *Shazzam* work for DC Comics. Steve is a highly skilled graphic designer who works in the gaming, comics, and toy industries. He has also written and drawn his own comic book, *Fish N Chips.* Check him out at fishnchipscomics.com.

Russell Merritt is an active watercolorist and *sumi-e* artist. He is an instructor at The Works Museum and C-Tech in Newark, Ohio, and owns Banshuwa Studio. A student of Asian culture and history, Russell utilizes *sumi-e* techniques in much of his own art and freelance work. More of his work can be seen at his website, banshwaart.bravehost.com.

Steve Miller is an author and artist who has worked in numerous areas of the entertainment field. His drawings have been used in the production of videos, toys, RPGs, and video games. The latest of Steve's previous books is *Gung Ho! How to Draw Fantastic Military Comics.* He lives in Ohio with his wife and two children.

Dan Norton, with eleven years in the business and a lifetime love affair with comics, movies, and video games, has drawn some of the most famous comics characters of the past generation, including X-Men, Spider-Man, and Batman. He has also done conceptual design for several major film and game titles, including *Star Wars Episode III: Revenge of the Sith,* Britney Spears's video *Toxic,* and Sony's *Everquest.*

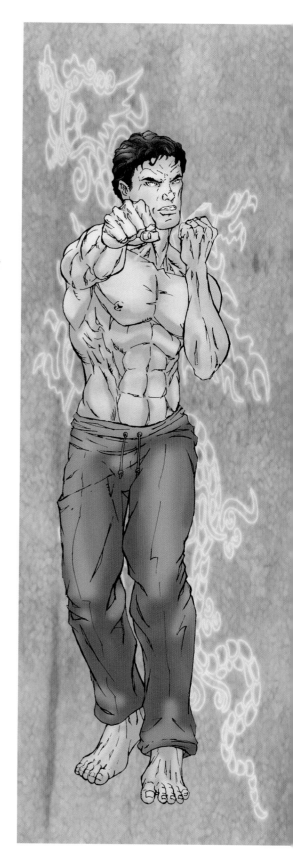

From the Author

Though you might not think so at first, the martial arts have a lot in common with other art forms—including the art of drawing.

The martial arts are systems—both techniques *and* philosophies—for training an individual's mind and body for combat while also instilling self-confidence and guiding him or her on the path to spiritual harmony. In many martial arts disciplines, students are trained in time-honored fighting styles that have been handed down from generation to generation. These forms—in Japanese martial arts, they're called *katas*—are broken down into simple steps that are taught through repetition and the constant reinforcement of key tenets.

In a way, that's just what I've tried to do in this book on drawing martial arts characters. First I introduce you to some central tools and techniques—the kinds of art supplies you'll need, the basics of martial arts anatomy, the essential steps to follow when creating action-filled scenes—and then I take you through a series of exercises designed to improve your skill level while always reinforcing what you've already learned.

As you're probably aware, there are dozens of different martial arts styles, but two of these styles pop into my mind when I think about the relation between the martial arts and the art of drawing comics. The first is the ancient—and very famous—Chinese martial art known as kung fu.

As I say, each of the martial arts is a whole philosophy as well as a set of specific fighting techniques, and the philosophy of kung fu has three key dimensions: *motivation, self-discipline,* and *time.* Motivation is the desire to perform well. Self-discipline is what you need to pursue that motivation wholeheartedly. And the dimension of time has to do with your commitment to a lifelong pursuit. Originally, the term *kung fu,* which literally means "human effort," was applied to the pursuit of expertise in any task. It was possible to be a "kung fu cook" or a "kung fu seamstress" so long as you totally dedicated yourself to perfecting your craft. Even today, it's not uncommon to use *fu* as a slang term for someone with proficiency in a particular skill—for example, accomplished Internet surfers are said to be masters of "web fu." Hopefully, this book will help you on the path to mastering your "art fu."

The second martial arts style that comes to mind is one that evolved fairly recently. It's called jeet kun do, and it was the creation of martial arts master and action-movie star Bruce Lee. Lee rejected traditional forms of practice, seeking instead to boil everything down to its simplest and most effective root. Jeet kun do is sometimes called an "eclectic" martial art because it samples moves from a variety of different disciplines and combines them into a style that's customized for the individual fighter. A student of one of the traditional martial arts forms is taught two or three defensive moves to counter an attack: If your opponent does move *A,* you counter with move *B* or *C.* But in jeet kun do, you're taught to tailor your counterattack to the particular opponent: If the opponent leads with move *A,* you can utilize move *B* or *C* from one style, or you can borrow move *D* from another style, *or* you can combine moves *C* and *D* into a totally new counterattack. If this sounds confusing, just imagine a fighter's dismay when he discovers that he is battling an opponent who is not limited to one particular playbook.

So what's the relation to drawing? Well, applying a jeet kun do mindset to your artwork will allow you to attack each project in the most efficient manner. The idea is not to get locked into drawing in only one set style, but rather to learn the foundational skills and then to continue to grow by experimenting with new techniques and approaches. If you constantly immerse yourself in the works of other cultures and keep experimenting with different styles and media, your skills will never become stagnant and your work will never be stale.

INTRODUCTION

If you want to learn to swim, jump into the water. On dry land, no frame of mind is ever going to help you.

Bruce Lee

INTEREST IN THE MARTIAL ARTS HAS BECOME A TRUE CULTURAL phenomenon. Thanks in large measure to the successful careers of martial-arts movie stars like Bruce Lee, Jackie Chan, Chuck Norris, Steven Seagal, Jet Li, and Jean-Claude Van Damme, the West has finally caught on to the traditions that have been practiced for thousands of years in the East. Americans used to refer to all martial arts generically as either karate or kung fu, but nowadays, with almost every form of the martial arts being taught somewhere in the United States, the correct names of the different branches have become common knowledge. Training dojos are popping up in every town, and in larger cities it seems like there's a storefront or studio on every block offering classes in kung fu, karate, jujitsu, tai chi, jeet kune do, aikido, judo, hapkido, or tae kwon do—to name just a few. You can't watch an action movie without seeing the star whipping some butt with a martial arts move. Cartoon kung fu characters entertain our children, while gamers enjoy flipping, kicking, and slamming digital ninjas in the latest video games. The martial arts have become big business in the United States, with sales of comic books, toys, and DVDs both fueling and reflecting the craze.

It is only natural that, as an artist, you would want to incorporate the energy of the martial arts into your characters. The movements of the best martial artists have a graceful elegance, and it takes some special training to transcribe that quality into your drawings. The martial arts are a brutal ballet—equal parts violent force and controlled fluidity. The various fighting techniques provide the perfect medium for showcasing the range and flexibility of the human form. So get ready to turn the bodies of your characters into living weapons as we kick, punch, grapple, throw, and chop our way through the magical world of the martial arts.

This book is intended as an artist's training manual and in no way, shape, or form should be used for martial arts physical training or combat. Though I've had a lifelong fascination with the martial arts, I've only dabbled in real, one-on-one combat skills. Beyond a few basic judo-inspired grabs, throws, and rolls that I was taught in the army, I've never undertaken any formal martial-arts training. Because I always strive for a high level of authenticity in my work, I have done a lot of research on the different fighting forms, but many of the character poses presented in this book have been enhanced for dramatic effect. Heck, some may not even be humanly possible, so don't try any of them at home.

Martial arts are among the few activities designed to give you a "total-person" workout. If you want to be a successful martial artist, you must develop your mind, your body, and your soul, and these three dimensions of your self should be fully engaged whenever you come to the drawing table.

I know you want to jump right in and create a kinetic full-contact battle scene—a chop suey fest of slashing swordsmen and spin-kicking ninjas. But just as you wouldn't expect to train at black-belt level the first day you walk into a new dojo, you need to familiarize yourself with some basic drawing concepts before leaping into some of the more advanced ideas covered in this book.

I hope you enjoy learning from this book as much as I have enjoyed writing it. My aim is not just to pass on information, but to inspire you to have fun in the learning process and to discover new ways of looking at your artwork, not just to pass on information. This how-to-draw book will teach you very little unless you consistently draw as you work your way through it. The real learning is not on these pages but in the magic you create when you sit down at your drawing table.

As we start down this path of artistic discovery let us make a pact. I will teach if you are willing to learn. So, Young Grasshopper, let's turn the page and get prepared for the wonderful adventure we are about to set out on by making sure you have the proper supplies.

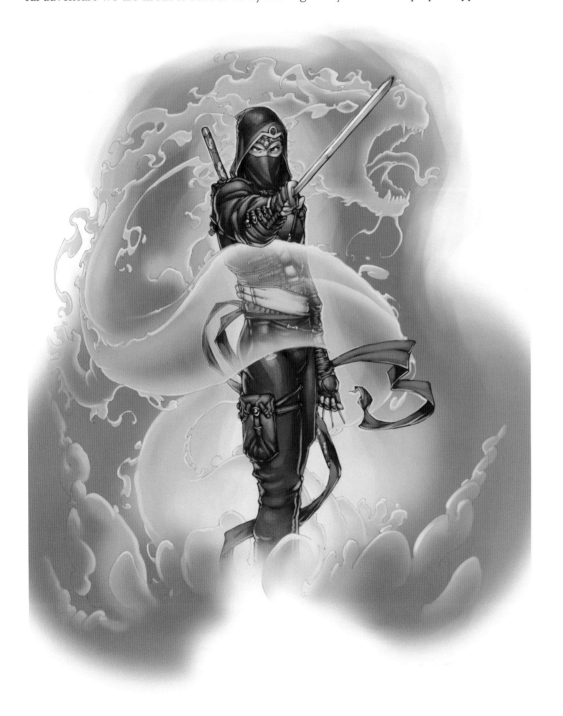

THE RIGHT SUPPLIES
(AND THE RIGHT MIND-SET)

Art is an expression of life and transcends both time and space. We must channel our own souls through art to give a new form and a new meaning to nature or the world. "Artless art" is the artistic process within the artist; its meaning is "art of the soul."

Bruce Lee

USING TOP-QUALITY ART SUPPLIES WILL HELP PUT YOU IN THE FRAME of mind to draw like a pro. Students of the martial arts are required to purchase a specific uniform to identify them as belonging to a particular martial arts discipline and a particular school. The instructors know that dressing young learners in clothes similar to those worn by seasoned martial arts experts makes the new students feel included and authentic. Now, I'm not going to tell you how to dress, but I will insist you take your drawing seriously—and the best way to start doing so is to outfit yourself with professional-grade materials. They don't have to be the most expensive supplies, but they do have to be materials that you are comfortable working with and that are dedicated solely to your artwork. You need to be in harmony with your pencils, pens, brushes, and paper, so that each time you approach your drawing table you take on the focused mind of a fighter entering a dojo to train. It's the only way to get the highest level of success from your work.

PENCILS

In martial arts the main tools are the hands and feet. Bruce Lee once said, "I refer to my hands, feet, and body as the tools of the trade. The hands and feet must be sharpened and improved daily to be efficient." In drawing, of course, we mainly use our hands (though feel free to practice drawing with your feet after you've mastered using your hands). And your hand will be an ineffective tool unless it wields a sharpened pencil.

There are many different types of pencils to choose from, so it is going to take a lot of experimenting for you to determine which best fits your style of drawing. The familiar "lead" pencil has a graphite-and-clay core encased in cedar wood, and such pencils are categorized by the lead's hardness. They range from 9H (extremely hard) to 9B (very soft), but a good place to start is in the middle, with an assortment of 2H, HB, 2B, and 4B leads. The common no. 2 pencil is a fine pencil for sketching and enables you to make a wide range of marks; you can certainly use a no. 2 pencil while you search for artist's pencils that suit your drawing style.

Using non-reproducing pencils is a common trick of the trade. You can lay out a figure and pencil right over the blue marks without having to erase the initial drawing. When the picture is reproduced by a copier or scanned into a computer the blue lines either fail to register or can be easily selected and removed.

Mechanical and clutch pencils are two popular kinds of refillable lead-holders. Mechanical pencils use leads of a constant weight (or hardness) and a constant size; the leads are chambered through a "controlled feed apparatus"—in other words, you click the pencil and the lead emerges from the point. With mechanical pencils, it's not just the hardness of the lead that matters but the diameter, as well. These leads come in a range of sizes, from 0.2mm in diameter all the way up to 4.0mm. The 0.2mm lead—a *thin-gauge* lead—is great for precision details, but it is also fragile and will break if you apply very much pressure. Sturdier, wide-gauge leads (2.0mm or 4.0mm) are useless for detail but excellent for large expressive marks and for rapidly applying tonal variations.

Clutch pencils use standard-size 2.0mm leads in weights ranging from 9H to 9B. Just like wooden pencils, clutch-pencil leads can be sharpened to a point as precise as the edge of a samurai warrior's sword.

Finally, comics artists often have use for non-reproducing pencils. Marks made by non-reproducing pencils don't show up when photocopied. The most common colors are blue and light green. Though modern computer scanning techniques make it easy to remove almost any colored lead, blue and green are the artist's traditional choices.

Don't feel as if you must find the *one* perfect drawing tool. Most artists accumulate a large variety of pencils over their careers and learn to utilize the right tool for each job.

ERASERS

There are a lot of things that are as applicable to the comics artist's life as to that of the martial arts practitioner. For instance, Bruce Lee once said, "Mistakes are always forgivable, if one has the courage to admit them." When you make a mistake, recognize it for what it is and learn from it. No one puts on a master's belt on the first day of training. When you see a martial artist who has achieved a black belt (or, in kung fu, a white or gold belt), you are looking at someone who has made thousands of mistakes but has chosen to learn from them.

When I sketch, I erase mistakes only after I've studied them and understand what I did wrong. If you immediately erase every mistake you make, you won't be able to recognize your weaknesses. Sketching is supposed to be a fluid exercise, like sparring in a practice ring. So, when sketching, learn to leave the poorly drawn line alone and to draw the correct line over it or next to it. Final drawings, however, are done for reproduction or show, and they should be representative of your current level of skill. They should be sharp and clean, like the moves of a martial artist demonstrating the mastery of a form during level-advancement testing.

When you legitimately need to use an eraser, choose the right one for the job. There are several different erasers on the market, and each has its own strengths and weaknesses. I use a gray kneaded eraser to lighten pencil work and either a white plastic polymer eraser or a Magic Rub eraser to remove large areas of pencil.

Pencils and erasers are a comics artist's most important tools. Types of pencils you might experiment with include standard no. 2 pencils, non-reproducing pencils, artist's lead pencils in a variety of hardnesses, mechanical pencils, clutch pencils and non-reproducing pencils. Erasers include gray kneaded erasers (which have the consistency of Silly Putty), plastic polymer erasers, and Magic Rub erasers. And don't forget the pencil sharpener if you're using lead pencils.

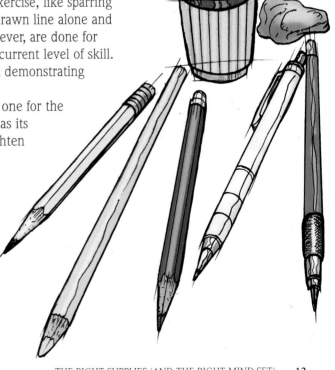

INK

Inking gives your drawing permanence and prepares it for reproduction, but it should also be seen as an extension of the original creative process. Inking involves more than just tracing your drawings: When applying ink, you are also trying to instill balance and clarity in your figures. Although it is easy to learn the basics of inking, it takes years to master this skill. But don't let the difficulty of inking scare you away from it. There are several excellent pens and brushes on the market to assist you in the learning process. Again, give them all a try and come back to the ones you are most comfortable with.

I currently use a combination of dip pens, brushes, and technical pens to get the desired look for my final art. For detail work, I use dip pens with either a Hunt no. 102 or no. 107 crow quill pen nib. Dip pens do not contain their own ink but rather are dipped into a bottle every few strokes to replenish the tiny ink reservoir in the nib. (For ink, I prefer either Higgins Black Magic or the Calli brand black calligraphy ink made by Daler-Rowney.) The advantage of dip pens lies in the wide variety of strokes that can be produced by varying the pressure on the nib. Even greater line-weight variation can be achieved with a brush; I use Winsor & Newton Series 7 sable no. 1 and no. 2 brushes to achieve lively, organic line weights. Technical pens (available in both refillable or disposable models) do not have to be constantly refilled, as they contain ink cartridges; they are easy to use but produce a static line weight. They're great for nonorganic forms, where precision is important. Felt-tip pens and markers are great for sketching or filling in large areas of black, though many artists look down on them since their ink is not as permanent and tends to bleed over time.

Ink is, of course, meant to be permanent, so correcting mistakes made in ink is a little more involved than using an eraser to get rid of pencil marks. To cover up my inked-in blunders, I use either a diluted white gouache paint or a correction-fluid pen. With the advent of computers and digital print-ready files, you may also choose to retouch and remove mistakes by using an image-editing program like Photoshop. (Most of the examples in this book are reproductions of the artist's pencil drawings darkened on a computer. It is probably more helpful for training purposes for you to see the roughness of the original pencil drawings rather than drawings in which everything has been tightened up by some slick ink work.)

Inking implements, by the way, require a strict cleaning regimen. Make sure to clean your inking tools with soap and hot running water after every use.

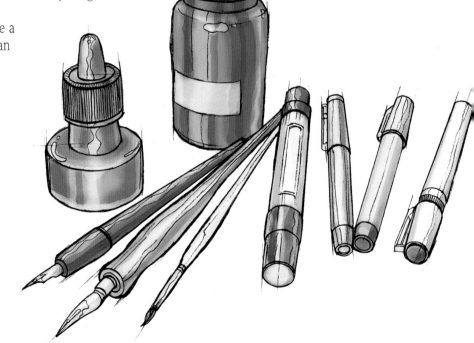

Dozens of different implements are available for inking. Each has its own advantages—and there's a different learning curve for using each tool effectively. Shown below the ink bottles at right are (from left to right) a crow quill dip pen, another dip pen, a paintbrush, a marker, a fine-point marker, a disposable technical pen, and a refillable technical pen.

SUMI-E

Sumi-e, or *suibokuga,* is a Japanese brush-painting discipline in which forms are depicted with as few brush strokes as possible. To Western students, who are usually taught to depict subject matter in hyper-realistic detail, this may seem an odd approach, but understanding the fundamentals of sumi-e will benefit you no matter what style of inking you choose. Sumi-e emphasizes harmonic composition built on three elements: line, color, and *notan,* which means the balance between lights and darks. The word *notan* is a composite of two ideas: *no* (meaning "concentrated") and *tan* (meaning "pale" or "faint").

There are four main brush strokes in sumi-e, called the Four Gentlemen: the bamboo stroke, the wild orchid stroke, the chrysanthemum stroke, and the plum branch stroke. These strokes, which are used to paint the plants after which they are named, are the basis for all sumi-e painting. American comics artists employ dozens of different strokes, but as with the sumi-e strokes, they can only be accomplished after you've mastered the basics of brush control.

Deceptively simple in appearance, sumi-e reveals a fundamental truth applicable to both art and the martial arts: You must become proficient with the basics before advancing to the more complex components. Those who master the sumi-e style of inking will instill in themselves the artistic fortitude needed to tackle more intricate styles of inking. There is an element of artistry in the *process* of inking, not just in the final product. How you produce a line is as important as the line you produce. Remember how, in *The Karate Kid,* Ralph Macchio's character, Daniel LaRusso, grows impatient with the repetitive activities Mr. Miyagi (played by Pat Morita) instructs him to perform? Wax on, wax off. Paint the fence. Sand the floor. Daniel thinks Mr. Miyagi is just using him for free child labor, but Mr. Miyagi is actually laying the foundation for Daniel to become a skilled martial artist. Sometimes things that appear simple teach complex truths.

Sumi-e literally means "ink pictures." (An alternate term, *suibokuga,* means "water-ink pictures.") As in Japanese calligraphy, only black ink is used.

PAPER

Now that you have all the pencils, erasers, pens, and brushes you need, you'll probably want something to draw on. I do most of my sketching and rough layout work on cheap copier/printer paper. But for my final illustrations I use two- or three-ply bristol board, which is what most comics artists use. Bristol board is available in both rough and smooth finishes, and you should experiment with both to see which gives you the best results.

Work large! Too many beginning artists start out by drawing their figures very small—and then get frustrated when they can't master drawing narrow, precise lines. I suggest practicing on paper that is at least 11 by 17 inches. Try to draw from the shoulder, not the wrist. You'll find that the larger paper will help you master the long, graceful lines needed for polished-looking artwork.

OTHER TOOLS

You will need some straightedges and a set of french curves to help you draw straight lines and consistent arcs. As you get a feel for how you work most efficiently, you will start to collect various doodads and specialized pieces of equipment to streamline your drawing process. If you never stop experimenting, your creative spark's pilot light will never go out.

When I went to art school, we had wooden mannequins to help us study the human form. Nowadays, there are toy action figures with more than sixty points of articulation. You may find that using one of these figures will help you visualize the way the parts of the body connect and work together. They can also help you see the way that light and shadow affect a figure's appearance.

Adaptability is an important trait for any artist to develop. Be aware that the kinds of art supplies on the market—and their quality—often change. (Sometimes, entire product lines disappear.) It is therefore often necessary to learn the subtleties of new brands and materials. When you do find a particular brand or tool that you are comfortable with, buy it in quantity and stash the additional materials in your drawing dojo. You might not find them the next time you visit the art-supplies store.

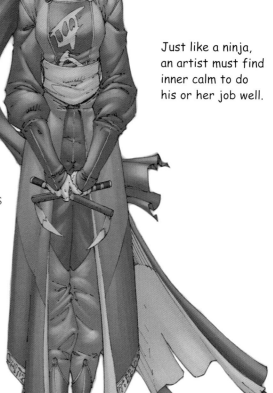

Just like a ninja, an artist must find inner calm to do his or her job well.

THE ARTIST'S MIND-SET

Being an artist—whether a martial arts master or an illustrator—requires that you adhere to a path of discipline. It is not good enough simply to acquire knowledge; you must also learn to channel that knowledge into physical expression. Here, again, are some wise words, this time from Bruce Lee's son, Brandon: "For me, the martial arts is a search for something inside. It's not just a physical discipline."

It is time you start thinking of yourself as an artist. I'm not saying that you should buy a black beret and start hanging around jazz cafés, but rather that you should value every drawing you create. Whatever you were before—and along with everything else you are—you are now an artist. Because you are a person of worth, whatever you create will inherently also be of worth.

The most important tool you bring to the drawing table is not something you can buy in an art supplies store; it is your mind. You must equip yourself with the correct mind-set every time you draw.

In martial arts, this mind-set is called *fudoshin*. Fudoshin is Japanese for "immovable mind," and it points to a state of self-control in which your mind is undistracted and free from conflicting thoughts. When a skilled martial arts practitioner achieves fudoshin, his or her mind and body operate as one, with no hesitation or forethought before action.

Fudoshin does not mean inflexibility, but rather a condition that is not easily upset by internal thoughts or external factors. It implies balance in being. For the illustrator, this entails finding time and space in which to dedicate yourself to perfecting your craft. As you continue to hone your artistic skills, drawing will become second nature to you. You will no longer need to reflect on why you draw this line or that; instead, you will know what lines to make unconsciously and as if on impulse. As in most disciplines, success in comics art depends both on natural skill and on focus and dedication. It is this combination that separates the hobbyist from the professional.

Another important concept is *zanshin,* which in Japanese means the "continuing mind." Zanshin is a heightened state of awareness of your surroundings, and it goes hand in hand with fudoshin. You never want to stop learning from the world around you. As you focus your mind on your art, also stay attentive to your environment, constantly looking for interesting patterns or details from life that you might like to transcribe onto your paper. Keep a teachable spirit, always remaining willing to consider a new or better approach to your art. In this way, you will stay focused on where you are now, but you won't become static in your techniques.

Balance is as important for the illustrator as for the martial artist.

DISCIPLINED BODIES

Kata ("form") should be worked comprehensively, carefully, and completely.

Nat Peat Sensei,
Yudansha Kobu-Jitsu Karate-do Federation

MARTIAL ARTS MASTERS work hard to achieve athletic excellence, and we comics artists should honor their efforts by perfecting our skill in drawing anatomy.

Anatomy is a stumbling block for many would-be artists, but I'll show you how to karate-chop that block in two. In most forms of cartooning, anatomy is highly stylized: the emphasis is more on what looks cool rather than on physically accurate depiction. This is not to say I'm giving you permission to chuck your anatomy and figure-drawing books. Keep those close at hand for reference as you go through the exercises in this book. The central idea I want to instill in you is the need for consistency. You've got to know the rules so you can bend them without completely breaking them. Your figures should be drawn consistently, using the same basic forms and shapes.

The martial arts require one to be in top physical condition—agile, disciplined, and strong. Sheer muscle mass is not always a plus in martial arts competitions, because contestants need to be light and quick on their feet. Martial arts practitioners therefore tend to favor a lean, sculpted physique over the bulked-up physique of competitive body builders.

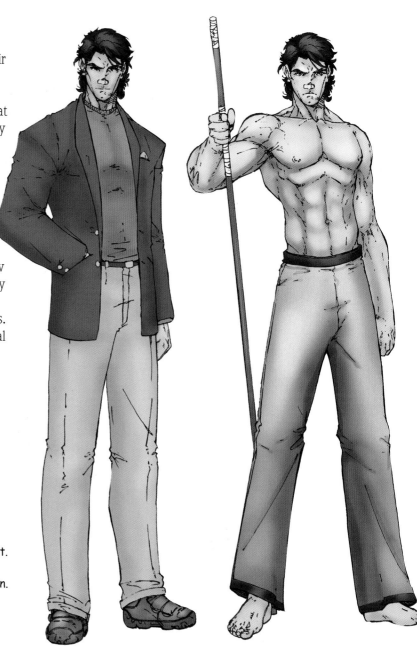

Martial artists shed their street clothes so they have greater freedom of movement. Let's go one step further and see what lies beneath the skin.

MALE VERSUS FEMALE FIGURES

When drawing a male figure, you want to emphasize his athletic prowess. The shoulders should be broad and the muscles well-defined. Serious martial arts practitioners maintain a strenuous workout program of cardiovascular and endurance training and low-weight/high-reps strength training. The result is a highly sculpted physique with very low body fat.

Artists spend a great deal of time and energy making sure all the parts of their figures are proportional to each other. By "proportional," I just mean that each anatomical feature is the right size when compared to the rest of the body (for example, human beings' legs are longer than their arms). Since figures are drawn at many different sizes, using a ruler is impractical, so artists measure a figure against itself, using the size of the head as the basis for all other measurements. In real life, most men are six to seven heads tall; an easy way to make a figure seem more powerful and dramatic is to make him eight to nine heads tall. At the shoulders, a trim, well-built adult male is about three heads wide, while his trunk tapers to about two heads in width at the waist.

A common mistake is to draw the legs as continuous cylinders that bend at the knees. In actuality, the lower half of the leg curves and sits a little farther back than the top half, so that the body's weight is distributed throughout the lower limbs and does not rest entirely on the feet.

This guy, shown in a "turnaround" view (back, front, and side), is about eight heads tall—not Superman proportions, but not your average Joe, either.

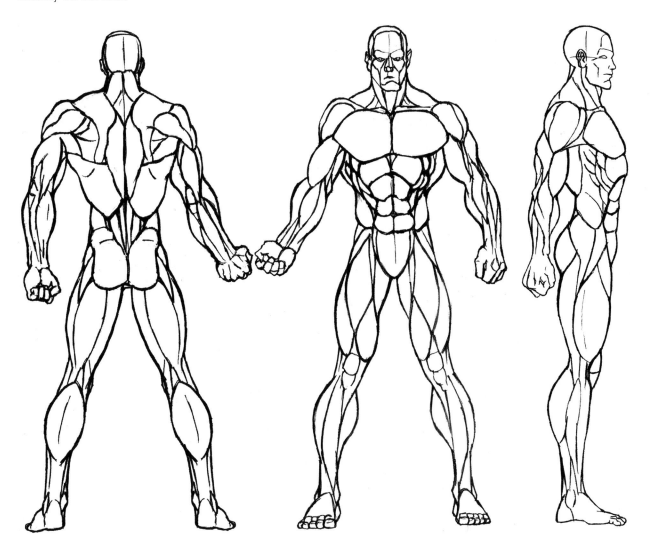

The female form is basically very similar to the male's, but there are several important details you must take note of so your ladies don't come off looking like they play linebacker for the Pittsburgh Steelers. In general, women should be drawn with much less muscle definition than men—not that they are weaklings! Women have less muscle mass, so a woman's frame is slighter than a man's. Plus, women's muscles are usually less defined than men's, meaning a smoother and more realistically feminine form results when you use fewer lines to define their muscles. A woman's shoulders are only about two heads wide, and the female form tapers at the waist and widens again at the pelvis. A woman's pelvic girdle widens during puberty to accommodate pregnancy, and this gives women's bodies a slightly different overall posture and weight distribution.

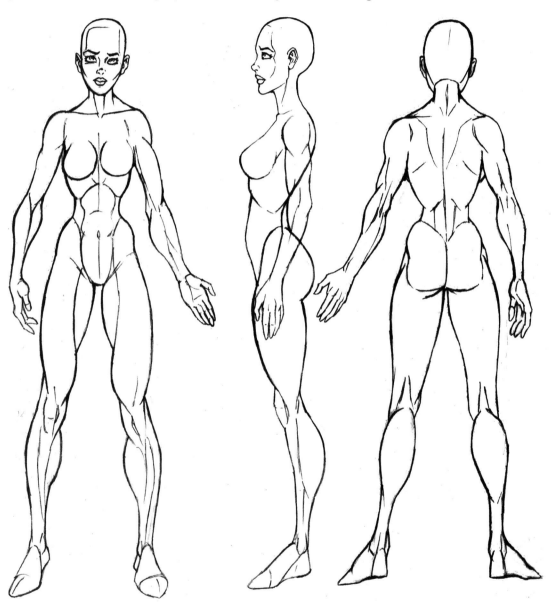

This turnaround view of the female body illustrates some of the differences between men's and women's forms. The so-called "hourglass" appearance of a woman's silhouette results from the similar width of the shoulders and hips. (Many artists who are just starting out don't make their female characters' pelvises wide enough, and so they end up with boyish-looking women.) The angle of the chest cavity's tilt is more pronounced in women, as is the angle of the pelvis, and these differences produce a more pronounced S-curve in the female backbone.

A woman's different physique makes her center of gravity lower, giving her a greater sense of natural balance. A woman is able to extend her upper torso farther than a man, while maintaining control of her equilibrium. Female martial artists are often described as cat-like because their low center of gravity allows them to flow from one pose to the next with effortless grace.

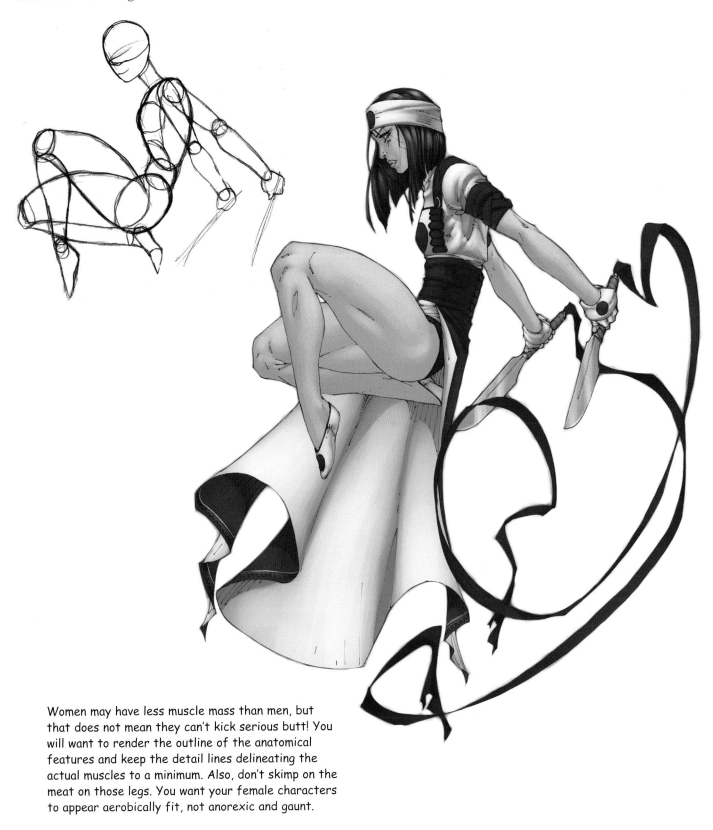

Women may have less muscle mass than men, but that does not mean they can't kick serious butt! You will want to render the outline of the anatomical features and keep the detail lines delineating the actual muscles to a minimum. Also, don't skimp on the meat on those legs. You want your female characters to appear aerobically fit, not anorexic and gaunt.

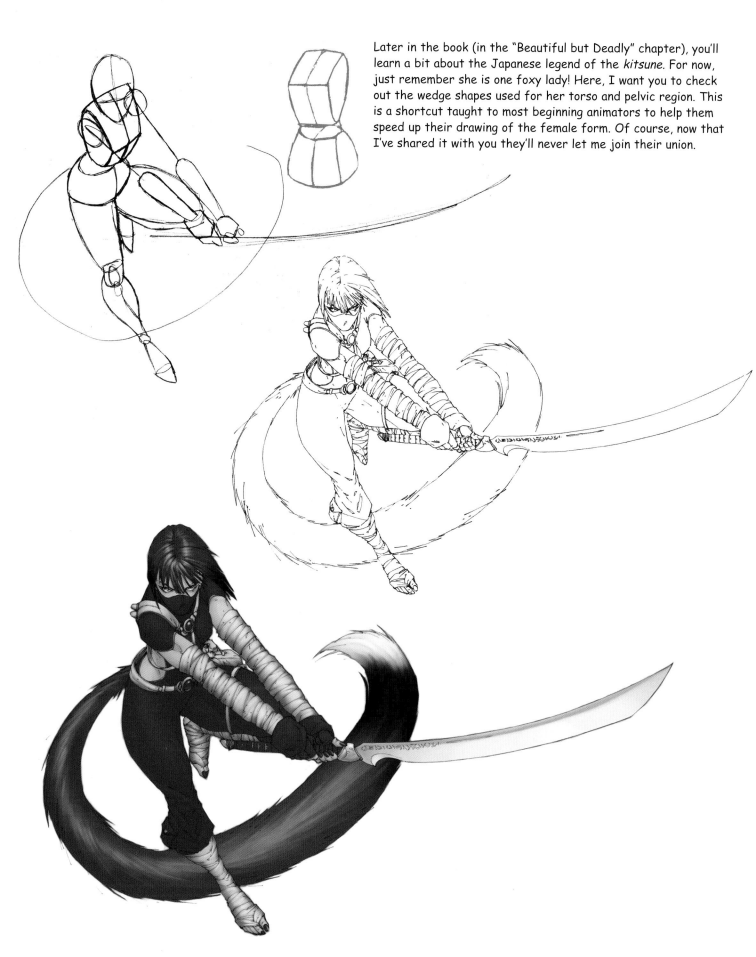

Later in the book (in the "Beautiful but Deadly" chapter), you'll learn a bit about the Japanese legend of the *kitsune*. For now, just remember she is one foxy lady! Here, I want you to check out the wedge shapes used for her torso and pelvic region. This is a shortcut taught to most beginning animators to help them speed up their drawing of the female form. Of course, now that I've shared it with you they'll never let me join their union.

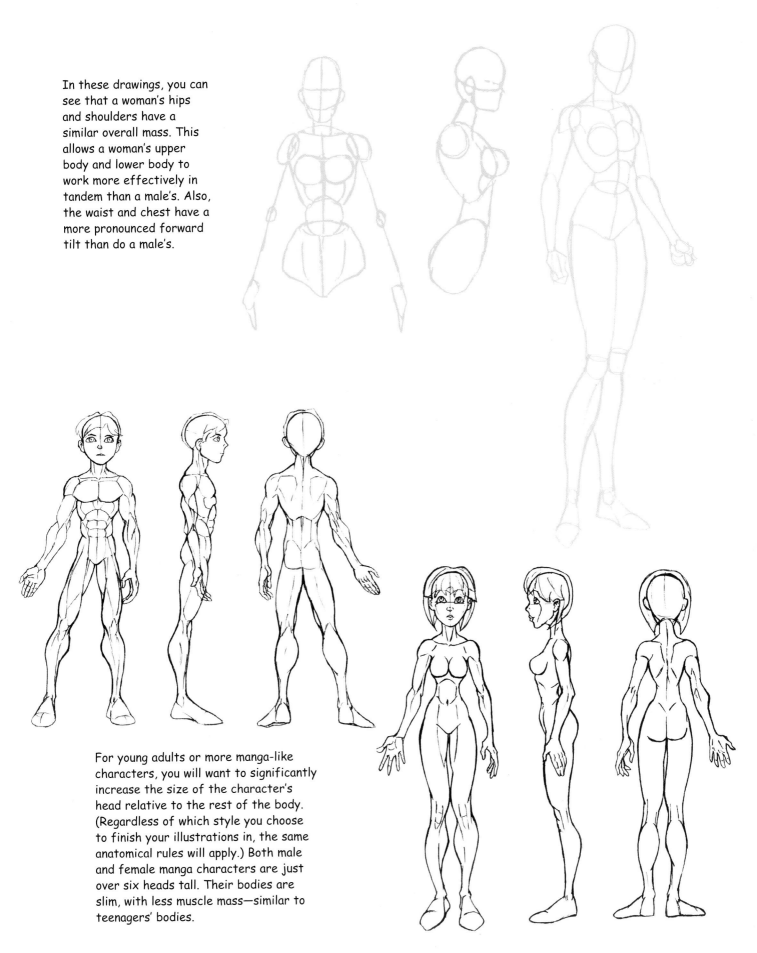

In these drawings, you can see that a woman's hips and shoulders have a similar overall mass. This allows a woman's upper body and lower body to work more effectively in tandem than a male's. Also, the waist and chest have a more pronounced forward tilt than do a male's.

For young adults or more manga-like characters, you will want to significantly increase the size of the character's head relative to the rest of the body. (Regardless of which style you choose to finish your illustrations in, the same anatomical rules will apply.) Both male and female manga characters are just over six heads tall. Their bodies are slim, with less muscle mass—similar to teenagers' bodies.

PRESSURE POINTS

When you draw a fight scene, you want to aim your characters' blows at key "pressure points" on their opponents' bodies. A pressure point can be either an area of the body that is especially vulnerable to injury or a nerve center that produces debilitating pain when struck. In martial arts movies, you'll often see a master passing on his secret knowledge of a one-strike death blow to a prized student. This is mostly the stuff of a screenwriter's imagination, though it is true that blows to some areas (like the windpipe) can actually result in death.

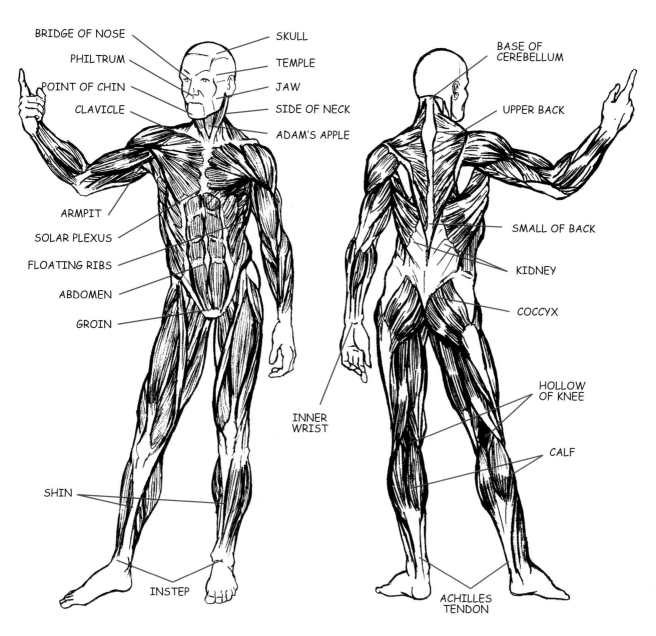

For effective depictions of martial arts action, aim your characters' strikes at the key nerve clusters in their opponents' bodies. Hitting one of these pressure points will spark the opponent's pain receptors, making them flash like a pinball machine and possibly causing paralysis or unconsciousness.

JOINTS

The human body is flexible. There are 206 bones in the human body (about half of them in the hands and feet). Wherever two bones meet, movement is possible because of the connection called a joint. Joints are key areas in martial arts, used for various locks and holds in which opponents' natural physical limitations are turned against them. For instance, by twisting an attacker's arm behind his back and applying backwards pressure to his pinky-finger joints, you can control the attacker's whole body. (When you think about it, it's amazing that you can immobilize someone by controlling just his little finger.)

The body has several different types of joints—all of them important in the martial arts. These different kinds of joints allow various parts of the body to perform different kinds of movements:

- *Hinge joints* at our knees and our elbows allow for bending in one direction.

- *Pivot joints* allow rotation around an axis. The neck and forearms have pivot joints. In the neck, the occipital bone (at the back of the skull) spins over the top of the axis. In the forearms, the radius and ulna twist around each other.

- *Ball-and-socket joints* permit radial movement in almost any direction. They are found at the hips and shoulders.

- *Ellipsoid joints* are similar to ball-and-socket joints. They also allow multidirectional movement, though to a lesser degree. The wrist is an ellipsoid joint.

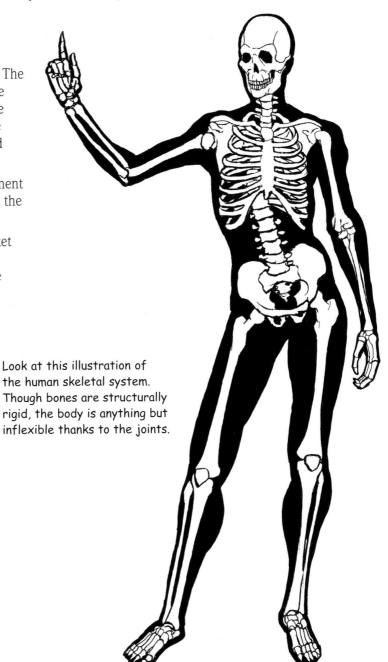

Look at this illustration of the human skeletal system. Though bones are structurally rigid, the body is anything but inflexible thanks to the joints.

THE "READY" STANCE

In a martial arts competition, the combatants face one another before and after a match. In more formal settings, they stand erect, with arms at their sides, and then they bow. In a street brawl the bow is usually dispensed with, since a less-than-honorable opponent might use this opportunity to land a sucker punch. Instead, the fighters face each other, make eye contact, and flex their muscles in a show of force, trying to intimidate the challenger while sizing him up.

Watching a warrior assume a fighting stance and move toward his opponent is almost as cool as witnessing the combat moves themselves. As the combatants prepare to fight, the air becomes charged with the electricity of the upcoming confrontation. The "ready" stance is a strong fighting position for sparring or for an actual fight, and it's a pose you will be required to draw often.

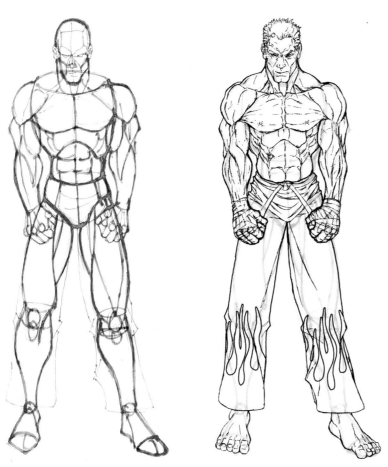

Honor is very important in the martial arts. Each combatant is expected to face the opponent and bow, both before and after a match. This battered brawler is clearly an example of the latter. The adrenaline that courses through the body during a confrontation causes muscles to contract and become easily visible under the skin.

Maintaining balance is essential if a fighter wants to remain in control of his body. The ready stance allows the fighter to distribute his weight evenly between his two feet. The fighter rests on the balls of his feet, rather than the heels, so a kick can quickly be unleashed from either leg.

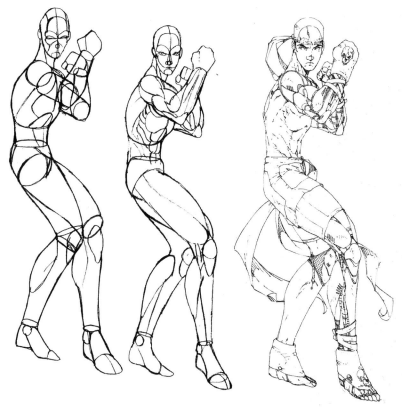

The martial art form known as muay thai—Thai kickboxing—has a slightly different ready stance. One foot is positioned in front of the other, with the feet about a hip distance apart. The weight is placed almost entirely on the rear leg. Both knees are slightly bent, and the trunk is upright. The forward leg is cocked and ready to move or strike. The arms are in a raised boxing position, with the elbows bent in toward the front of the body and the fists held near the chin.

Follow your nose. A good rule of thumb is the nose knows how to keep a figure balanced. If you can draw a line straight down from the nose and it falls somewhere between the two legs, your figure will appear balanced.

Your average Joe is around seven and a half heads tall. Idealized figures are often drawn about eight heads tall, and especially heroic figures (like superheroes) are depicted as being nearly eight and a half heads tall. This guy is almost ten heads tall. Most of the additional length comes from the elongated chest and extra-long legs. Once you have a firm understanding of ordinary proportions, do not be afraid to bend the rules to fit your character.

PRELIMINARY DRAWINGS

The "ready" stance illustrations on the previous pages include a preliminary sketch, the completed figure drawing, and the final, inked art, including background. As you work through the examples in this book, you may wonder whether all artists draw preliminary drawings every time they construct a figure. Well, every artist works differently, and most adopt a style of drawing that's uniquely their own. The preliminary drawings presented in this book represent the key points in constructing a figure and are there to help you learn how to "think through" your figure drawings.

That said, it's true that most artists start out with some kind of "underdrawing." It can be a rough sketch, a lightly constructed composition guide, or a value study (a quick sketch noting placement of lights and darks). But whichever kind of preliminary drawing the artist chooses to use, it will establish the basic size, shape, placement, and proportions of the figure or figures.

I do initial roughs for all my drawings before committing to the final illustration. In the "ready" stance example, I drew the basic figure in marker, scanned it into my computer, and then printed it out in a much lighter tone on the final illustration board. I created the background separately and then combined the figure and the background using Photoshop. I use this method whenever I want to play around with various background elements but don't want to erase and redraw around the figure on the final board.

Artists draw what they know, and if you don't understand figure construction in your head, well-drawn figures aren't going to magically appear when you put pencil to paper. To simplify the process of "thinking through" a figure, first imagine the figure as being composed of simple shapes. Since the human form is so complex, most artists build a figure out of simple 3-D forms that represent the major anatomical features. As the illustrations below show, there is more than one way to establish the basic shapes, and you'll need to experiment to find the technique you're most comfortable with.

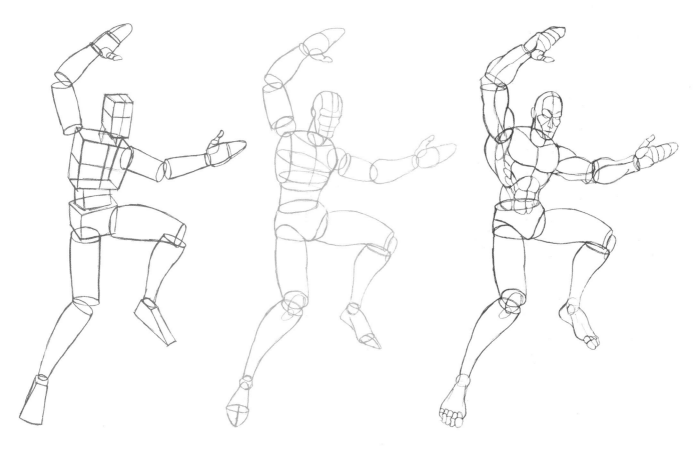

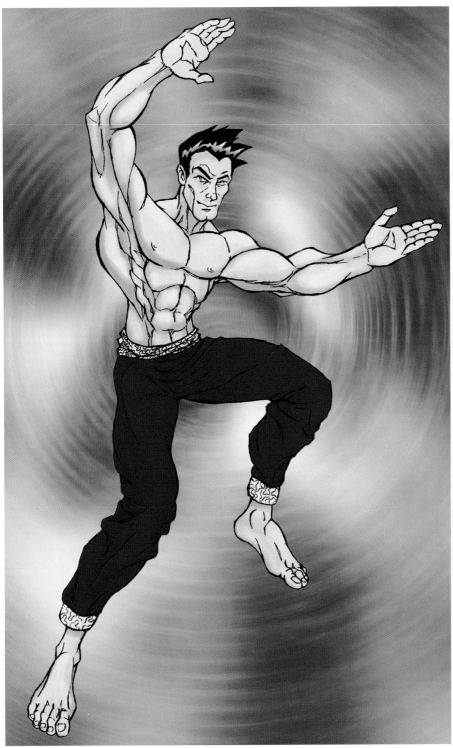

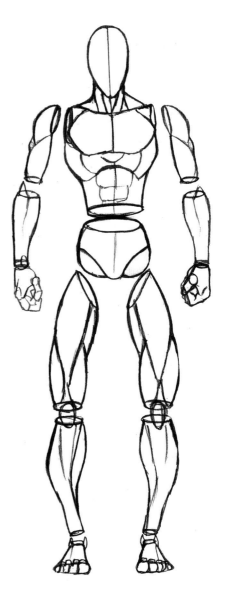

The basic anatomical forms—head, chest, pelvis, arms, legs, hands, and feet—are the building blocks of the whole figure.

If you first build your figures out of simple forms like cubes, spheres, or ovals, it will be much easier for you to develop dramatic poses for them. In the set of drawings opposite, the blue sketch at the far left uses simple boxes and cylinders to establish the space the figure will occupy; this "cube" method is especially helpful for putting a figure into proper perspective when the character is posed at a tricky angle. The green figure, second from the left, instead uses oval shapes for the head, torso, and pelvis. The third example, in red, shows the figure with the major muscle shapes roughed in. Above is the finished art.

FORESHORTENING

Foreshortening is the term describing the "compressed" appearance objects sometimes have when seen from a particular viewpoints. From certain angles, certain parts of an object may appear shortened (or may be partly or entirely hidden). If you don't understand what I mean, take an ordinary drinking glass and view it first from the side. From this view, you see the whole, six-inch-tall glass. If, however, you tilt the glass slowly toward you, gradually turning it until you are looking directly down into its mouth, you will notice that the apparent height of the glass gradually decreases until you can't see the sides of the glass at all—just the circle formed by the rim. This trick of perspective is key to drawing convincing figures. I hope you can see how building a figure out of simple forms comes in especially handy when any part of the figure is foreshortened. It is far easier to draw a cylinder in perspective than it is to immediately draw all the bones and muscles of an arm properly foreshortened.

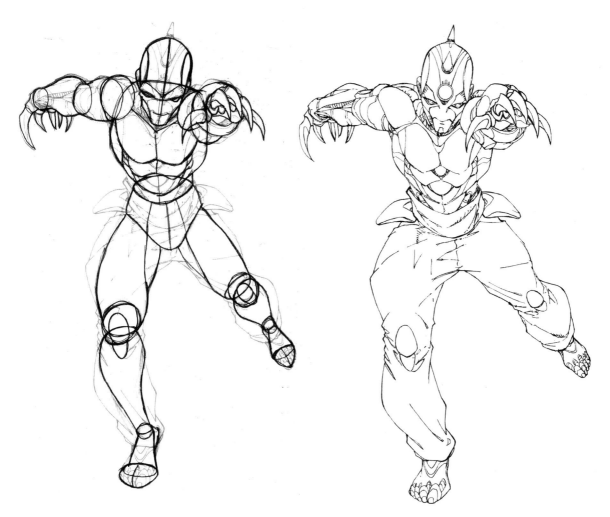

Notice how most of the length of the left arm of this formidable martial arts robot is hidden because you are looking almost directly down its shaft. This is a pretty extreme example of foreshortening, but you can also see that the right arm, which stretches toward the background, is also foreshortened, to about half its normal length. (The left leg is foreshortened, too.) It may seem that foreshortening is easy because you're actually drawing less of the figure, but this is deceptive. Before drawing a foreshortened figure, you must first work out the proportions in your head. This skill takes a while to learn, and the only way to get better at it is to practice.

HEAD AND FACE

The human head has an oval, or egg, shape. To get the basic shape, begin with a circle representing the top portion of the head and face, then extend that circle downward into an oval shape ending in the chin, as shown in the illustration below. The eyes are about halfway from the top of the head to the chin. The ears and the bridge of the nose are at roughly the same level, so a guideline drawn for the eyes will help you position these features, too. The mouth falls about halfway between the bottom of the nose and the edge of the chin. I make my characters' chins a little larger and more prominent than what the average guy would have, so my characters' mouths are a little higher up than normal. Remember always to start with the general before you draw the specific; you need to rough in all the facial features before you focus on the details of the eyes and other features.

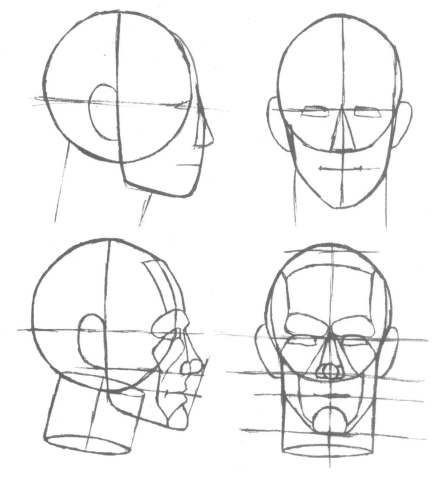

These four drawings illustrate the basics of head construction.

The human skull is made up of many prominent bone structures, which create sharp angles. When the skull is covered with flesh and skin, many of the edges become less distinct, but major structures like the eye sockets (called the orbits), the cheekbones, and the jawbone (or mandible) are still clearly distinguishable.

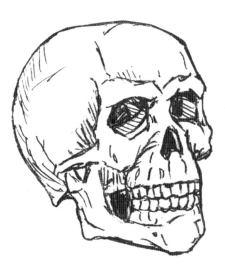

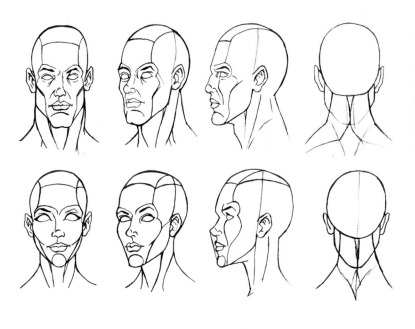

The head and face convey your characters' moods, so it is extremely important to become comfortable with drawing the key features. As you draw, you should be constantly envisioning the facial features as three-dimensional shapes, not as flat lines. The nose is an elongated pyramid shape whose apex lies between the eyes and whose lower edge includes two points indicating the nostrils. The human eye is round, so the eye appears rounded from every angle. The mouth is more than just a line. The jawbone, or mandible, moves toward and away from the skull on points fixed right below the ears. Every time the mouth opens, the whole jaw opens. The male head is much more angular than the female, so remember to emphasize the roundness of the features when drawing female characters' heads and faces.

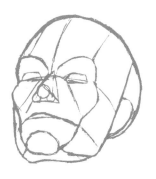
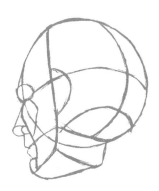
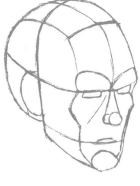

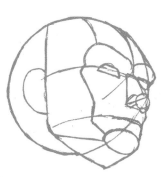

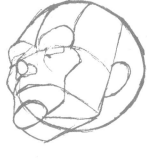

These drawings show how the head is constructed from many different angles. Your characters' heads will be placed in some pretty wild positions as the characters perform various martial arts moves, so it is imperative that you practice drawing the head from every conceivable angle.

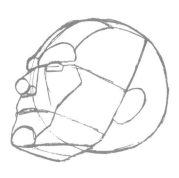
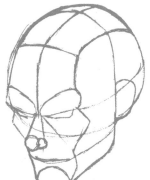
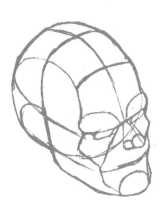

CHEST, WAIST, AND PELVIS

The chest, waist, and pelvis work together, so they must be drawn in relation to each other. These interrelated forms comprise the central mass of all your figures, so getting their proportions and direction right is key to constructing believable figures. The head and limbs will be built upon what you establish in this step, so special care should be given to understanding these components before moving on.

Since there are dozens of muscles and bones at play in the torso, you will want to simplify it into easily manageable forms rather than beginning with complex anatomical representations. Some artists use cubicle forms, envisioning the chest and pelvis as a pair of boxes, as in the drawing at right. I prefer to a set of oval shapes, as in the four sample drawings below.

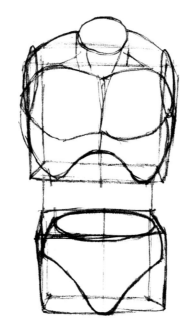

This drawing shows the chest and pelvis as two separate boxes, but remember that these two masses are connected by the spinal column, which allows for and controls the figure's range of motion.

I believe that constructing the torso from a set of oval shapes gives the figure a more organic look. Occasionally—and especially when drawing the figure from an unusual perspective—I will use boxes instead, but once I understand the composition I always translate the boxes into ovals before moving from the sketch to the finished drawing.

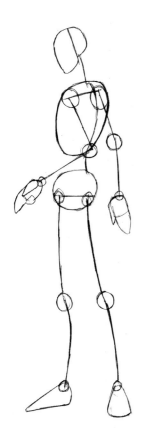
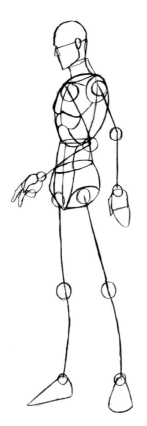
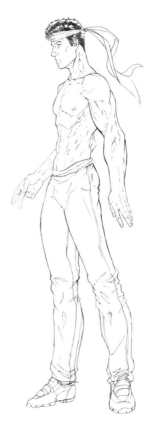
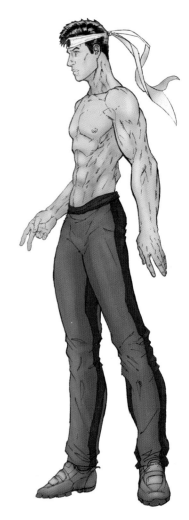

Martial arts practitioners are especially limber and are capable of twisting and turning to a greater degree than most folks. Maintaining a sense of fluidity is essential if you want your figures to look dynamic and not like static statues. Keeping your initial lines loose and light will give the final figure an animated appearance.

One good way of teaching yourself to draw the torso is to think of it as a large pillow shape. A pillow has roughly the same mass and dimensions as the upper body. Drawing a dividing line about two-thirds of the way down the pillow establishes the place at which the torso twists—that is, the waist. The pelvis distributes the body's weight to the two legs. When the body twists at the waist, the shoulders compensate, and maintain balance, by turning at an angle opposite that of the pelvis. Figures in motion utilize the same principle, but a moving figure will also have to compensate for the momentum of the body.

In martial arts moves, several discrete actions are linked in one continuous and precise motion—with one action flowing into the next as the practitioner remains mentally aware of the exact beginning and end of each arch of activity. If this sounds complicated, it is. In fact, this is *the* challenge of mastering the martial arts. Accurately conveying such actions on paper is similarly tricky, but the risks are much lower. Artists don't come away from their drawing tables battered and bruised if they do not correctly execute their tasks!

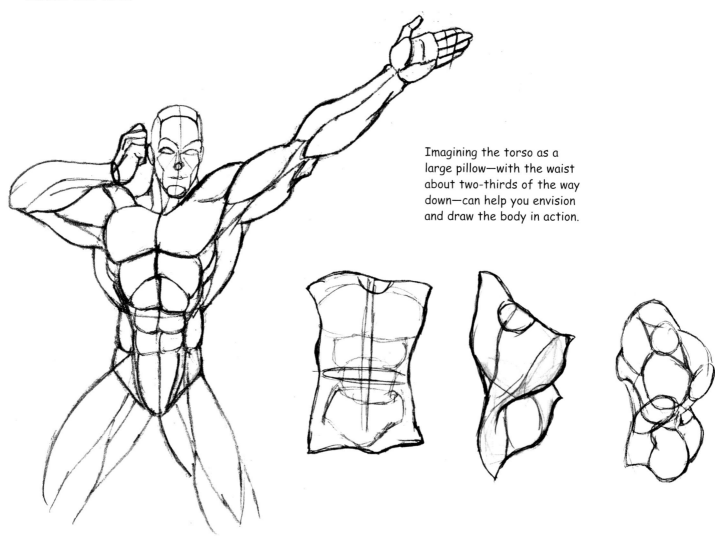

Imagining the torso as a large pillow—with the waist about two-thirds of the way down—can help you envision and draw the body in action.

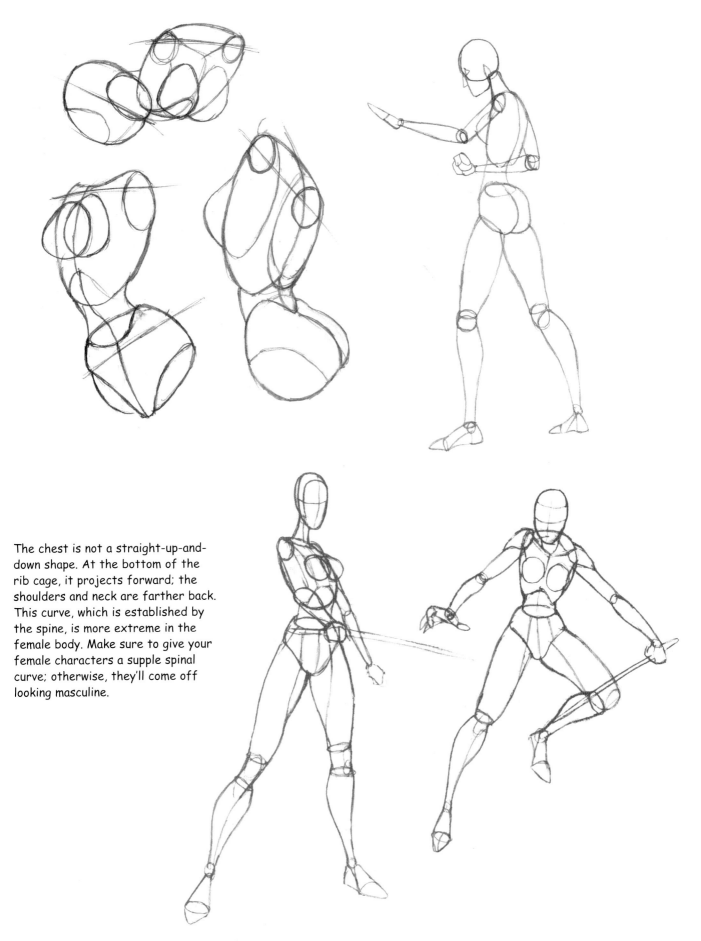

The chest is not a straight-up-and-down shape. At the bottom of the rib cage, it projects forward; the shoulders and neck are farther back. This curve, which is established by the spine, is more extreme in the female body. Make sure to give your female characters a supple spinal curve; otherwise, they'll come off looking masculine.

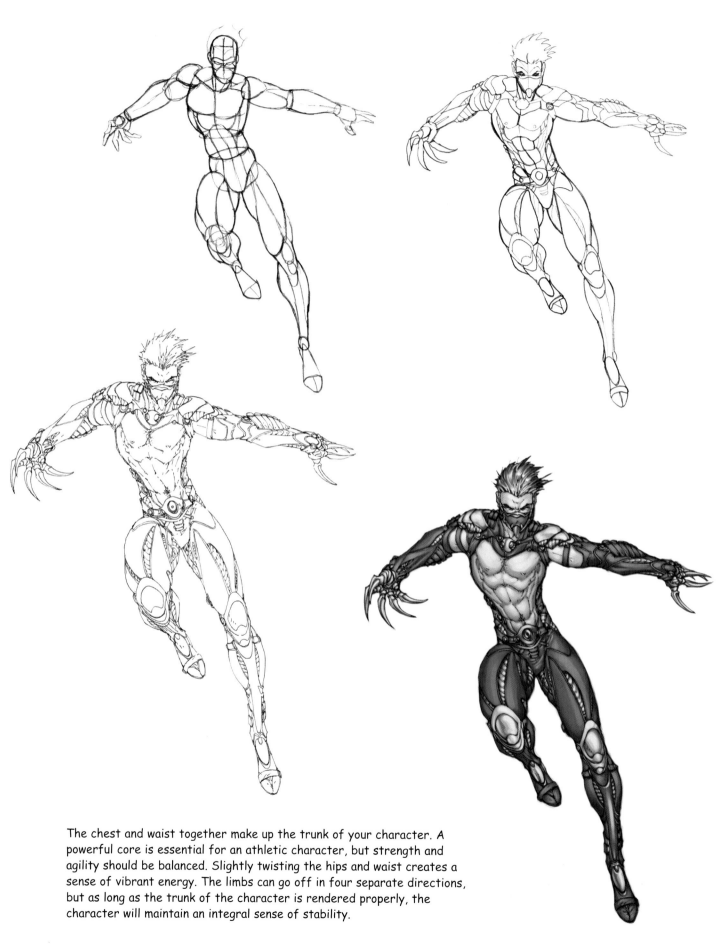

The chest and waist together make up the trunk of your character. A powerful core is essential for an athletic character, but strength and agility should be balanced. Slightly twisting the hips and waist creates a sense of vibrant energy. The limbs can go off in four separate directions, but as long as the trunk of the character is rendered properly, the character will maintain an integral sense of stability.

ARMS AND LEGS

When you think of the martial arts, you probably immediately envision hands and feet flying in all directions, propelled at lightning speed. Well, those hands and feet are attached to arms and legs. Drawing martial artists' limbs is a lot of fun, since you get to depict arms and legs in the most unlikely positions and combinations. No other kind of comics allows you to draw characters' legs positioned over their heads (or at least not so frequently) or arms snapping to their full length before penetrating wood or concrete.

Thankfully, the limbs' basic shapes are relatively easy to draw. Arms and legs share a similar range of motion, as they are both attached to the body at ball joints (the shoulders and hips, respectively) and both have central hinged joints (the elbows and knees). The arms' range of motion is, however, greater than that of the legs, since the shoulder blade is not stationary but actually glides across the exterior of the rib cage at the back.

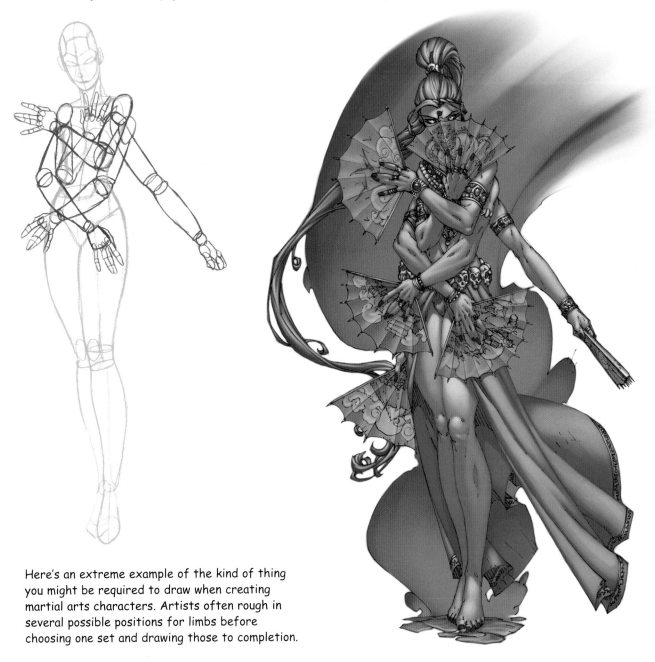

Here's an extreme example of the kind of thing you might be required to draw when creating martial arts characters. Artists often rough in several possible positions for limbs before choosing one set and drawing those to completion.

In their final form, the upper and lower halves of the limbs differ in appearance, but they can all be quickly roughed in with simple cylindrical shapes. I think of the upper arm as having a mass similar to that of two soda cans stacked one on top of the other, while the lower arm is a cylinder comparable to an elongated drinking glass or a cylindrical flower vase. The legs possess the same basic shapes, but the scale is larger. When I'm roughing in the limbs, I draw a ball at each end of each arm and leg so I can imagine the cylinders "rolling around" the ball sockets at the shoulders and hips and to remind myself that the wrists and ankles are capable of a wide range of motion.

In the drawings below and opposite, you can see that, in the initial steps, the figures start out as little more than stickmen (or, in these examples, stickwomen) composed of simple ovals and connected lines. Even characters as complex as these are no match for an artist who has practiced the basics of limb construction. By drawing-through each arm (that is, sketching the whole arm, even the parts that will be hidden by other shapes in the finished art), even the most complicated arrangement of limbs can be drawn with ease. Remember always to draw the basic shape of the limb before moving on to the specific details; it is much easier to erase and redraw a simple cylinder rather than to fully render a limb and then have to reposition it.

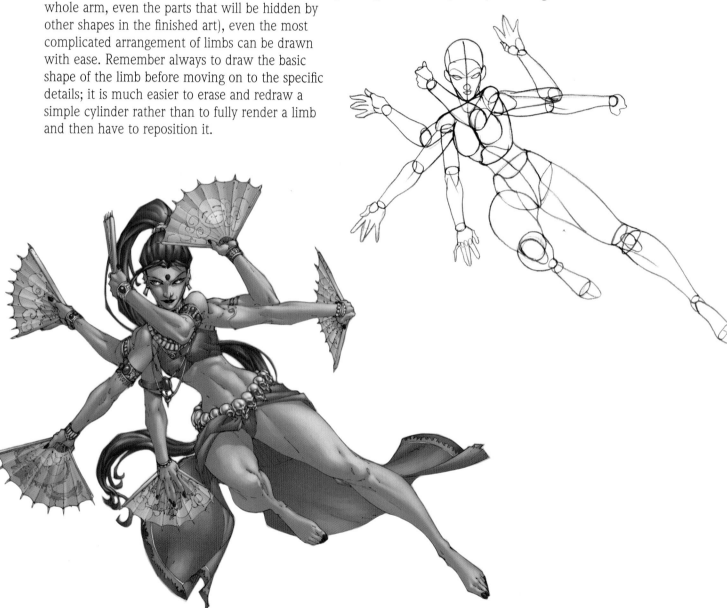

Artist Brett Booth has taken the concept of roughing-in the limbs one step further with this many-armed character. Notice how, in each case, each arm is roughed in using the same simple shapes and then rendered with musculature and shading specific to the position of the arm.

HANDS

At one point in the movie *The Karate Kid,* the teacher, Mr. Miyagi, says, "Is okay to lose to opponent. Must not lose to fear." The topic of drawing hands makes me think of that quote, because there is no other anatomical feature that gives artists such fear. Don't worry if you share this dread, for I know many professional artists who still struggle when drawing hands.

Whole books have been written on how to draw hands, but let me share just a few shortcuts to help you render expressive hands simply and quickly. Equipped with this knowledge, you'll soon be on your way to filling page after page with flying fists of fury.

I think the best technique for drawing hands is the one I learned from my buddy Bryan Baugh, who was a storyboard artist on the *Jackie Chan* cartoon series. Early in my career, Bryan was gracious enough to pass on this wisdom as he watched me struggle with drawing a simple fist. "The key is to not think of it initially as a hand, but to draw it as a simple mitten shape and then refine it and add the fingers," he said. Once the mitten shape was in place, it was easy enough to subdivide the end of it into fingers. This was more than ten years ago, and I have drawn hands the same way ever since.

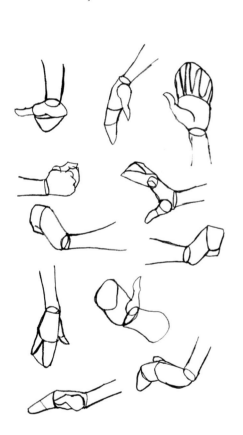

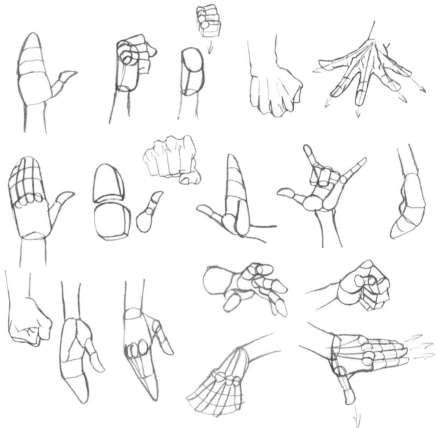

Simplifying the form of the hand by first creating a basic mitten shape is essential for drawing hands quickly and properly. It is better to rough in your hands as mitten shapes with flippers showing where you will eventually place the fingers.

Once you have drawn the basic mitten shape of the hand, you can divide the flipper section into three subdivisions for the digits of the fingers. Remember: The joints of the fingers appear in an arc when the fingers are splayed. The hand's bones radiate out from the wrist (sort of like a rake), meet at the knuckles, and then, as fingers, move away from the hand itself and gain free mobility. If you get confused about the position of a finger, just trace the series of bones that lead to it back to the wrist.

Here are some notes on other things to remember when drawing hands:

- When the hand is open, each finger radiates out from the main part of the hand in a way similar to the tongs of a rake.

- When drawing fingers, try to keep detail lines to a minimum. Concentrate on clearly marking the knuckles and finger joints, but be very cautious about adding in other lines, which may cause the hands to look geriatric.

- Each finger joint allows the segment it controls to bend inward at an angle of almost 90 degrees. This is what allows a human being to make a fist—in which the fingers curl in all the way to the palm.

- When drawing a fist, think of each curled finger as a single blocklike shape.

- When the hand is clenched in a fist, the thumb rests on top of the index and middle fingers.

- Although the thumb is similar to the other fingers, it attaches to the hand near the wrist rather than at the knuckle line. Its placement allows it to jut out at an angle of almost 90 degrees in relation to the other fingers. Like the other fingers, the thumb has three joints, but the first and largest segment of the thumb is situated against the palm of the hand, so only the last two segments are clearly visible when the hand is seen from the back or side.

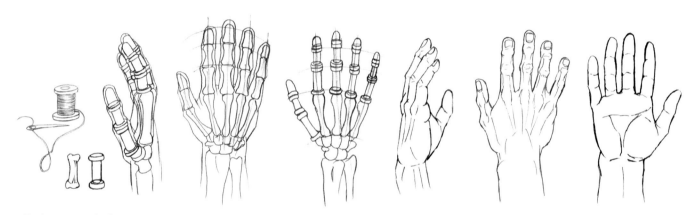

I picture each finger bone, or phalange, as having an appearance similar to that of a spool of sewing thread—a cylindrical mass with two wider ends. When the bones are covered with flesh and skin, the finger segments have a more squared-off appearance—rather like that of a rubber eraser. By combining aspects of the spool and the eraser you get a working organic shape suitable for representing the fingers' segments.

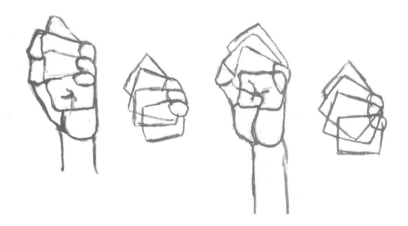

If you plan on drawing fighters, you'd better get used to drawing fists. The fist is a principal weapon in every martial arts combatant's arsenal. A shortcut for drawing believable fists is to think of the curled fingers as separate cube shapes with a common connection point at the knuckles. Rather than trying to position every phalange properly, just draw the fingers as cubes and then go back into them (when the drawing is near completion) and draw only the segments that are visible.

FEET

In the martial arts, feet are employed as weapons as often as fists. Boxers know that the greater the length of the arm, the greater the force that can be generated for a punch. Imagine a boxer whose reach is as long as his legs, and you can see the advantage that employing feet as "fists" confers on a fighter. As one martial arts teacher once put it, "Two hands are two doors. It takes footwork to open the door."

To a beginner, feet can look like as difficult to master as hands, but they are really much simpler. The foot's basic shape is a wedge. Seen from the inward side, the sole of the foot has two distinct curves, at the ball of the foot and at the heel, and these curves are connected by an arch that distributes the body's weight between the back and front of the foot. Martial arts students are taught to place most of their weight on the balls of their feet, lightly resting on their heels for support; this allows for speed of movement and makes it easier to move the mass of the body into action.

The foot often gets overshadowed by its flashier relative, the hand, but there is no reason not to render feet with the same amount of care. Feet are vitally important for a fighter, and in the martial arts they are usually not hidden by shoes and socks. So you'd better get used to drawing those Ten Little Piggies of Fury.

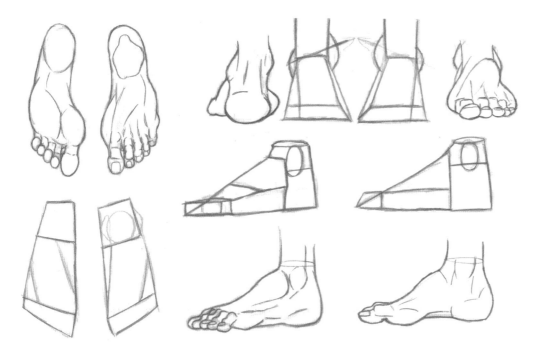

Here you can see the basic wedge shape of the foot. Even though you begin your drawing of a foot with a simple wedge shape, it is important to round off the edges as you refine the mass. Notice that the foot does not sit flat on the ground—there's an arch between the ball of the foot and the heel. The inner edge of the sole curves in toward the body's center. The outer edge, which is straighter, is referred to as the *blade* of the foot; this is the contact point for most kicks. The ankle is the fulcrum around which the foot rotates. The ankle visibly protrudes from the rest of the foot, with the inner bump being slightly higher than the bump on the outside of the foot.

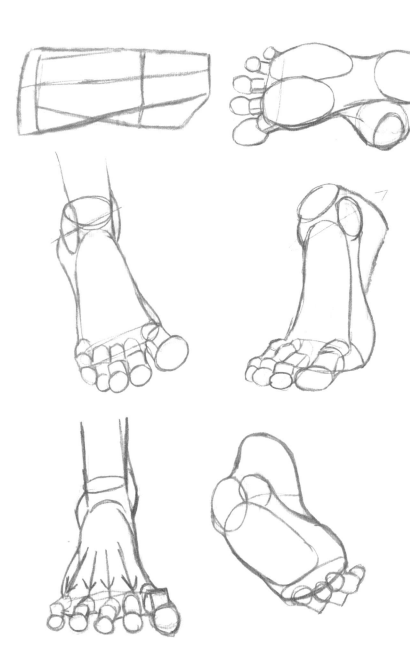

I tend to draw my characters with larger-than-normal feet to emphasize their stability. The bones of the feet are similar to those of the hand, but the toes, obviously, are much shorter than the fingers. Still, you can use shortcuts in drawing the feet that are similar to those used when drawing the hands. Draw the toes as small cylinders with a slight curve and a rounded end. (If that doesn't work for you, try this: More than one artist has confessed to me that they draw toes as basically flesh-colored peanuts.) If you need more help, feel free to strip off your socks and be your own model. Unlike other body parts, you should be able to twist and turn your own feet into just about any pose you will be required to draw.

Some martial artists, particularly those practicing ninjitsu (the style of martial arts developed by Japanese ninja spies and assassins) favor footwear that divides the first two toes from the other three. This footwear (sometimes called a two-toe boot since it looks as if it has two large toes) doesn't confine the toes as tightly as other shoes, and it thus allows greater control of balance and weight distribution. When drawing toes, I use a concept much like the two-toe boot's design. Rather than trying to draw the toes individually, I find it much easier to first divide the area occupied by the toes in half and then to subdivide the "inner" section into the big toe and its neighboring second toe and the "outer" section into the other three toes. Beginners who try to all draw five toes at once, either by working inward from the pinky toe or outward from the big toe, often run out of space before getting all five toes in. It is better to start at the middle, divide the toes into two sections, and subdivide from there.

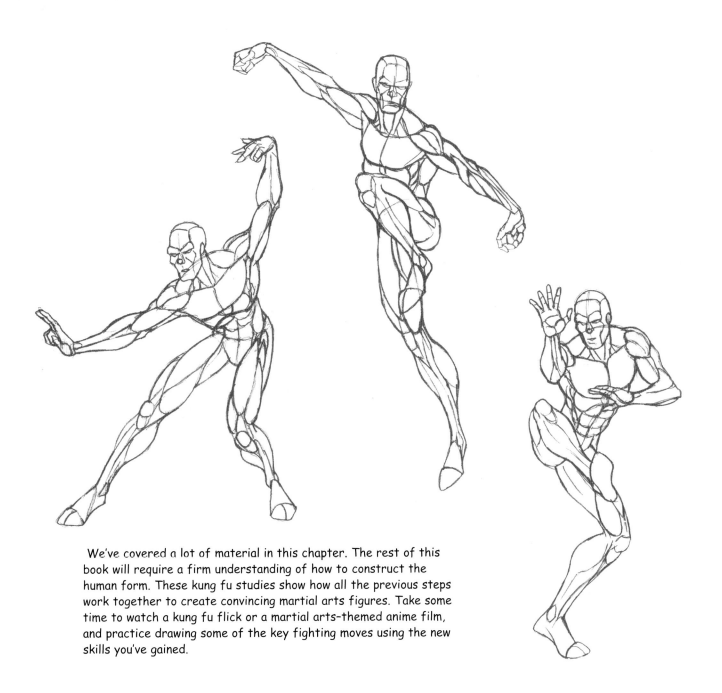

We've covered a lot of material in this chapter. The rest of this book will require a firm understanding of how to construct the human form. These kung fu studies show how all the previous steps work together to create convincing martial arts figures. Take some time to watch a kung fu flick or a martial arts-themed anime film, and practice drawing some of the key fighting moves using the new skills you've gained.

By now you should have a pretty good understanding of how to draw each component of the body. Continue to practice drawing the individual parts and then start to combine them into larger portions of the total figure. For instance, begin by drawing just the chest and hips and then add the neck and head. Or draw a limbless torso and then attach arms to the chest and legs to the pelvic area. Then try adding hands and feet to your figure's limbs. It is much easier to tackle human anatomy in small, manageable steps. After you've gained a working understanding of the body's basic masses, turn the page and get ready to start flinging those bodies into jaw-dropping martial arts action!

The Art of Action

An artist's expression is his soul made apparent—
his schooling as well as his "cool" being exhibited.
Behind every motion, the music of his soul is
made visible. Otherwise, his motion is empty, and
empty motion is like an empty word: no meaning.

Bruce Lee

The name of the game is *ACTION*.
It is not enough to have a firm grip on
anatomy and to draw body shapes correctly. You
must also be able to draw your figures in
dramatic motion. Your artistic eye needs to work
like a high-speed, freeze-frame camera to capture
the subject during the most interesting and
dynamic moment of the action.

Artists accomplish this by first sketching a
vibrant gesture drawing. Gesture drawings,
which are sometimes called action drawings,
convey the basic position and thrust of a figure.
Correct proportions and anatomic accuracy are
not essential at this point; what is indispensable
is to draw fluid lines with plenty of energy. Once
you have the basic pose of your figure, you can
go back to it and build the anatomic forms on
top of the gesture drawing. Think of your gesture
drawing as a roadmap for the location of the
body parts.

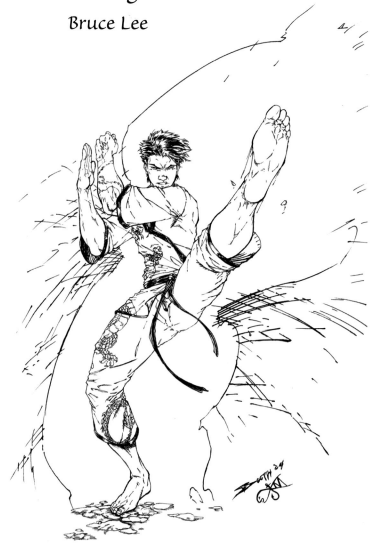

One detail you should establish early on is the relative slant of
the shoulders to the hips. Determining this slant allows you to
position the chest and hips effectively, after which you can build
the rest of the body one piece at a time—just as we practiced
doing in the previous chapter, on anatomy.

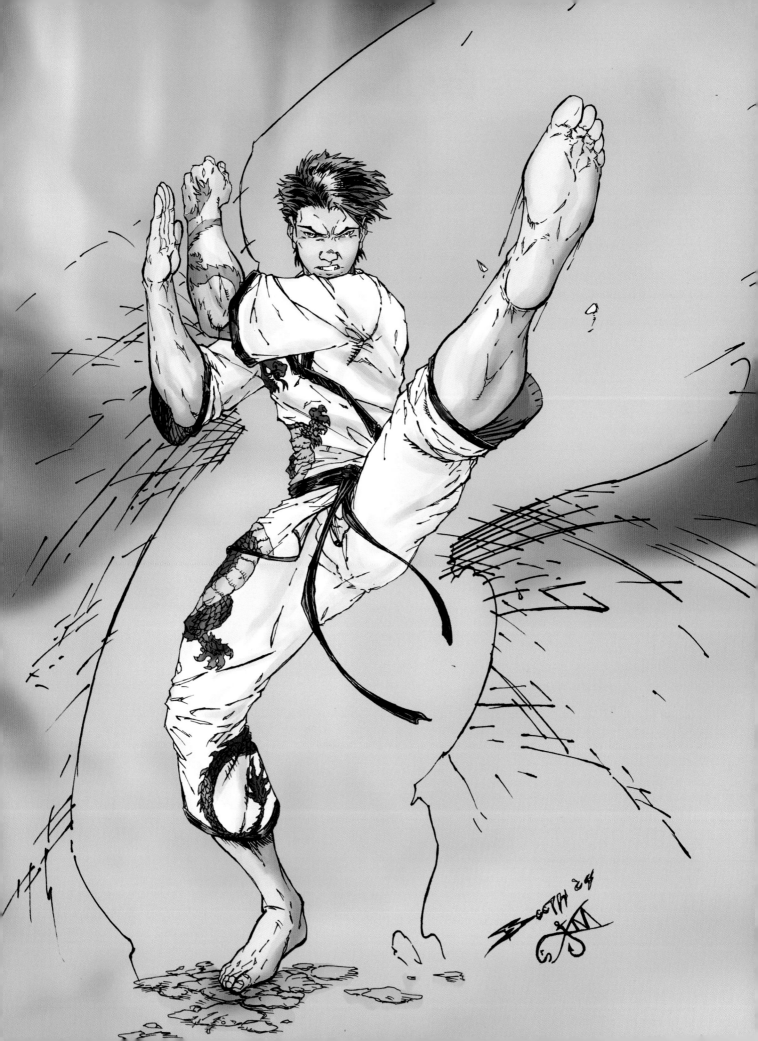

Capturing the Gesture

Gesture drawings look simple, since they often consist of only two or three rapidly laid down pencil marks, but this seeming simplicity is deceptive. The difficulty lies not in knowing *how* to draw the lines, but in knowing *where* to draw them. Just as novice white belts will spend weeks, or even months, perfecting the basic moves of a martial arts discipline, artists need to master the ability to establish the thrust and force of their figures quickly and precisely.

It is wise to spend as much time as you can on mastering the art of the gesture drawing—filling entire pages and whole sketchbooks with studies of figure positions and movements. Artists never tire of drawing the human figure, and the gesture stage is the fastest way to try out a new pose. You may find it helpful to obtain permission to attend a martial arts training facility to observe the students in action. You can also watch martial arts anime or live-action kung fu flicks, pausing the video to copy the characters' movements. Think of these exercises as taking artistic "notes": Your sketches are not meant to be finished drawings but rather attempts at duplicating motion with the fewest lines possible.

A gesture drawing is nothing more than a quick scribble to get the basic action of the character down on paper. Gesture drawings show the direction and orientation of the limbs and key body masses, but they are only a rough guide for you to build on. They're so simple in appearance you may be tempted to skip this step, but without a lively gesture drawing you final drawing runs the risk of appearing stiff and lifeless.

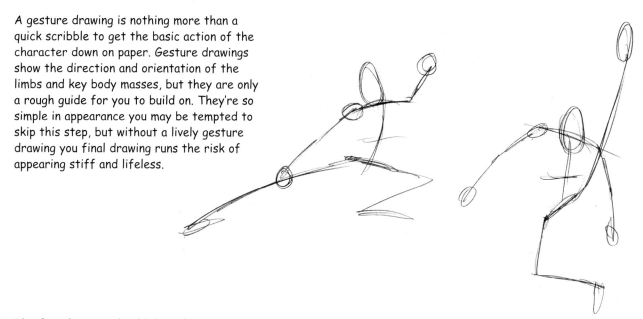

The first line you should draw for a preliminary figure is the backbone. The hips and shoulders work in harmony with the spine to move the figure gracefully. Stiff figures result from not "hanging" the shoulders and hips on the spine. The shoulders and hips curve with the direction of the backbone, creating an angle where the hips' and shoulders' central lines bend toward each other. The resulting curve of the backbone is either like the letter *C* or the letter *S*. The backbone line is often referred to as the *axis line,* since it determines the axis around which all the other components of the body will turn. Once you have established the position of the hips and shoulders, move on to the head and then the limbs; always draw from the middle of your figure outward.

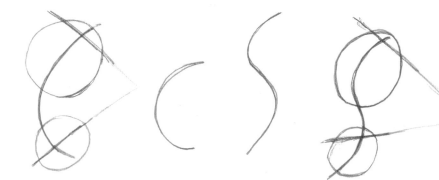

CONVEYING KINETIC ENERGY

It is essential to convey a sense of kinetic energy in your figures. *Ki* (or *chi,* as it is sometimes spelled) is the Chinese concept of the life force or spiritual energy of a living being. For our purposes, I will use ki to stand for the central energy depicted by a figure.

The figures in your drawings must appear to be propelled into motion by this energy or life force. Some practitioners of the martial arts believe that the ki can be concentrated in various parts of the body to enhance the effectiveness of a move or to provide strength or endurance approaching the superhuman. The concept of The Force in the *Star Wars* films and the way the character Neo— played by Keanu Reeves—moves within the Matrix in *The Matrix* movies are cinematic expressions of the concept of ki. Ki does not have to be thought of in metaphysical terms. If you wish, you can use the term simply to describe the appearance of energy—and, trust me, you will want your martial arts characters filled to the brim with energy. Sometimes, the easiest way to establish energy is to give the torso and pelvis vibrant energy and then to convey the same energy throughout the rest of the figure.

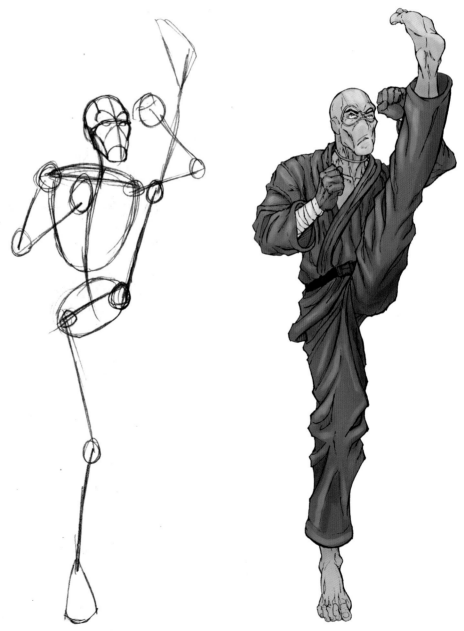

The final position of the foot before it starts to descend is the high point, or apex, of the kick. This is the ideal pose for the figure. Drawing the leg at any of the other positions along its path—no matter how anatomically correct your drawing might be— just wouldn't have the same dynamism. You want to capture the movement at its greatest display of force, and this is usually when the foot or hand has reached its greatest extension.

Unarmed martial arts attacks are all about propelling body masses toward the opponent. The position and force of the limb that's being driven toward the foe affect the other body masses. Some moves commit all of the body's mass into projecting the blow; these hits land with a greater impact but may temporarily throw attackers off balance, opening them to counterattacks in which their own momentum is used against them. Experienced martial artists learn to maintain a sense of balance during offensive moves, keeping their center of gravity within a controllable range. Their limbs snap out toward the enemy and are then quickly retracted, greatly decreasing the window of opportunity for an opponent to capture and lock the limb. (A lock is when a part of the body is caught and twisted to prevent the rest of the body from moving.)

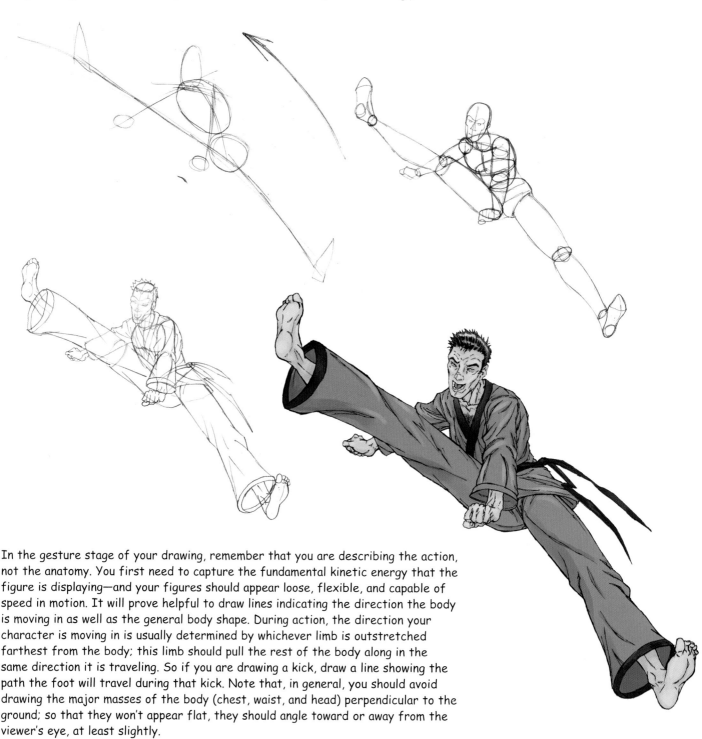

In the gesture stage of your drawing, remember that you are describing the action, not the anatomy. You first need to capture the fundamental kinetic energy that the figure is displaying—and your figures should appear loose, flexible, and capable of speed in motion. It will prove helpful to draw lines indicating the direction the body is moving in as well as the general body shape. During action, the direction your character is moving in is usually determined by whichever limb is outstretched farthest from the body; this limb should pull the rest of the body along in the same direction it is traveling. So if you are drawing a kick, draw a line showing the path the foot will travel during that kick. Note that, in general, you should avoid drawing the major masses of the body (chest, waist, and head) perpendicular to the ground; so that they won't appear flat, they should angle toward or away from the viewer's eye, at least slightly.

FLESHING OUT THE "MATCHSTICK" MEN

"I can't even draw a stick figure," is a comment I often hear from non-artist types. Many artists may scoff at the statement—as if drawing stick figures were beneath them—but the observation is an important one. Unless you can draw a good stick figure you have no hope of drawing a believable, fully fleshed-out person. The stick figure—that is, the gesture drawing—is where you establish the personality and movement of your character.

You will notice that the examples in this book don't always show the gesture stage of the drawing. While the step is important, the same information is presented in the next step in the drawing process, the "matchstick step." The matchstick is basically the gesture step with ovals for the main body masses added. Most experienced artists don't mentally separate the steps as they are drawing, because it has become second nature to them to quickly lay out a figure and finish it to completion. The process of breaking down the progression is most helpful for beginners, but eventually, as you become more accomplished, you will find that the steps blur together.

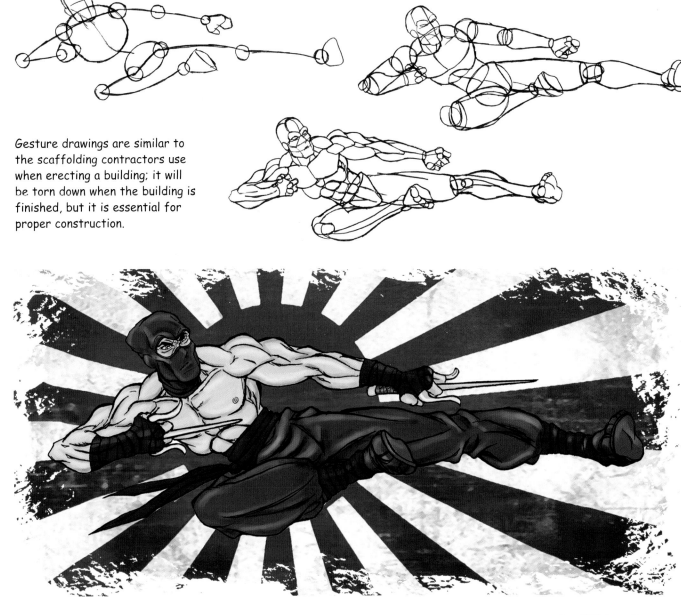

Gesture drawings are similar to the scaffolding contractors use when erecting a building; it will be torn down when the building is finished, but it is essential for proper construction.

Thinking-through the Action

The unusual, many-limbed character depicted on these pages—a "dancing Martian" created by Brett Booth—helps illustrate how an artist "thinks through" the range of motion the body possesses and shows how versatile the simple matchstick man can be. The matchstick drawing is capable of providing a framework for any character your imagination can come up with, no matter how outlandish.

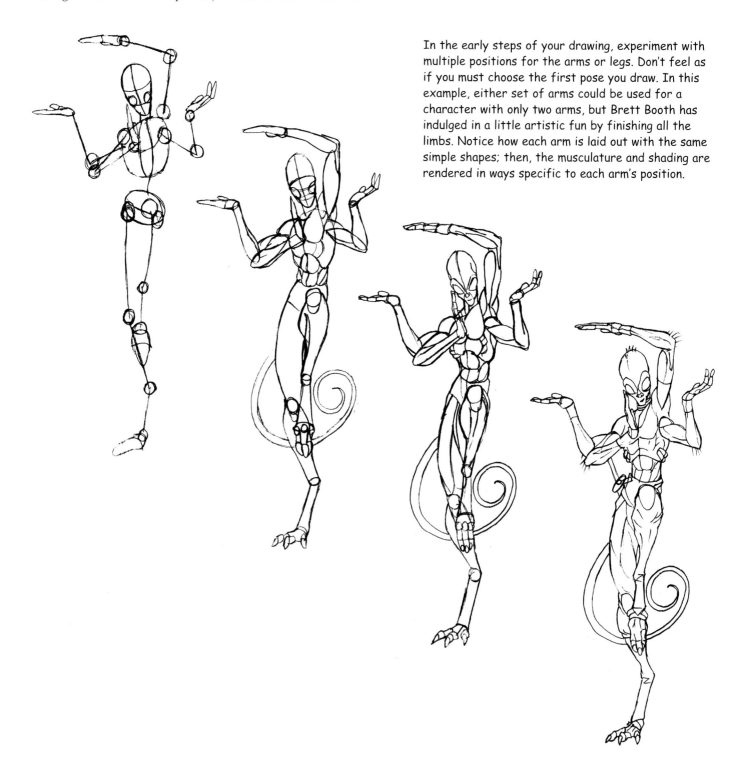

In the early steps of your drawing, experiment with multiple positions for the arms or legs. Don't feel as if you must choose the first pose you draw. In this example, either set of arms could be used for a character with only two arms, but Brett Booth has indulged in a little artistic fun by finishing all the limbs. Notice how each arm is laid out with the same simple shapes; then, the musculature and shading are rendered in ways specific to each arm's position.

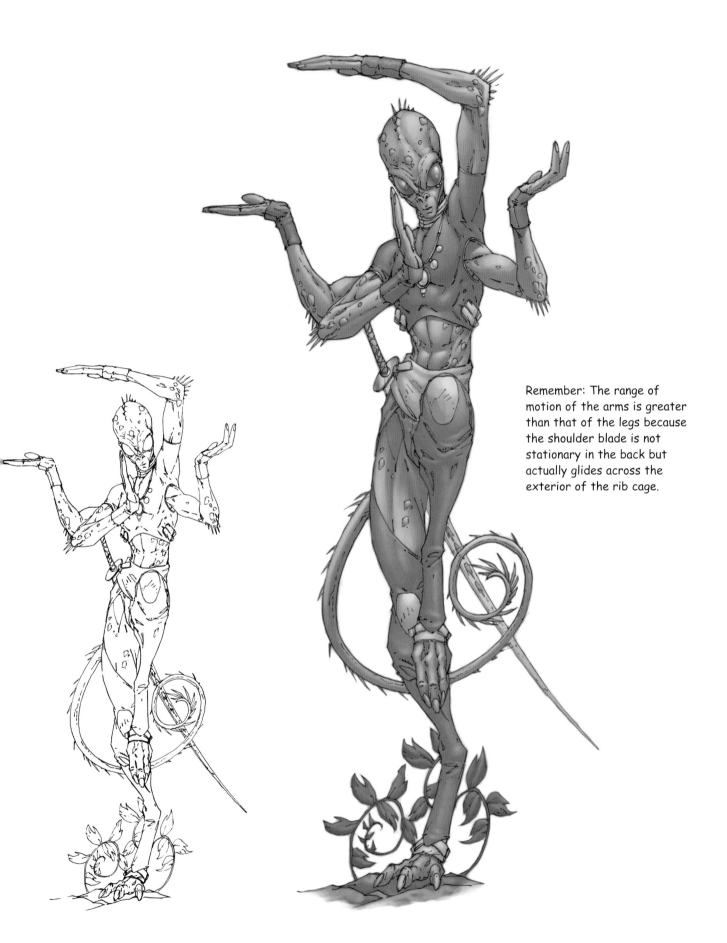

Remember: The range of motion of the arms is greater than that of the legs because the shoulder blade is not stationary in the back but actually glides across the exterior of the rib cage.

Achieving Balance

As the Karate Kid's teacher, Mr. Miyagi, said, "Better learn balance. Balance is key." Martial artists continually propel themselves into action and then revert to a more centered state of balance. You will want to become accustomed to drawing these two very different key states—the figure in motion and the figure at rest (not that the true martial artist is ever really at rest). Although I said earlier that gesture drawings are also called action drawings, don't let the term *action* confuse you. This initial step is just as important for establishing balanced figures not currently in motion.

Practice makes perfect. Have you ever observed a class working out at a dojo? The students will perform the same move dozens of times until they can unconsciously perform the move flawlessly. Do not progress to the finer points of anatomy presented in the next chapter until you are able to draw a figure convincingly at the gesture stage in every pose imaginable.

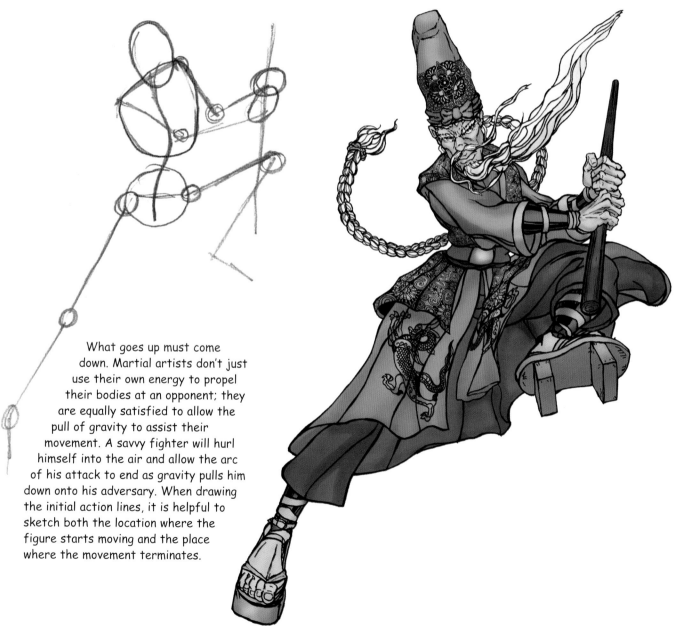

What goes up must come down. Martial artists don't just use their own energy to propel their bodies at an opponent; they are equally satisfied to allow the pull of gravity to assist their movement. A savvy fighter will hurl himself into the air and allow the arc of his attack to end as gravity pulls him down onto his adversary. When drawing the initial action lines, it is helpful to sketch both the location where the figure starts moving and the place where the movement terminates.

When a figure is balanced the weight is distributed between the two feet. For motion you want to do exactly the opposite. Thrust is created by clearing having your character off balance and moving in one clear direction.

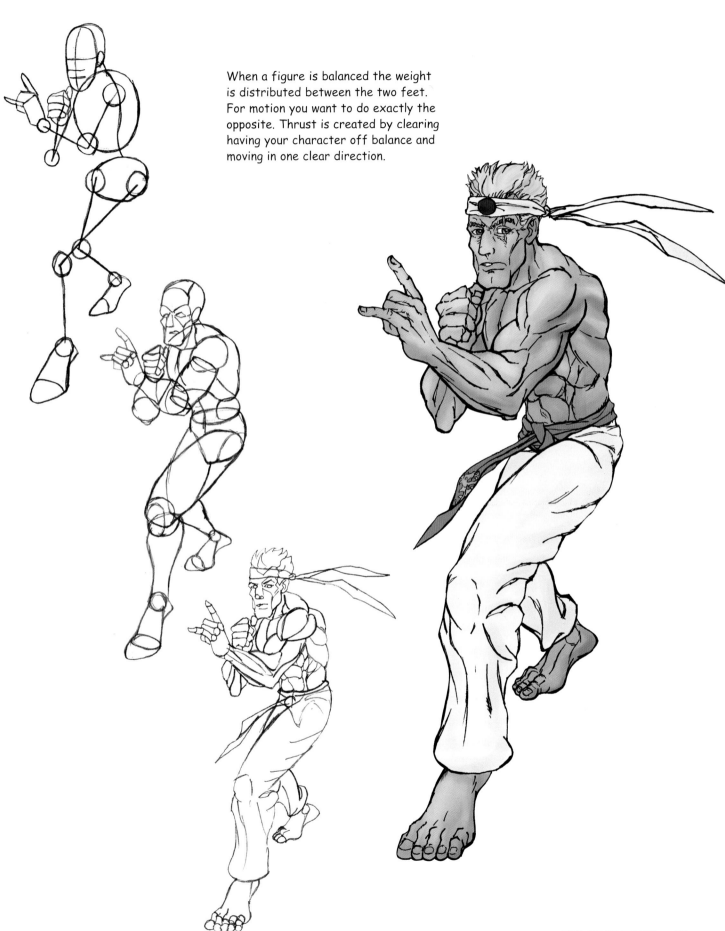

Uniforms and Costumes

This is a karate dojo, not a knitting class.

Sensei Kreese,
The Karate Kid

"YOU ARE WHAT YOU WEAR" MAY BE THE MOTTO OF SHALLOW, overly fashion-conscious people, but it does contain an element of truth. Nothing identifies a martial artist's discipline faster than his or her style of dress. From the insect-like armor of the samurai to the chromatic robes of the Shaolin monks, martial arts characters get to wear some really interesting outfits. There are almost as many different styles of dress as there are fighting styles. We'll quickly cover some of the basic principles of drawing clothing, which will help you with whatever fantastic garb you choose to dress your characters in.

Feel free to find inspiration for your characters' outfits in the rich history of Asian dress. Many of the items worn by martial artists came to have uses other than those they were first conceived for. For example, wooden sandals originally designed for the soft ground of the rice paddies have the advantage of distributing weight evenly across the whole sandal—allowing for speedy samurai footwork. The low brim of the sun-shielding coolie hat concealed the wearer's face, providing excellent camouflage for a famous samurai or a disgraced ronin trying to travel anonymously. Traditional billowing robes not only kept the body cool but also disguised the movements of one's limbs and provided excellent places to hide weapons.

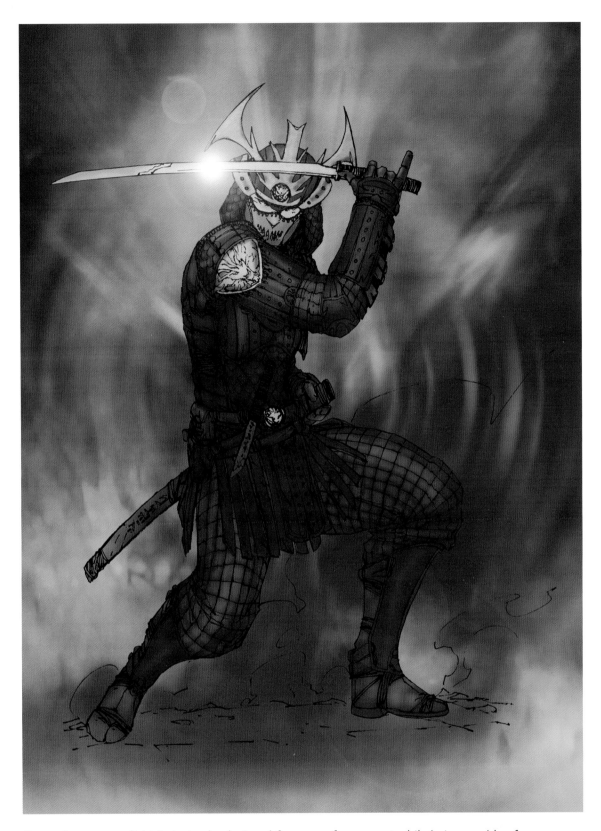

Samurai armor was light but sturdy, designed for ease of movement while being capable of stopping sword blows or arrow strikes. It was constructed mainly of bamboo woven with thread and rope, which gave the armor greater strength and durability than armor made from a single material. A solid-metal chest plate provided extra protection for vital organs. Samurais' elaborate helmets, constructed of riveted pieces of iron, provided excellent shielding for both the head and neck—a smart design, since decapitation was one of the surest ways to end a sword fight.

THE KEIKOGI—BASIC UNIFORM

The basic martial arts garb is the *keikogi*—a Japanese word that means "uniform for training." In the West, the term is often shortened to just *gi*, which is used generically to denote the various uniforms worn in different martial arts disciplines. Since the basic gi varies from one discipline to another, you will want to consult photo references to accurately depict each specific style of gi.

The gi is designed to allow the limbs an unencumbered range of motion. The uniform is so loose that it obscures many of the wearer's basic anatomical features. This is helpful when fighting since it partially hides the body's movement from one's opponent. (The combatant isn't telegraphing all of his or her actions beforehand.) Unfortunately, though the tendency of clothing to mask the body and its actions is valuable when sparring, it works against the artist, who is trying to fully comprehend and visualize the underlying structures. For this reason, the clothing worn by many of the figures in this book is much more form-fitting than traditional martial arts garb.

Practitioners of karate traditionally wear a white gi that features an overlapping, kimono-like top. A colored belt signifies the pupil's level of achievement, with the black belt reserved for those who have achieved a master ranking. Most karate stylists do not wear shoes while training.

Kung fu students wear a very different-looking uniform. Kung fu uniforms usually consist of tops with Chinese "frog-style" buttons rather than overlapping fronts. The uniforms, though often black, can be of a variety of colors. Unlike karate practitioners, kung fu artists commonly wear shoes.

SAMURAI ARMOR

Japanese samurai armor was first used during the Gempei War of 1181–1185. The armor was very expensive to produce and maintain, so it was worn only by emperors and members of the highest military class. The components of the suit of armor *(kikou)* fit together and overlapped much like the parts of an insect's exoskeleton to provide maximum protection of vital organs. The upper-body armor (known as the *do*) included the *sode*—the suspended plates protecting the shoulders and upper arms. Silk cords were passed through loops on the sode and then tied at the back in a decorative knotted tassel called the *agemaki*. Additional bamboo or leather shoulder guards were placed over the suspension cords, and a leather plate was placed across the bow cords to protect them from being cut during a swordfight.

A samurai's protective helmet (called a *kabuto*) typically consisted of eight to twelve plates, all fixed together with metal bolts. The helmet would display the samurai's rank and the group or clan to which he belonged. These marks, along with the distinctive ponytails emerging from the samurais' helmets, allowed for quick identification of friends and foes on the battlefield.

Shikoro is the term for the set of five plates that were fastened to the bowl of the helmet and that protected the face and neck. The shikoro's top four plates were upturned to create the *fukigaeshi*, which prevented the vertical slicing of the shikoro's horizontal fastening chords. The visor *(mabisashi)* fastened to the front of the helmet helped to keep the sunlight out of the samurai's eyes, and its protrusion also offered the warrior's face a degree of protection from the extended downward strike of an enemy's sword.

THE KIMONO

Perhaps you want to dress your female characters in something a little more formal. Kimonos are T-shaped, ankle-length robes that are made of silk and are usually very expensive. Kimonos are excellent for concealing weapons, which can be fastened to the wrist and secreted within the very wide sleeve or hidden within the folds of the garment. Kimonos differ in style and color depending on the occasions when they are traditionally worn and on the age and marital status of the people wearing them.

The kimono is worn with the left side over the right and secured by a wide belt (called an *obi*) tied in the back. Kimonos are generally worn with thonged wooden-platform footwear called *geta* or with *zori,* a type of thonged footwear that closely resembles flip-flops. These shoes require special split-toed socks called *tabi.* Sometimes another shorter kimono, called a *nagajuban,* is worn as underwear beneath the outer kimono.

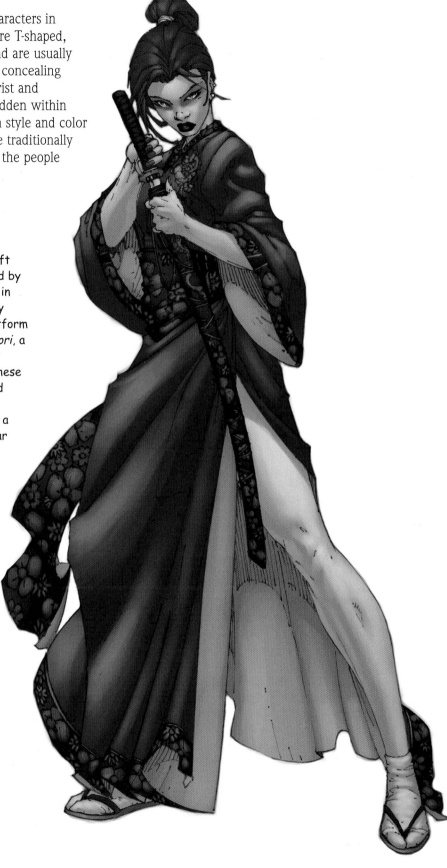

Folds and Wrinkles

Fabric is dramatically lazy. Cloth does not care where it goes or what shape it takes on. It is as happy to be moved and shaped by gravity as by the body's movement. It is constantly being manipulated by the forces acting upon it, and so the uniforms your characters wear will constantly change shape as your characters move about.

The same basic action lines you use to draw your figures' bodies come into play again as you dress them. Cloth folds in the direction of tension pulling on it; it falls under the influence of gravity when the tension is released. The tension appears in clothes as lines radiating out from a central point—most commonly around the shoulders and at the elbows, the crotch, and the bends of the knees. Cloth does not care whether it is a sleeve or a pant leg—it will move and fold governed by the same principles—so if you learn how to draw sleeves, it is only a minor matter of changing location and dimensions to draw the pants.

The material that clothing is made from is also important. Silk, polyester, cotton, and leather all fold according to the same basic rules, but the thickness and pliability of the material determine the number and variety of folds. Generally speaking, thicker materials tend to fold less, since sturdier fabric maintains the base shape of the garment. Thin clothes, by contrast, have less intrinsic stability and tend to wrinkle more. Even after you've learned the basics of how clothes fold, it is still helpful to look at actual fabric or at photo references to determine the particular characteristics of the material you are depicting.

Finally, the cut of a garment (or its parts) affects the shape of the folds. For example, sleeves are basically cylinders, so folds appearing in sleeves have a roundness approximating what you would achieve were you to trace a line around any cylindrical object.

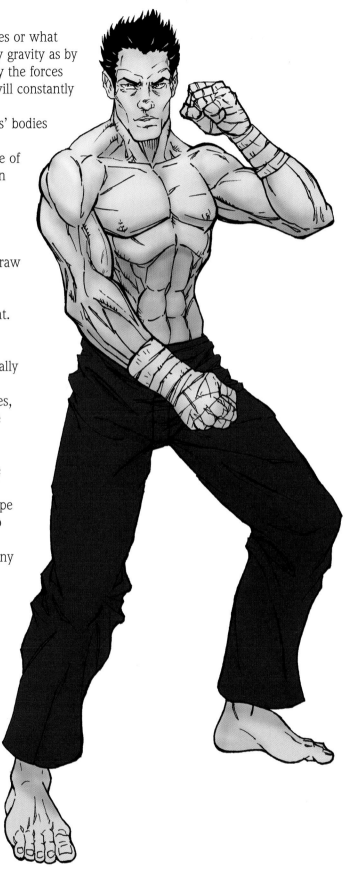

Notice how the sets of fold lines on this figure's pants originate from his crotch and the bends of his knees. In general, fold lines tend to radiate out from the central mass of a figure or point toward the joint nearest the place where a fold originates. Unless the fabric is stretched by extreme tension, these lines are seldom straight. Being lazy, cloth prefers to take an arching, rounded path. Even though it moves in the direction of the action, it is also constantly being pulled down by gravity, and the result is fold lines that curve, at least slightly.

You can clearly see that the folds on this character's sleeves originate on the bottom sides of the sleeves, where they connect to the body of the garment. As the arms move up and away from the body and the fabric is pulled, tension is created on the bottom sides of the sleeves even as tension is released from the opposite sides. As you can see, this creates a surplus of fabric on the tops of the sleeves, where the cloth bunches up and wrinkles. The general principle is that when fabric is moved, it creates tension on one side of a garment (which will appear as directional wrinkles radiating out from a common point) while on the opposite side excess fabric is compacted together, creating compression wrinkles. These drawings also show the twisting effect the torso has on the shirt. The effect is similar to what happens when you wring out a washcloth; twisting the fabric results in spiraling wrinkles that trace a path around the underlying object.

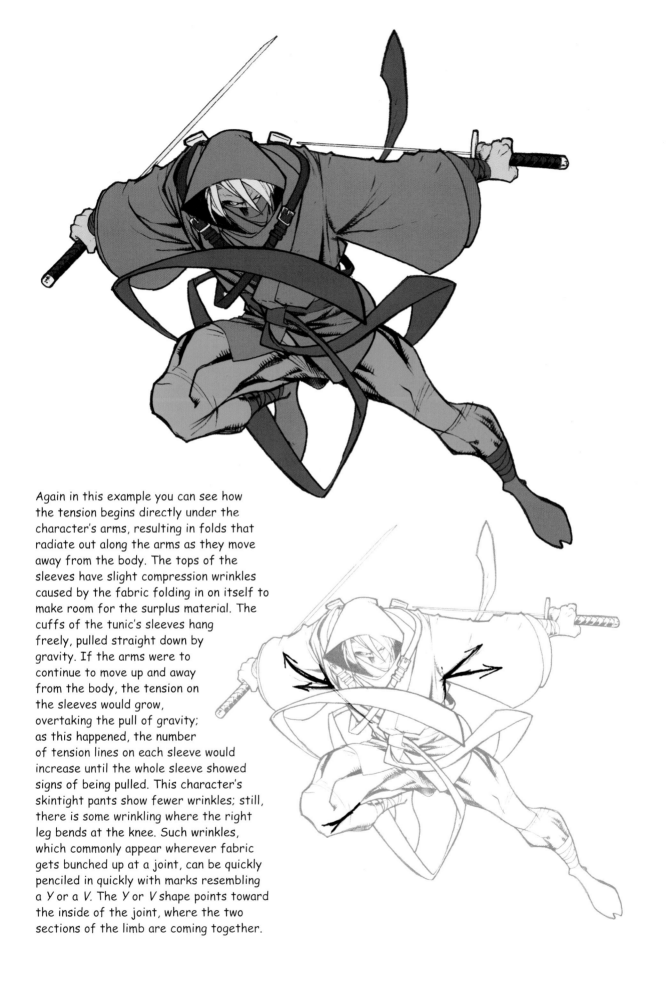

Again in this example you can see how the tension begins directly under the character's arms, resulting in folds that radiate out along the arms as they move away from the body. The tops of the sleeves have slight compression wrinkles caused by the fabric folding in on itself to make room for the surplus material. The cuffs of the tunic's sleeves hang freely, pulled straight down by gravity. If the arms were to continue to move up and away from the body, the tension on the sleeves would grow, overtaking the pull of gravity; as this happened, the number of tension lines on each sleeve would increase until the whole sleeve showed signs of being pulled. This character's skintight pants show fewer wrinkles; still, there is some wrinkling where the right leg bends at the knee. Such wrinkles, which commonly appear wherever fabric gets bunched up at a joint, can be quickly penciled in quickly with marks resembling a *Y* or a *V*. The *Y* or *V* shape points toward the inside of the joint, where the two sections of the limb are coming together.

COOLIE HATS

The characters portrayed in the drawings below and opposite are both wearing the shallow conical straw hat commonly known as a coolie hat—a staple item of dress in many martial arts video games and anime films. These large, round, brimless hats originated in the rice fields of East and Southeast Asia, where farmers typically worked from sunup to sundown. The hat's ingenious circular design provides shade no matter where the sun is in the sky above. The coolie hat is secured to the wearer's head with a chin strap (or, in some cases, it rests on a harness atop the head).

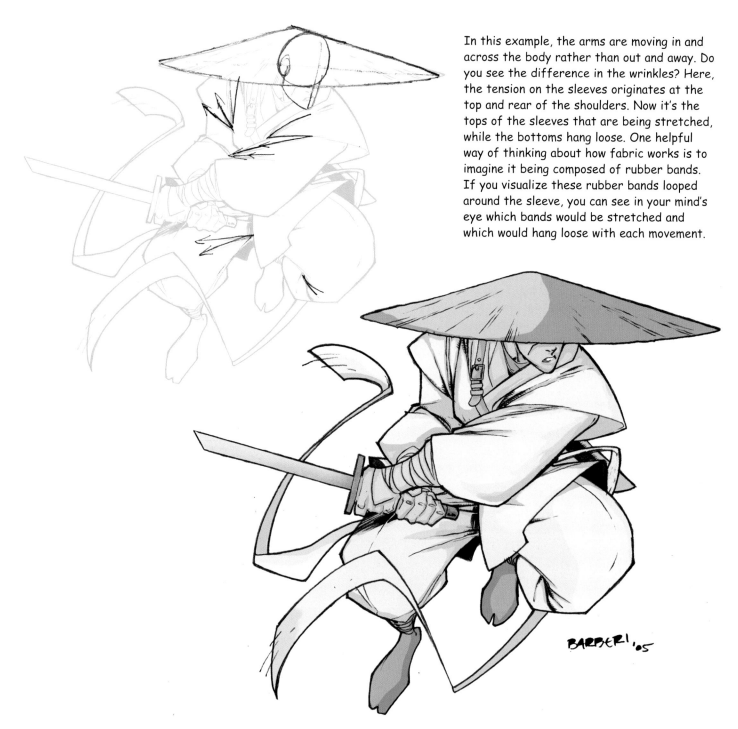

In this example, the arms are moving in and across the body rather than out and away. Do you see the difference in the wrinkles? Here, the tension on the sleeves originates at the top and rear of the shoulders. Now it's the tops of the sleeves that are being stretched, while the bottoms hang loose. One helpful way of thinking about how fabric works is to imagine it being composed of rubber bands. If you visualize these rubber bands looped around the sleeve, you can see in your mind's eye which bands would be stretched and which would hang loose with each movement.

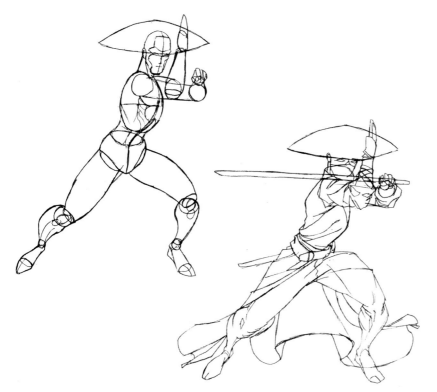

This figure's clothing offers some variations on the garb shown in the other illustrations. Here, the sleeves of the coat are much more form-fitting, so there is less fabric to billow and hang loose. The same points of tension are evident at the joints, however, and both the pants and the coat are affected by the twist of body. The tail of the coat hangs loose and curls in on itself. (This technique is useful for drawing capes as well as long coats.) The direction of the coattail's folds is caused by gravity pulling the fabric down, while the curve is another result of fabric's "laziness"—a compromise between the downward pull of gravity and the forward motion of the figure. The character's right leg (on the left side of the drawing) creates tension on the pants by moving down and back away from the body, while the left leg creates tension in the opposite direction as it moves out and up. The result is sets of tension lines that run from the legs back toward the crotch.

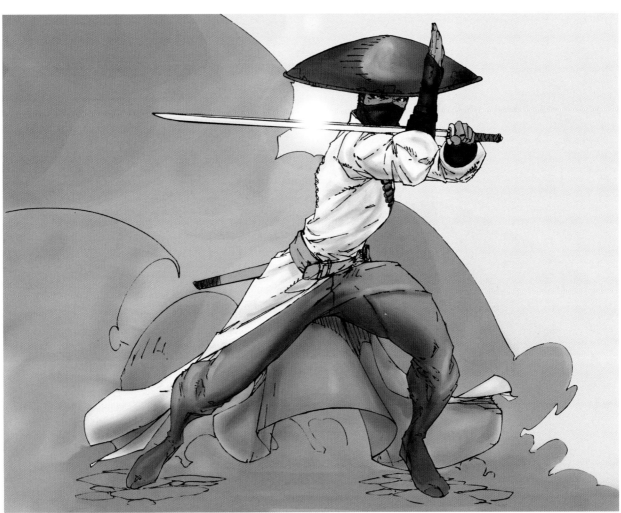

WEAPONS OF POWER

The sword has to be more than a simple weapon; it has to be an answer to life's questions.

Miyamoto Musashi

PERHAPS THE ONLY THINGS MORE EXOTIC THAN THE moves employed by martial artists are the weapons they wield! Many martial arts weapons originated in farm communities, where peasant uprisings required cheap and readily available fighting implements—usually common tools that could either be used just as they were or be easily adapted to combat purposes (for instance, by honing or sharpening). There are hundreds of different types of martial arts weapons. This chapter provides brief descriptions of some of the most popular ones.

The three main aspects of a weapon are *impact*, *range*, and *control*. Impact determines how much force the weapon strikes with. Weapons like nunchucks or *tonfa* sticks can do more damage than the bare hand. Range measures the striking distance of the weapon. A *bo* staff may look like an ordinary piece of wood, but its six-foot length greatly increases a fighter's striking distance. Control speaks of how effectively a particular weapon can be utilized by a master. All physical weapons are governed by the laws of physics and thus become unwieldy if their momentum or a post-impact shock wave sends them careening in an unexpected direction. The sword is an excellent example of a highly controllable weapon. Its balanced blade and handle allow it to be swung with lightning speed while still moving as a harmonious extension of the swordsman.

SWORDS

The swordsmiths of Japan took their work very seriously. They would embark on ceremonial fasts and submit to ritual cleansing ceremonies before forging a new blade. Each sword was seen as a unique work of art and an expression of the swordsmith's soul. Sword-making was viewed more as a process of giving birth than as simple craftsmanship. Japanese swords were of extremely high quality, in part because Japanese steel was far superior to the metals used for swords elsewhere. For all these reasons, Japanese swordsmiths received worldwide renown.

Originally, Japanese swords followed older Chinese and Korean designs and had straight blades, but through many bloody battles, samurai warriors learned that curving blades made from steel that had been repeatedly superheated, cooled, and heated again possessed a greater tensile strength.

Samurai developed intricate armor, which allowed them a great range of motion so they could engage in combat with fierce vigor. Today we have poly alloys that are ten times as strong as their bamboo-based armor. Perhaps this is what the samurai of the future will look like. It is your job as an artist to use the designs of the past as inspiration for those of the future. Even when creating the fantastic and fictional, immerse yourself in fact for inspiration.

Swordsmen often began their duels with the blade held high in a two-handed grip, as seen here. The combatants would circle one another looking for the ideal opportunity to initiate combat. During these preliminary maneuverings the duelists sized each other up, trying to identify any possible weaknesses in their foe's fighting style. In movies, sword fights often go on for several minutes, with the fighters crashing through shot after shot. In reality, many sword-fighting encounters were over after only a few concise strokes.

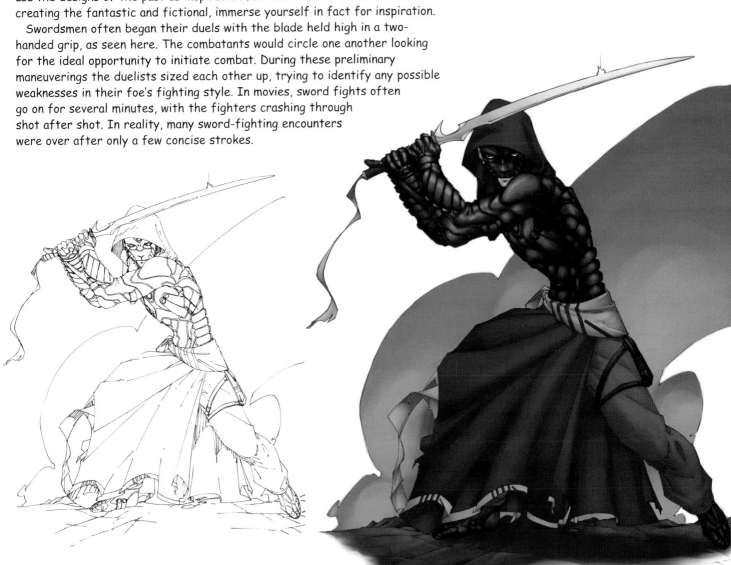

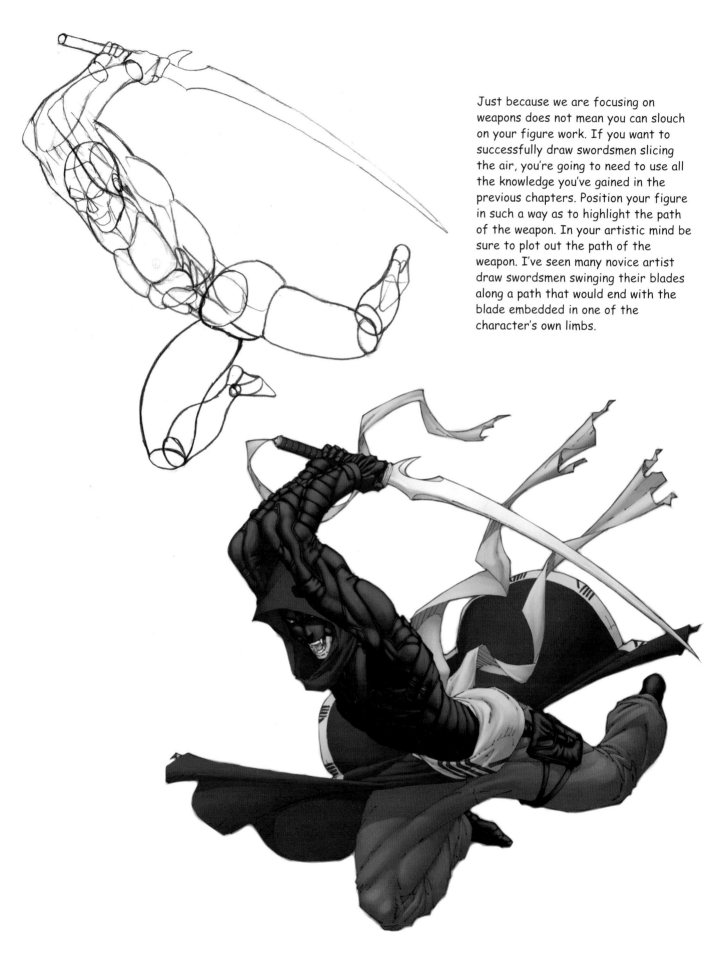

Just because we are focusing on weapons does not mean you can slouch on your figure work. If you want to successfully draw swordsmen slicing the air, you're going to need to use all the knowledge you've gained in the previous chapters. Position your figure in such a way as to highlight the path of the weapon. In your artistic mind be sure to plot out the path of the weapon. I've seen many novice artist draw swordsmen swinging their blades along a path that would end with the blade embedded in one of the character's own limbs.

Weapons play an important part in most martial arts video games. Often the designer uses a distinctive design or unexpected size to emphasize a weapon's uniqueness. In fact, the weapon is sometimes more important than the one who wields it. Many blades are given descriptive names and possess colorful histories longer than any mortal could ever achieve. Once you have a good grip on what authentic weapons look like, try experimenting with signature weapons for individual characters.

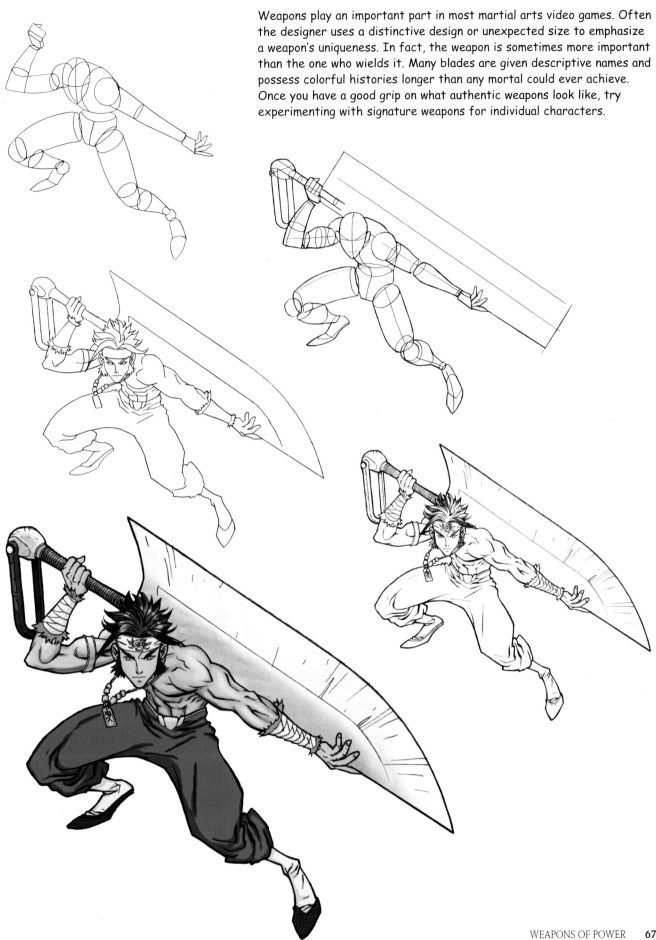

The *katana*—a long (at least 24 inches), single-edged sword—is probably the most familiar Japanese sword. (The Japanese word *daitō* is a generic term for the long sword. Though the long sword is primarily used for cutting, its curvature is slight enough to allow for effective thrusting, as well.)

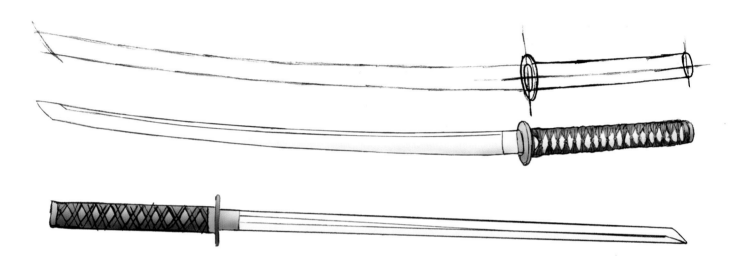

There are only a few key things to keep in mind when drawing a sword of whatever type. Be sure to align the blade and the handle by drawing a single guideline for both. The handle is a simple cylinder, and the blade can most easily be drawn with the aid of a french curve.

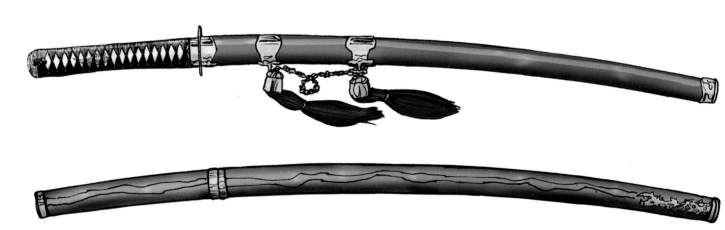

The Japanese created intricate scabbards for their swords. The scabbard, or *saya,* should be drawn so that it lines up perfectly with the handle of the sword.

Samurai Weapons

Samurai were privileged to wear two swords—the long katana and the short *wakizashi* (collectively known as *daisho*). Though the katana was generally gripped with both hands, a physically powerful samurai warrior could wield it one-handed while brandishing the wakizashi in the other hand, for a double-blade attack. The katana's scabbard (saya) and handguard *(tsuba)* were often intricately designed works of art in their own right.

The wakizashi was a similarly crafted sword but shorter than a katana—between 12 and 24 inches in length. Together, the two weapons (or daisho) represented the social power and personal honor of the samurai. The long blade was used for open combat, while the shorter was considered a sidearm better suited to close, hand-to-hand combat. When entering a house, a samurai was required to leave his katana at the door with a servant. The wakizashi, however, would be worn at all times and was the weapon of choice for indoor fighting. A samurai and his wakizashi were, in fact, never parted; even as he slept, the short sword would be with him—stashed beneath his pillow.

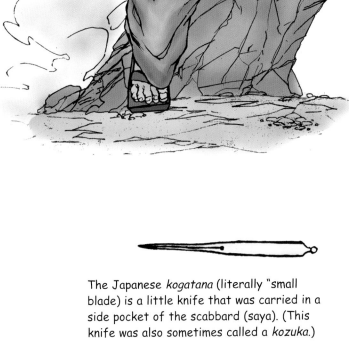

You can clearly see the difference in blade sizes between the katana and the wakizashi in this illustration of a *ronin,* a masterless samurai. A samurai became a ronin if he lost his master's favor or if his master was dishonored or exiled. Ronins often became mercenaries—trading the noble spirit of the samurai for financial reward as a hired swordsman.

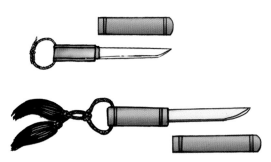

The *tantō* is a Japanese dagger whose blade measures from 6 to 12 inches. Though tantōs usually had single-edged blades, some were double-edged. This knife differs from other samurai blades not only in its smaller size but also in its design. Intended primarily as a stabbing instrument, it was a favorite weapon of the ninja. Its light weight made it the perfect weapon for stealth attacks and assassinations.

The Japanese *kogatana* (literally "small blade) is a little knife that was carried in a side pocket of the scabbard (saya). (This knife was also sometimes called a *kozuka*.)

KENDO "SWORDS" AND ARMOR

Kendo is a Japanese martial-arts style of fencing that developed from traditional techniques of katana swordsmanship, known as kenjutsu. Utilizing "swords" made of split bamboo (*shinai*) or wood (*bokuta*), as well as protective armor (*bogu*), practitioners battle each other in nonlethal combat.

When drawing kendo fighters, it is important to get the basic forms of the combatants down on paper even though their bodies will mostly be hidden by their armor and robes. Doing this will ensure that the figures have accurate proportions and credible stances.

The different elements of kendo armor are pretty specific, so I used lots of photo references to make sure I was drawing everything accurately.

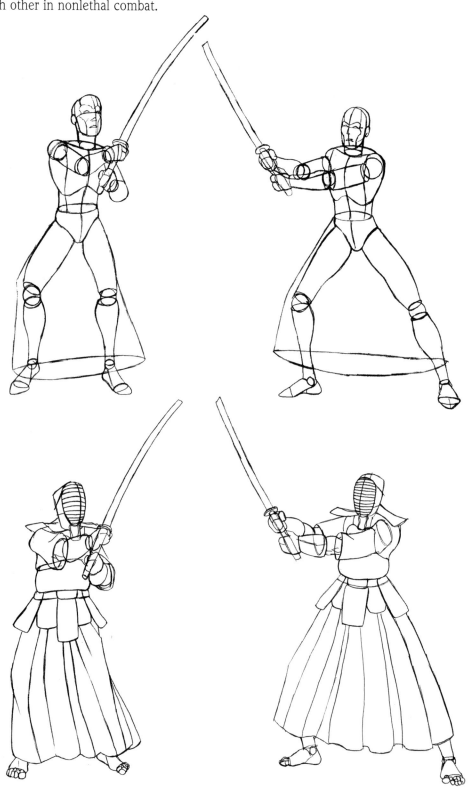

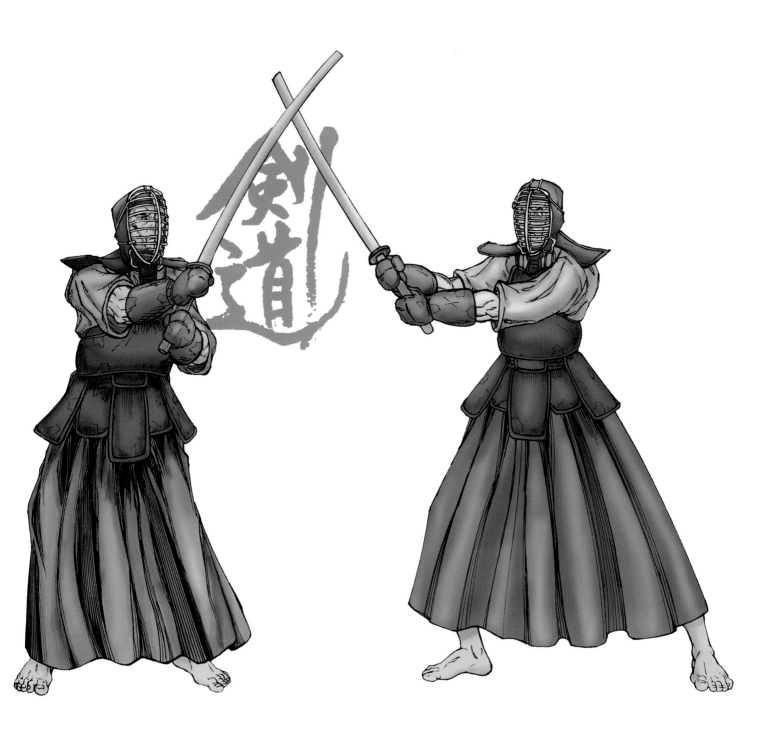

Even though the protective covering used in kendo is very intricate, it is easy to draw if you start with simple basic shapes and then refine them to more precise forms.

Heavy Bow

Ancient Japanese archery as practiced by the samurais was known as kyu jutsu. (The modern-day day equivalent is kyu do, The Way of the Bow.) The heavy bow, fashioned from bamboo, is asymmetrical in shape. This distinctive form allowed it to be used on horseback; the bow could easily be switched from hand to hand without getting snagged on the saddle. Practitioners of kyu do learned to draw the bow in such a way that the arrow was level with the top of the head and then to bring the bow down to chin height, bearing in on their target. For rapid reloading, the archer held a second arrow by the little finger of the hand drawing the bow.

The archer is drawn with his legs spread wide apart to provide a solid base and balance. The string of the bow must be drawn with a straightedge to ensure that it appears taut. The arrows must also be perfectly straight, so keep that ruler handy!

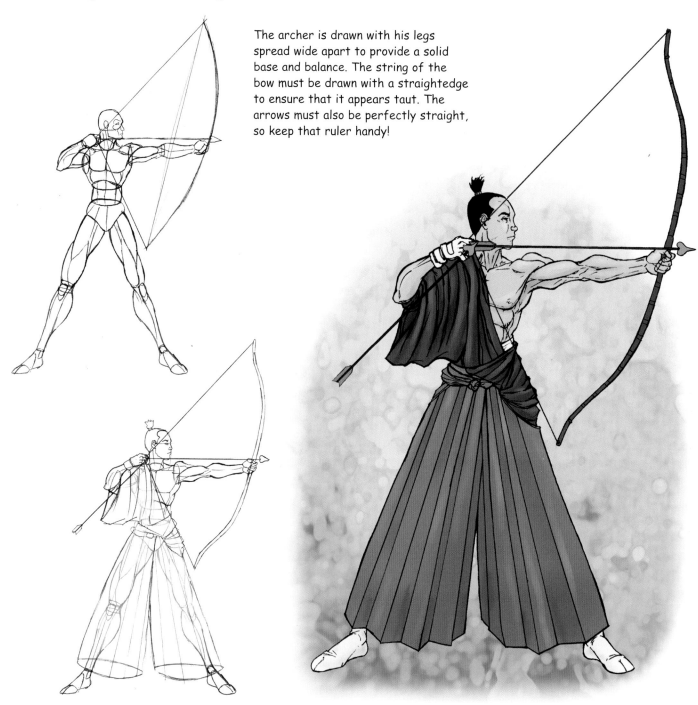

Iron Fan

Another martial arts weapon of Japanese origin is the iron fan, or *tessen*. The folding tessen had eight to ten bamboo or metal ribs—sometimes with a reinforced metal edge—and could even be used as a regular fan to cool the owner. The tessen was viewed as less deadly than a sword, and many duels were fought with the tessen to prevent either party from getting killed. Unfortunately, this strategy didn't always work. In the hands of a skilled tessen fighter, the fan could even defeat an opponent armed with a sword, and Japanese history records many fights in which someone died from a tessen's blow even when both parties had agreed to a nonlethal sparring. The fact that fans were such common accoutrements of Japanese dress meant, however, that both samurais and commoners could carry a tessen without being viewed as a threat.

When spread, the tessen fan is a section of a circle. The easiest way to draw the fan is to begin with the whole circle and then draw the ribs radiating out from the center point. Subtract the unused part of the circle for the final fan shape.

Jutte

The *jutte* was a sturdy truncheon utilized to deflect and trap sword blades. When a blade was caught between the jutte's single prong (called the *kagi*) and its central shaft, the sword could be wrenched from the wielder's hands or even broken in two if the move was executed quickly enough. The jutte could also be used to trap the wrist or ankle of an unarmed opponent, or as a stabbing weapon.

TONFA

The *tonfa* (sometimes called the *tong fa* or *tuifa*) is an ancient baton that originated in Okinawa. Very similar to a modern-day police baton, the tonfa was held along the edge of the arm parallel to the ulna (the hard arm bone that you can feel running from your wrist to your elbow) and were used in pairs. Each tonfa rotated from its handle and could swing out with great force before returning to its starting position, where it could block any incoming blows.

This guy's skintight clothing gives him freedom of motion as he brandishes his deadly tonfas. Tonfas are not just offensive weapons—they can also be used defensively to fend off punches, kicks, or hand-held weapons.

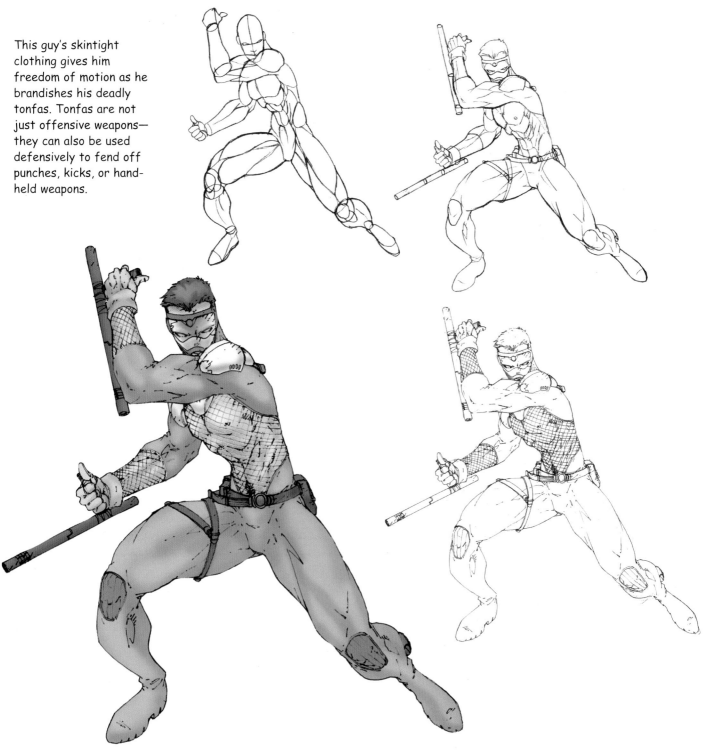

Nunchaku

The weapon called the *nunchaku* consists of a pair of metal, wood, or rubber sticks connected at their ends by a short chain or rope. (Rubber nunchaku were used for training.) Nunchaku are also referred to as nunchuks or by the slang term "chucks."

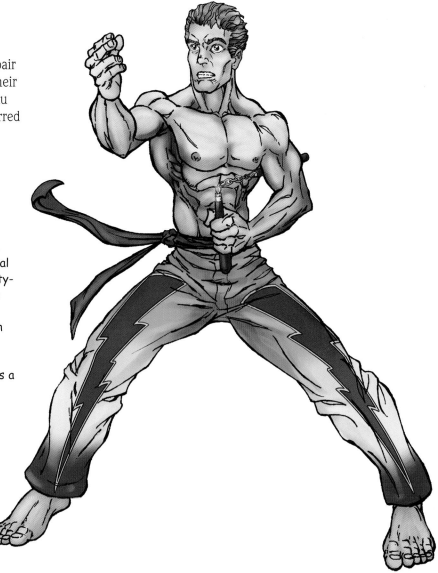

Weapons increase a fighter's range. A combatant armed with nunchaku can strike from several feet farther away than an empty-handed attacker. By controlling the velocity and balance of the spinning nunchaku, a fighter can deliver a blow capable of shattering bone. And the nunchaku's circular path creates a spherical shield so long as the fighter keeps it in motion.

San Jie Gun

The *san jie gun* is very similar to the nunchaku, but it consists of three sticks connected by a chain or rope instead of two.

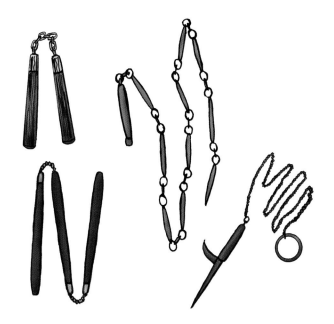

Martial artists have used a whole range of nunchaku-like weapons. Besides the nunchaku (on the upper left), these include the san jie gun (lower left), the *kau sin ke* (center), and the especially fierce-looking *kusarigama* (right).

SAI

The *sai*, which is believed to have come from Okinawa, may have originated as an agricultural tool for threshing rice or handling bails of straw or hay, though many historians insist it was always designed for use as a weapon. A skilled user could use a sai as a projectile; when thrown, it has a lethal range of twenty to thirty feet. If the sai was hurled with enough force, the narrow central shaft could even penetrate a samurai's armor. The sai has achieved notoriety in comics and movies because it is the weapon of choice of both Elektra, the Marvel Comics assassin, and Raphael of the Teenage Mutant Ninja Turtles.

A sai looks like an unsharpened dagger, with a long central shaft and two smaller prongs, called *tsuba,* which were used to trap limbs or swords. Sai are often shown in pairs, but many users actually carried three. The spare would be concealed in case one sai was lost during combat.

BALISONG

The *balisong,* or butterfly knife, can be traced back to the village of Balisong, in the Philippines. This folding pocket knife has two handles that counter-rotate around the tang. In the hands of an expert, the blade can be twirled between the fingers and tossed from hand to hand with great flourish. The lightning-fast twirling motion is hypnotic—excellent for distracting an opponent before making an offensive thrust. Skilled wielders of the balisong can open and close the blade with one hand, flashing the halves of the handle back and forth in an impressive series of movements.

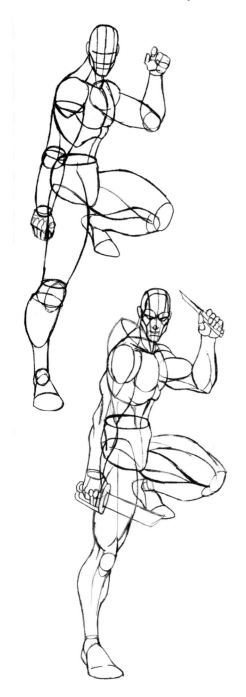

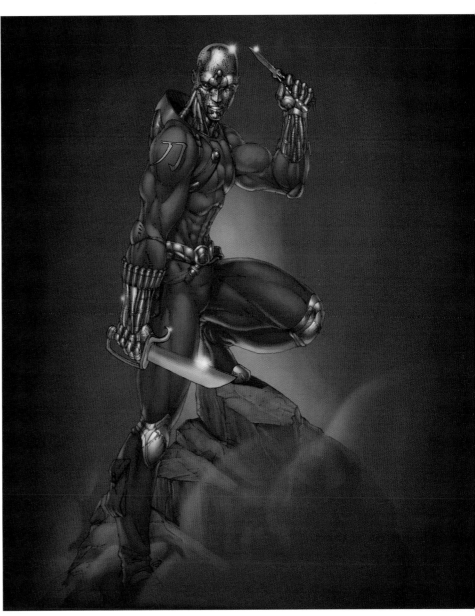

Once you have a good solid pose and have done all the hard work of making sure the anatomy is correct, you're free to go wild with the details. The inscriptions on this knife-man's metal mask and the intricate details of his uniform are what set this guy apart from your garden-variety slasher. When creating a character who specializes in wielding sharp steel, it only makes sense to give him a disposition as icy cold as the metal he swings.

Bo Staff

The *bo* is a long staff of wood or bamboo used to increase leverage and provide a greater reach of attack. This simple piece of wood—which might appear harmless—can prove lethal when in the hands of a practiced wielder. A small motion made by the user holding one end of the bo translates into a much faster, more forceful motion at the other tip of the staff.

A bo can be used as a blunt striking weapon, a device for locking an opponent's limbs and immobilizing him, or to trip a foe or knock him off balance.

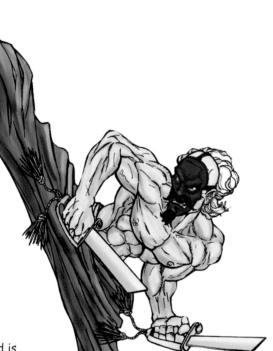

Each butterfly sword is smaller and lighter than a long sword but larger than a dagger, and a nimble user could defeat a sword-wielding opponent even before he had a chance to swing his blade.

Chinese Butterfly Knives

Not to be confused with the Filipino balisong, Chinese butterfly knives are a pair of short, flat swords commonly used in armed combat. The two fast-moving blades create an ideal weapon system for those with the speed and agility to wield them.

CHINESE SABER

Sometimes called a kung fu sword, or dao, the Chinese saber is one of the most popular Chinese martial arts weapons. The word *dao* is actually a generic term that in everyday use means "knife," but it can also refer to any of the many varieties of large, flat-bladed, single-edged broad swords. There is not one definitive shape for the dao; individual swordsmiths created their own signature looks to distinguish their weapons from others' blades.

CLIMBING CLAWS

In the olden days, many Japanese believed the ninjas had the power of levitation because they could infiltrate the highest fortress walls without a ladder. Well, they didn't float. They did their best Spider-Man impression and scaled the stony walls with the assistance of metal claws.

Ninja hand claws (*shuko*) were designed to be worn on the palms for climbing, scaling, and ice-walking. They could also be used offensively to grate an opponent's flesh or defensively to trap and break a sword. Ninja foot spikes (*ashiko*) provide additional leverage.

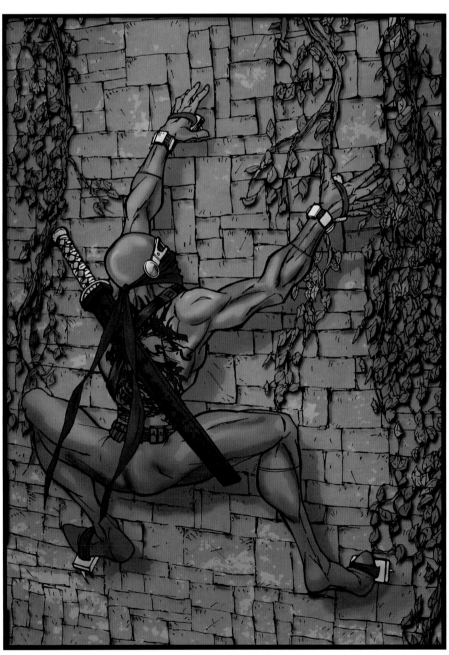

THROWING STARS

Throwing stars, or *shuriken,* are "snowflake"-shaped metal disks that can have as few as three and as many as eight sharp prongs or points. Though throwing stars can be used as weapons, they more often serve as a distraction, misdirecting a foe's attention without revealing the thrower's location. It is thought that the first shuriken may have been carpentry tools designed to pry nails loose from wood. Practitioners of ninjitsu were probably the first martial artists to adapt these tools for stealth combat. Ninjas sometimes coated the blades of shuriken with poison, since the blades' small size meant that throwing stars were seldom lethal by themselves.

To draw a throwing star, or shuriken, first draw a square, divide it diagonally from corner to corner, and then divide it in half horizontally and vertically. Then draw a circle within the square and use the guidelines you've already established to ensure that the throwing star's prongs are spaced at equal intervals.

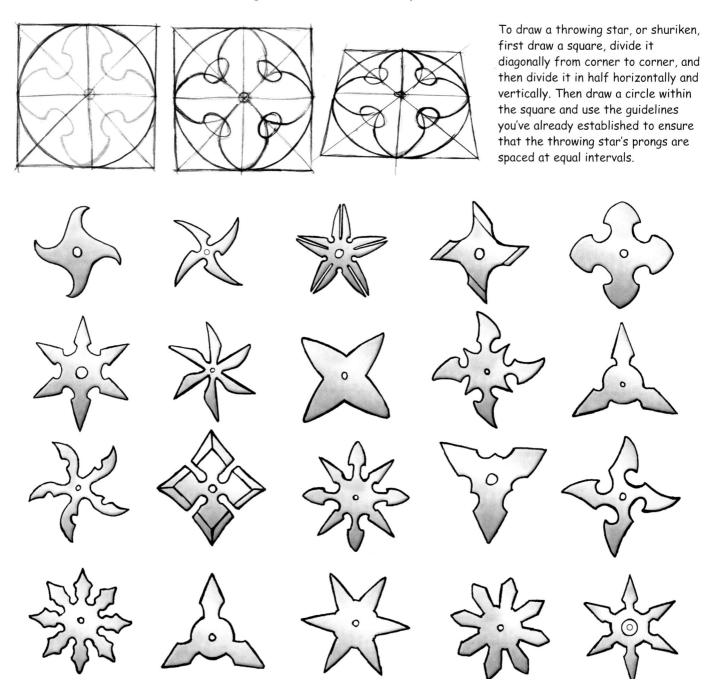

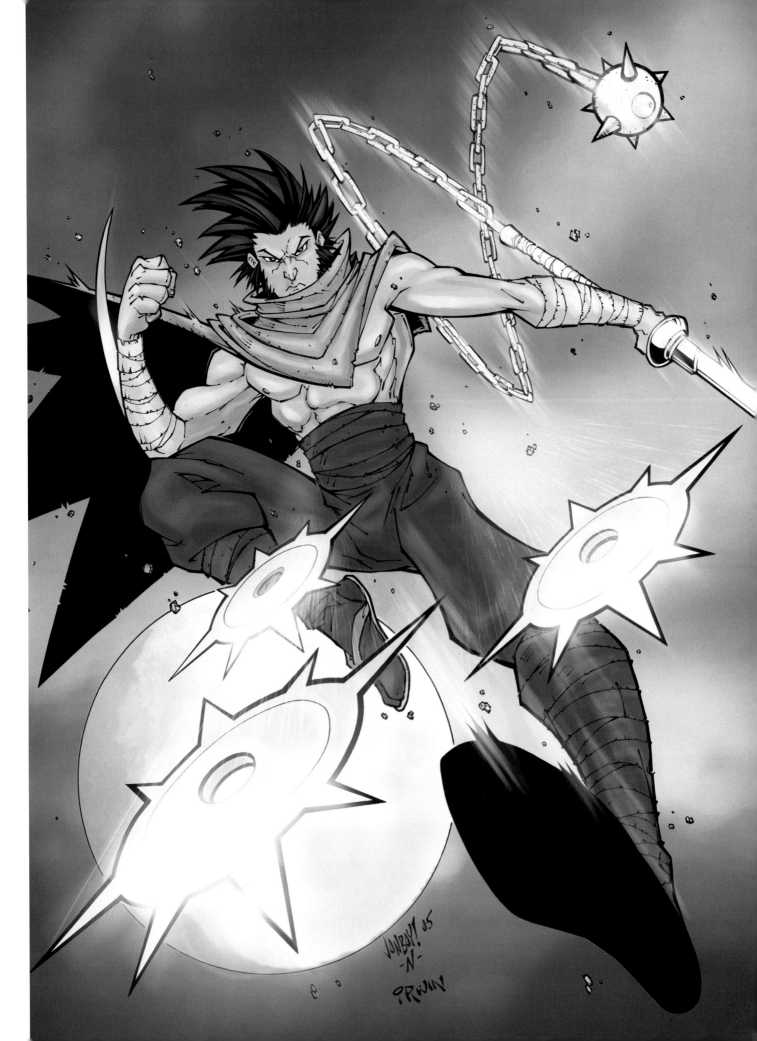

PACKIN' A PUNCH

Hitting does not mean pushing. True hitting can be likened to the snap of a whip—all the energy is slowly concentrated and then suddenly released with a tremendous outpouring of power.

Bruce Lee

IS THERE ANY FIGHT MOVE MORE BASIC than the punch? Throwing blows, fisticuffs, boxing—no matter what you call it, punching's prime objective is to propel your fist at your opponent as quickly as you can. In scientific terms, the punch is governed by Newton's Second Law of Motion, which says that the acceleration of an object is dependent on two variables: the net force acting on the object and the mass of the object. The greater the force, the greater the acceleration.

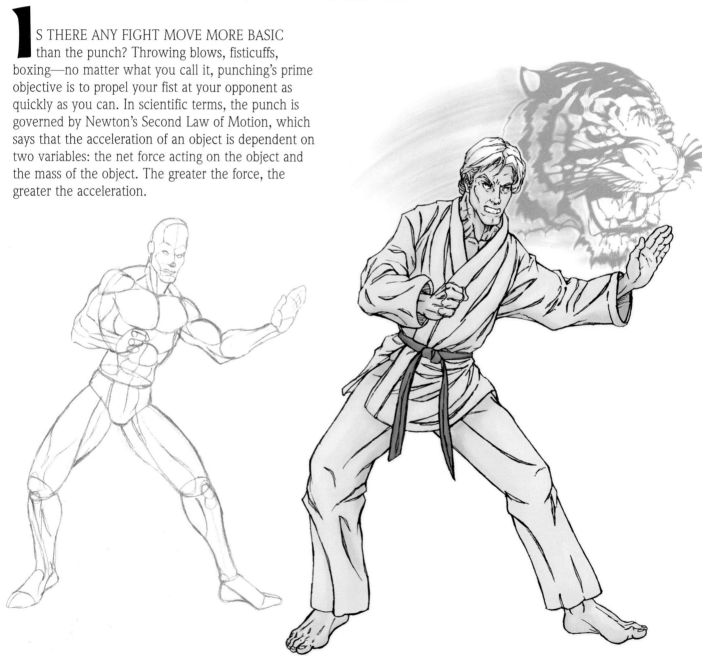

In ordinary English, this means you want to deliver the force of the punch as fast as you can to get the maximum impact. (Think of a bullet. It has very little mass. If you throw a bullet a someone, it won't cause much damage. Fire it from a gun, however, and the effect is drastically different.) You also want the point of impact to be as small as possible, so the pressure acting on the opponent is concentrated. For this reason, martial artists are trained to punch with only part of the hand, usually the space between the first two knuckles or the blade of the hand (the pinky side).

The "science of punch" also determines what happens afterward. The fighter wants to deliver the full force of the punch to his opponent, not back on himself. But physics also tells us for every reaction there is an equal and opposite reaction; thus, the puncher's body will absorb as much force as it delivers. This is where punching technique comes in. Martial arts blows are designed not only to connect hard, but also to minimize the recoil the puncher's body will receive. The easiest way to do this is to align the hand, wrist, and arm properly, so that the force is transmitted up the entire arm and into the body as a whole. This is why punching affects the puncher and the punchee differently; the guy receiving the punch is absorbing the impact of the strike in a very small area, usually only a couple of square inches, while the puncher absorbs the shock up the entire length of his arm.

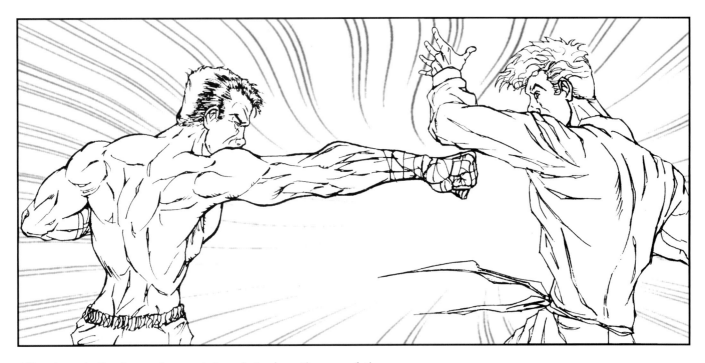

After impact, the force of a punch travels back up the arm of the fighter who has delivered the blow. By concentrating a punch between the first and second knuckles and aligning the hand with the arm and the arm with the shoulder, a fighter can deliver a blow and safely absorb the recoil. This is why fighters sometimes leave their arm extended after planting a particularly powerful blow; they are giving their body time to absorb the returned energy. Luckily for the artist, aligning the masses of the hand, arm, and shoulder does more than just convey correct fighting form—it also makes for a powerful image.

MUAY THAI PUNCHES

Muay thai ("Thai boxing") is a martial arts discipline that originated in Southeast Asia and that, as its name suggests, has long been associated with the country of Thailand. It is often referred to as the Science of Eight Limbs, because the hands, feet, elbows, and knees are all used as points of contact with the opponent—doubling the traditional four points of contact (hands, feet) employed in many other forms of the martial arts. The Thai military has long used muay thai to train its soldiers.

Muay thai practitioners use a lot of brute muscle. In any sport that confines the opponents to a ring—as muay thai does—many of the blows will be delivered at very close range. The most successful muay thai artists tend to have a chiseled, well-muscled build and long limbs, which give them an extensive reach and the power to use it.

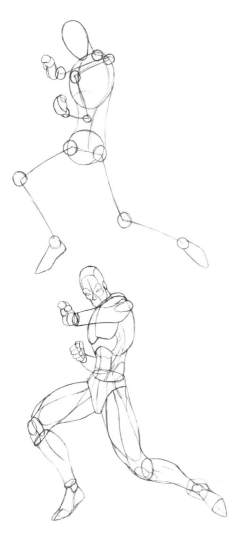

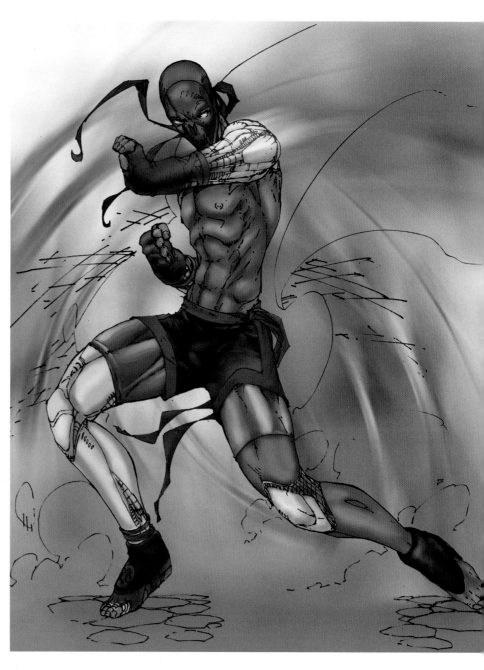

A punch should focus all of a character's momentum into an approximately two-square-inch point of contact on the hand. Even in the early steps of this drawing, you can see that much of the force of the character is being focused on the palm of the hand.

TAE KWON DO PUNCHES

Tae kwon do is a Korean martial arts discipline that is—as often claimed—the most popular style of martial arts in the world. Its roots date back thousands of years, but General Choi Hongh Hi's work in the 1950s laid the foundation for the modern art of tae kwon do.

Tae means "to kick or destroy with the foot"; *kwon* means "to punch with the fist"; and *do* means "way," or "art." Tae kwon do can therefore be loosely translated to mean The Art of Kicking and Punching, or The Way of the Foot and the Fist. Tae kwon do fighting moves are a mix of hand techniques drawn from Japanese karate and kicking techniques that originated in an indigenous Korean kick-fighting form called tae kyon. Although most people, when they hear the term *tae kwon do,* probably imagine flashy spin-and-jump kicks, practitioners of the art master several punches, as well.

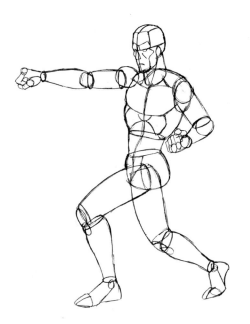

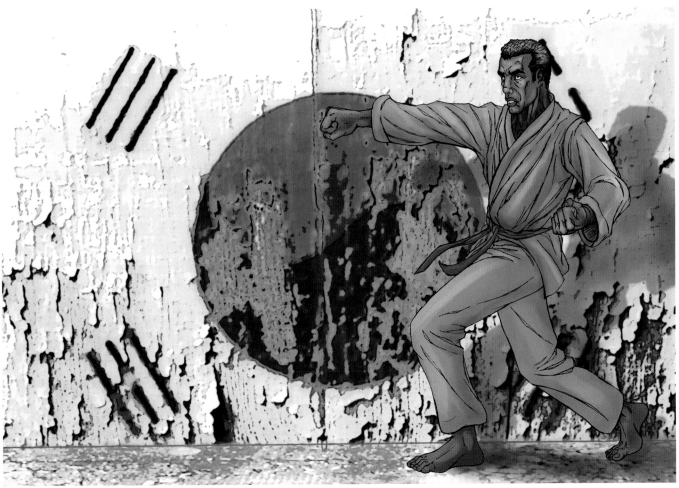

In these drawings we see an example of a lunge punch, used in tae kwon do, in which a simple twist of the shoulders propels the fist at an opponent. This punch, like many martial arts punches, is delivered in a way that keeps the fighter's center of gravity between his spread feet, preventing his opponent from using the fighter's momentum to knock him off balance.

BLOCKBUSTERS

Who hasn't been impressed when watching an expert martial artist splinter boards or shatter concrete? It truly makes him appear like a "man of steel" right out of the comic books. But how does he do it? We know from physics that for every action there is an equal and opposite reaction, so any blow delivering enough force to crack a cement block is also going to receive a lot of that energy back in the form of recoil. So how does the martial artist manage to absorb that force without being shattered himself? The secret lies the strenuous training martial artists undergo, which actually transforms the physical makeup of the skeleton. If you've ever broken an arm, the doctor probably told you that it would actually heal stronger than before. Well, as they train, martial artists sustain thousands of microscopic breaks along the length of the bones they use for striking, and as they heal their bones become denser and tougher.

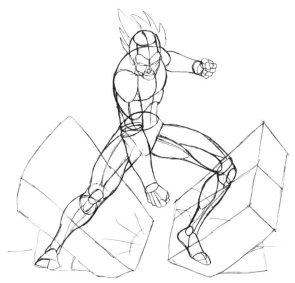

Martial artists are known for breaking things: wood, cement blocks, patio slabs. When they walk through a Home Depot, they aren't shopping for home-improvement materials; they're looking for *targets*. But why do they seem compelled to demolish perfectly good building supplies? Well, if you'd just learned a new bone-shattering punch, you might find it slightly difficult to find a volunteer for you to practice on. Concrete is four times as strong as human bone; It makes an excellent substitute and is a lot easier to obtain than a new sparring partner.

The most powerful punch is the one with the momentum of the whole body behind it. In this drawing, you can see that even though the punch is spearheaded by the fist, the character's whole body is committed to the blow.

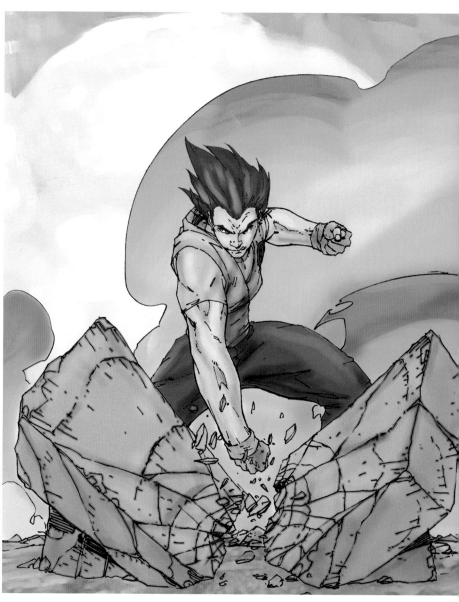

Superhuman Brawlers

In martial arts comic books and video games, some characters move beyond what is humanly possible into the realm of the superhuman. Often, a character's fists will glow or ignite into flames as he delivers a flurry of machine-gun-velocity blows. Sometimes, the superpower indicates that a character has transcended earthy concerns and aligned himself with a more powerful force—a Supreme Being or the very essence of Mother Nature.

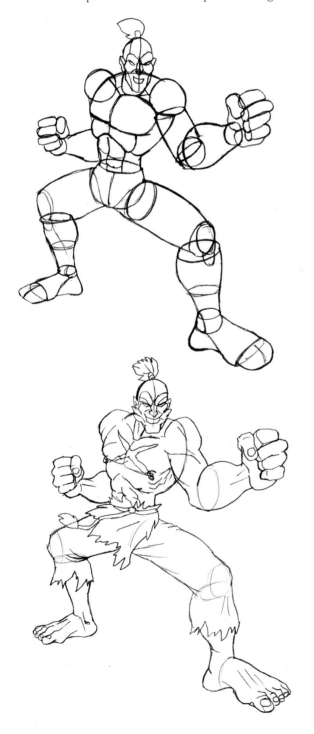

This brawler sure looks like a formidable foe. His tattered clothes and prominent scars mark him as someone who has seen more than his fair share of action. When designing a martial arts character, try to incorporate as many visual hints as possible to reveal the fighter's true nature.

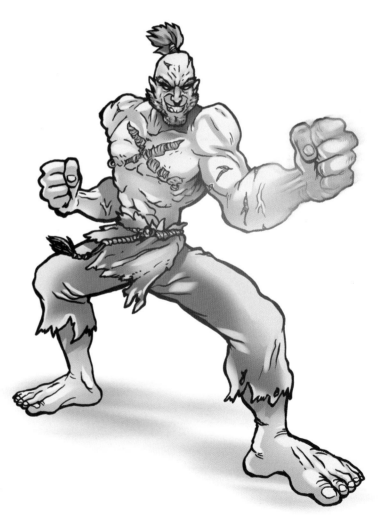

Kickin' It Up A Notch

Deja fu is the feeling that somehow, somewhere, you have been kicked in the head this way before.

Lu-Tze

KICKING STYLES MAY VARY, BUT the principle remains the same: Drive your leg into your opponent. A kick generally delivers a greater blow to a rival than does a punch, but kicking also has some downsides. Kicks are usually slower than punches, and they commit a larger portion of the body's mass to a single move. By assigning most of their attention and force to an offensive move, kickers sacrifice their defensive posture.

Kicks are dynamic when performed correctly, but they require a high degree of skill to be used effectively. For example, a kick often requires an initial chambering, or cocking, of the leg, which telegraphs what is coming next to the opponent. If this preliminary move is not executed very quickly, an alert enemy will have time to block or redirect the oncoming blow. Still, kicking does have the key advantage of keeping an attacker at a safer distance. Just as a lion tamer's whip can ward off a hungry cat, a series of well-executed kicks can keep an adversary at bay.

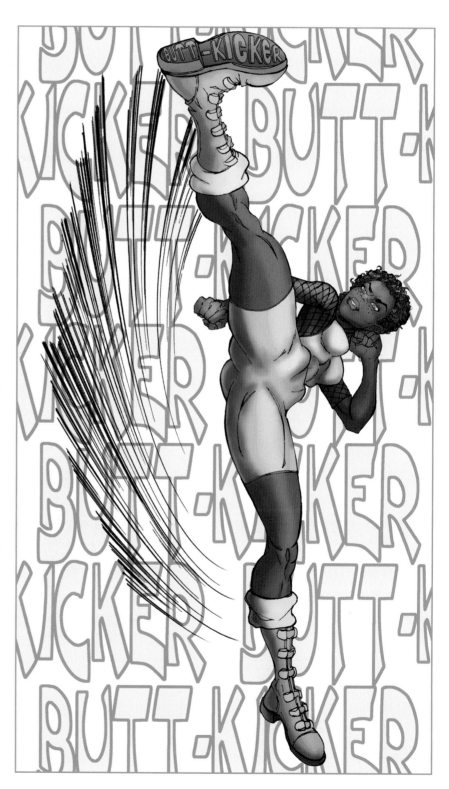

FRONT KICK

The front kick is a pretty straightforward move. Someone is standing in front of me, and I kick him. But the front kick clearly demonstrates the advantage kicks have over punches when trying to keep an opponent away. When an enemy moves into your punching range you open yourself to all sorts of trouble, but keeping a foe at a leg's distance protects you from close- and medium-reach blows.

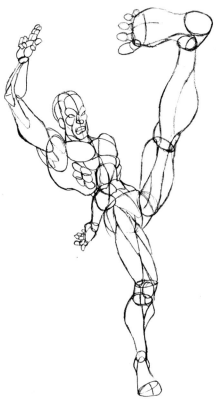

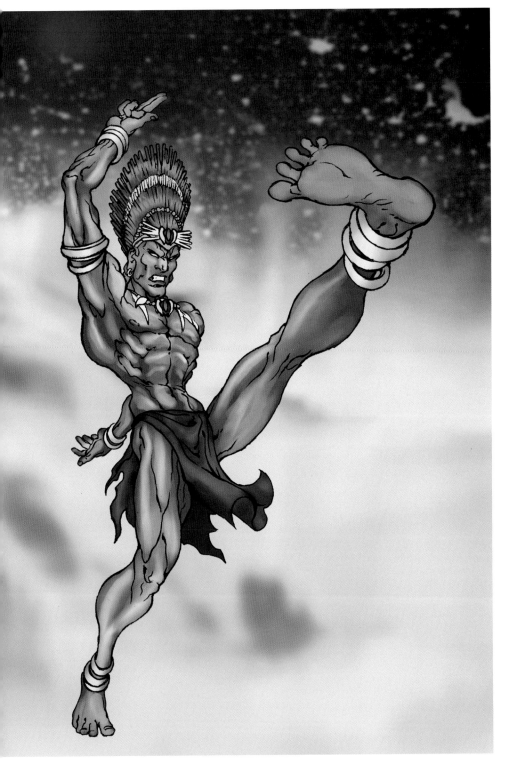

A kick involves much more than just raising a leg. The legs usually support the body's weight, so by sending a kick in an assailant's direction, a fighter sacrifices a good part of his balance. Obviously, you can't bend your toes into a fist, so you want to strike either with the heel (as in these drawings of a "tribal" kung fu fighter) or with the outside edge of the foot.

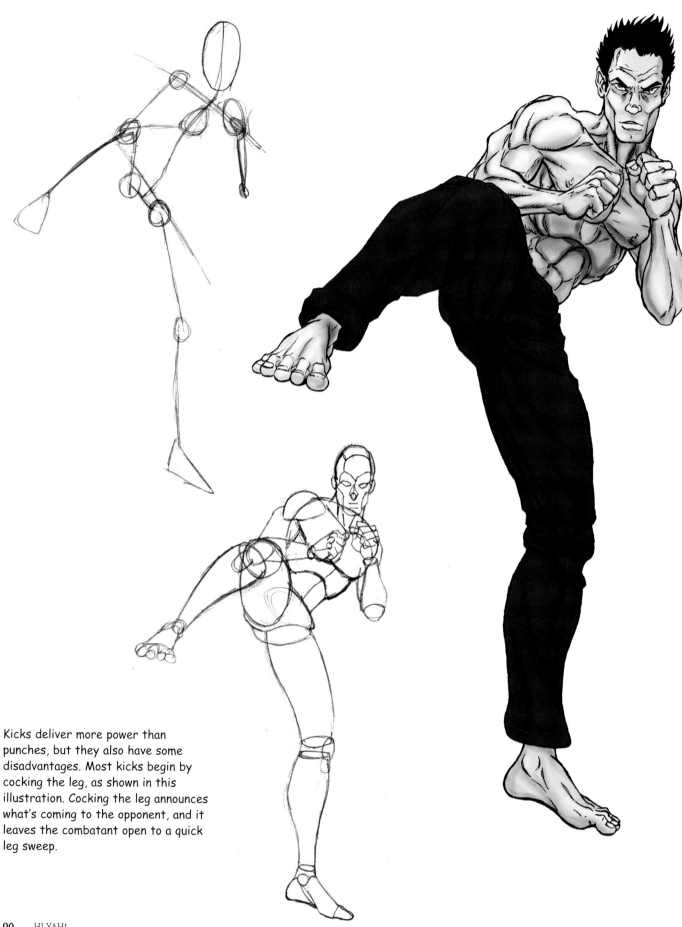

Kicks deliver more power than punches, but they also have some disadvantages. Most kicks begin by cocking the leg, as shown in this illustration. Cocking the leg announces what's coming to the opponent, and it leaves the combatant open to a quick leg sweep.

MUAY THAI KNEE KICK

Muay thai, or Thai boxing, has long been popular in Southeast Asia, and it has recently spread to Japan, Europe, and the United States. Although muay thai is primarily a ring sport, it has numerous self-defense applications. The discipline is renowned for its overall simplicity, with a repertoire of moves that include powerful roundhouse kicks, elbow strikes, knee thrusts, and basic boxing-style punches. Muay thai brawlers subject themselves to hundreds of hours of rigorous training designed to lessen the pain they feel at contact points. Sensitive areas like the knees, elbows, and (especially) the shins are repeatedly struck against heavy boxing bags to deaden the fighter's nerves.

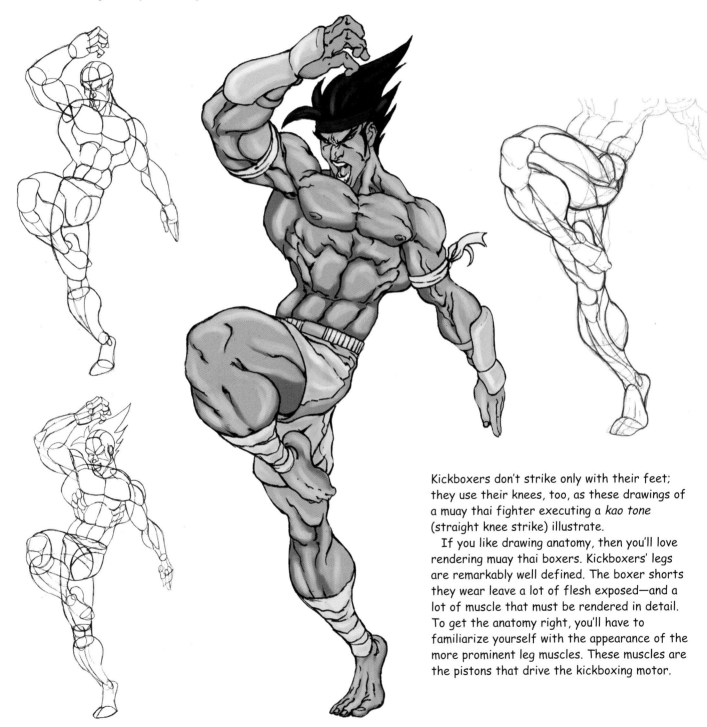

Kickboxers don't strike only with their feet; they use their knees, too, as these drawings of a muay thai fighter executing a *kao tone* (straight knee strike) illustrate.

If you like drawing anatomy, then you'll love rendering muay thai boxers. Kickboxers' legs are remarkably well defined. The boxer shorts they wear leave a lot of flesh exposed—and a lot of muscle that must be rendered in detail. To get the anatomy right, you'll have to familiarize yourself with the appearance of the more prominent leg muscles. These muscles are the pistons that drive the kickboxing motor.

BACK KICK

Powerful, effective kicks put the whole body in motion. What good is it to plant a heel with the strength of a horse if you knock yourself off-balance in the process? Therefore the thrust of the kicking leg is always offset by a balancing movement made by some other part (or parts) of the body.

The back kick, often employed in karate, is sometimes called a donkey kick or mule kick. Unlike most kicks, which are directed at an opponent in front of you, the back kick is aimed at a guy sneaking up on you from behind. The kick, which begins with a glance over the shoulder, uses the heel as the striking surface.

Because the leg is larger, heavier, and longer than the arm, kicks are very useful for female combatants, especially when they're competing against males, whose upper-body strength and arm reach are generally greater. And because kicks are more unexpected than punches, a kick may catch an attacker off guard and intimidate him. An attacker is likely to think twice about continuing an assault if he finds out that the woman he's confronted can use her sexy legs to repel him with brute force.

A leg, when fully extended, follows an almost perfectly straight line, as you can see from these drawings. Notice, too, how the masses on either side of the weight-bearing leg balance each other. As I've said before, the martial arts are like ballet—a *brutal* ballet. The point isn't just to unleash the power of the body, but also to balance each move with finesse and control.

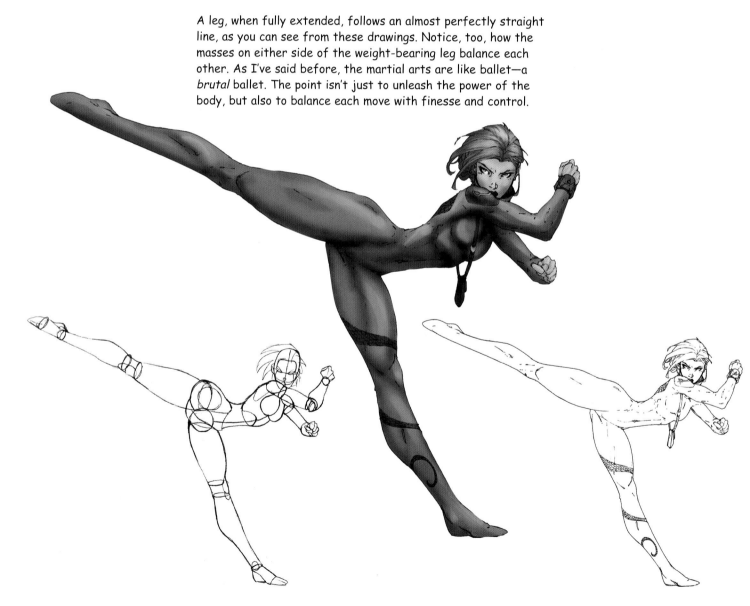

SIDE KICK

Side kicks are performed by chambering (cocking) the leg and thrusting the edge of the foot deep into your opponent. When combined with a forward slide on the weight-bearing leg, a side kick can deliver quite a wallop.

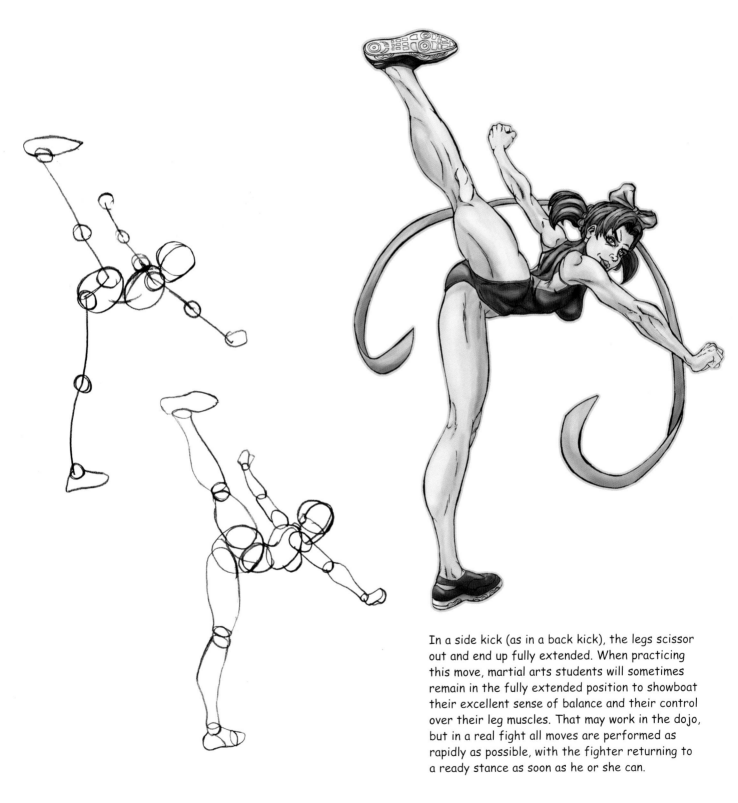

In a side kick (as in a back kick), the legs scissor out and end up fully extended. When practicing this move, martial arts students will sometimes remain in the fully extended position to showboat their excellent sense of balance and their control over their leg muscles. That may work in the dojo, but in a real fight all moves are performed as rapidly as possible, with the fighter returning to a ready stance as soon as he or she can.

JUMPING SIDE KICK

Most opponents are not going to leave themselves wide open and give you the time to perform a jumping side kick. But when a jumping kick is done correctly, the results can be quite impressive. In a street fight, no untrained brawler will want to take on a professional butt-kicker!

The advantage of this move is that it uses centrifugal force to concentrate *all* of the body's weight into the edge of one foot. The drawback is that it commits the whole body to a move that can be sidestepped. Even worse, a well-trained foe might deflect the kick's trajectory and hurl the kicker into a brick wall.

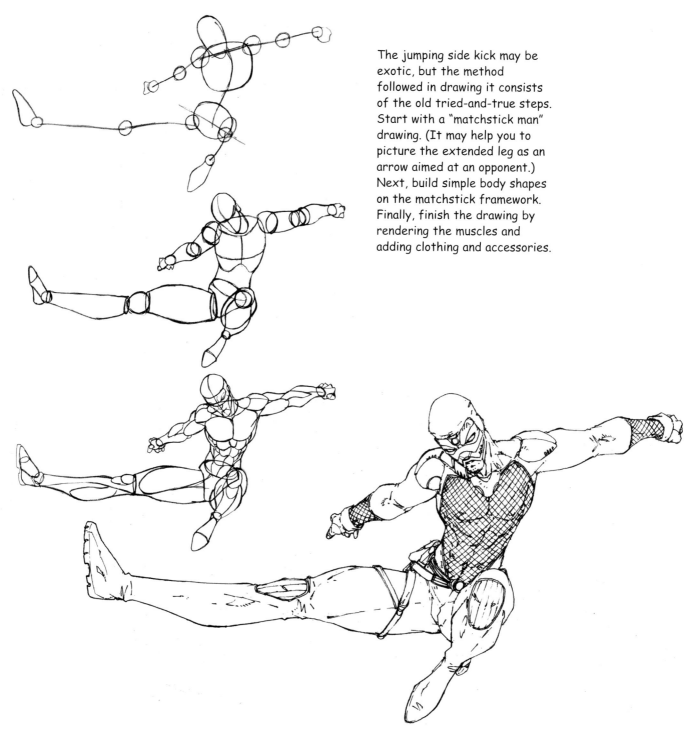

The jumping side kick may be exotic, but the method followed in drawing it consists of the old tried-and-true steps. Start with a "matchstick man" drawing. (It may help you to picture the extended leg as an arrow aimed at an opponent.) Next, build simple body shapes on the matchstick framework. Finally, finish the drawing by rendering the muscles and adding clothing and accessories.

SPIN KICK

In a spin kick, a fighter snaps his or her torso in a tight spiral, using that momentum to propel the leg out and toward the opponent. The spin kick offers a great example of how the upper body can play a significant role in adding extra oomph to a kick.

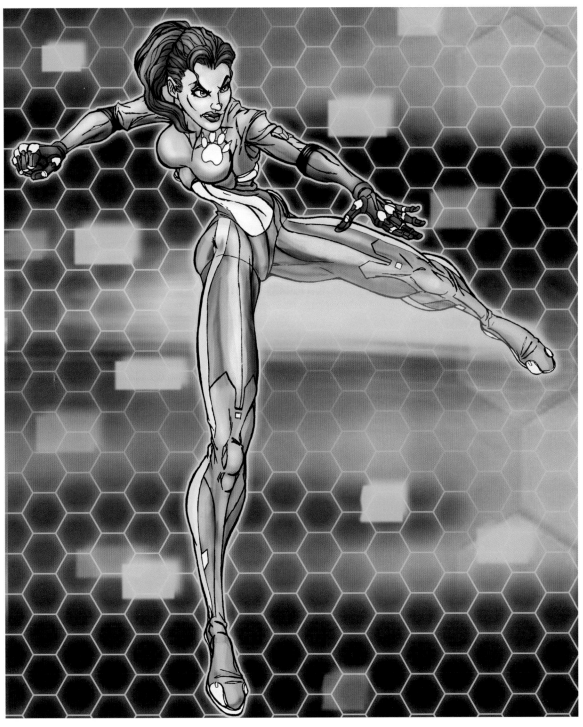

A spin kick actually starts at the waist. As the waist twists, the abdominal muscles thrust the shoulders back. This momentum moves down the thorax and pulls the leg along.

SWORD KICK

The best fighters are the ones who can alternate among several different means of attack. In a sword fight, the opponent will probably not be expecting to receive a tooth-loosening side kick.

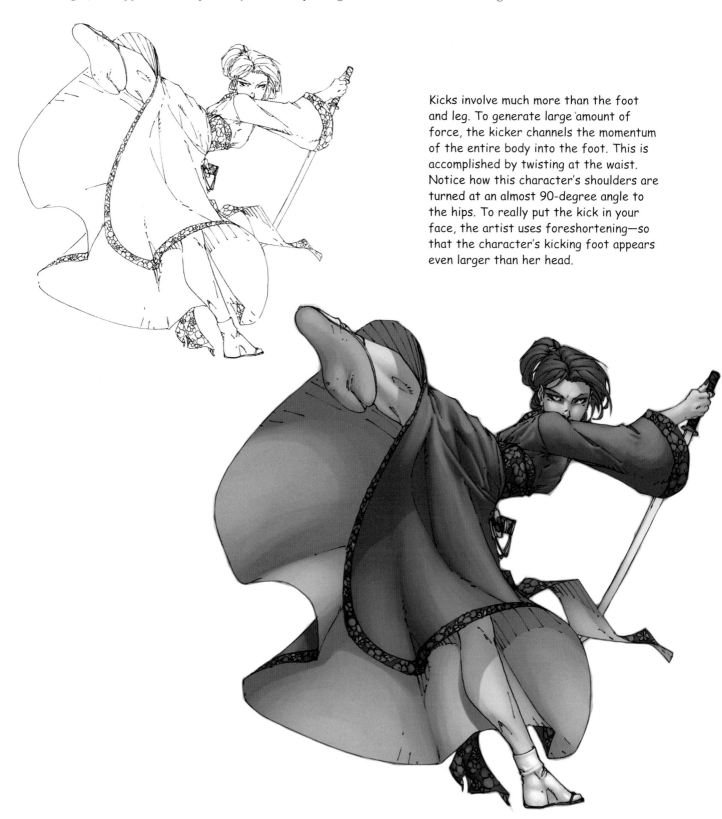

Kicks involve much more than the foot and leg. To generate large amount of force, the kicker channels the momentum of the entire body into the foot. This is accomplished by twisting at the waist. Notice how this character's shoulders are turned at an almost 90-degree angle to the hips. To really put the kick in your face, the artist uses foreshortening—so that the character's kicking foot appears even larger than her head.

UPSIDE-DOWN KICK

The upside-down kick is the most outrageous of all. The martial artist spins his or her entire body like a pinwheel, cartwheeling into the foe and extending one foot to land the kick. The body's momentum carries enough force to knock a rival cold. Truth be told, however, this kind of full-bodied kick is rarely used. Though it's a popular move in martial arts comics and anime films, it's a little impractical for real-life combat.

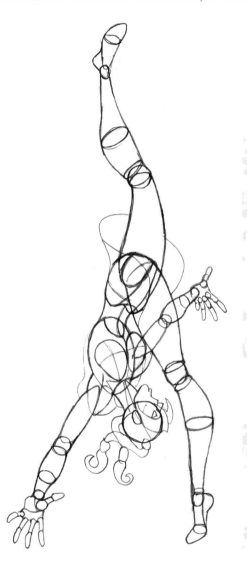

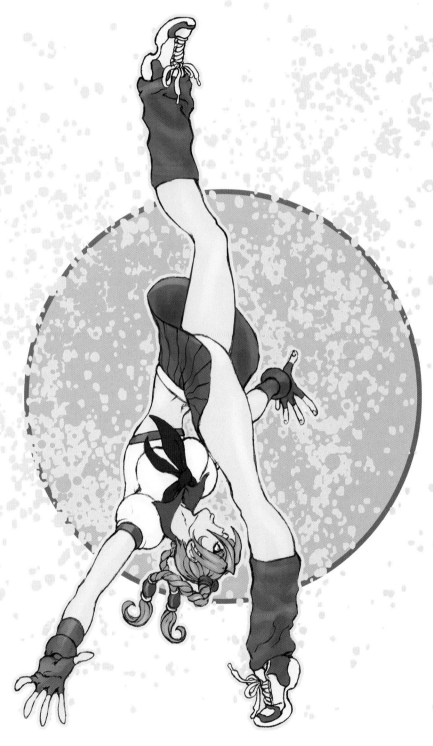

The farther the arms are extended, the greater effect they have in stabilizing the body and maintaining balance. Oppositely, when a kicker draws her arms tightly in toward her torso, she is trying to increase her upper-body mass—and thus add to the force delivered by a kick.

Good Guys Wear Black Belts

*Practice does not make perfect,
but instead a good practitioner.*

Nat Peat Sensei,

Yudansha Kobu-Jitsu
Karate-do Federation

EVERYONE LOVES THE HERO—BUT WHY?
What is it about the heroic character that makes
us root for him, especially when the chips are down?
Heroes are often distinguished by their exceptional courage,
nobility, and strength. These are fine qualities, to be sure,
but to fully engage your audience your hero has to have
more going for him than just a list of virtuous traits.

One time-tested way to pique an audience's interest is to
give your character "feet of clay"—a weakness or hidden
flaw. What fun is it to cheer on someone who is perfect—
who can automatically triumph over any adversity? Even
Superman has his kryptonite. By instilling a weakness in
your character you actually make him more accessible to
the audience, since we can all identify with
someone who is less than perfect.

Another way to build interest in your characters
is to give them great challenges to overcome. The
history of the martial arts is full of underdogs who,
through perseverance and determination, are able to
overcome all odds. One obstacle many martial artists have faced is the barrier of race
or culture. In the past—much more so than now—it was sometimes difficult for
students from foreign countries or other cultures to find a *sensei* willing to take them
on. But the current worldwide success of so many styles of fighting is a testament to
those noble teachers who looked past the color of people's skins and passed on their
learning because of what they saw *inside.*

Overcoming insurmountable odds is a well-worn staple of martial arts films, as
well. Take *The Karate Kid*: Daniel LaRusso personifies the underdog for all of us who
have ever been picked on by a bully or struggled to win the affection of someone
outside our social class. Under the tutelage of Mr. Miyagi, Daniel faces his trials head-
on and emerges the victor. In creating your martial arts characters, consider who
your own personal heroes are and identify which traits make them especially
praiseworthy in your eyes—and then translate those characteristics into the figures
populating your drawing pad.

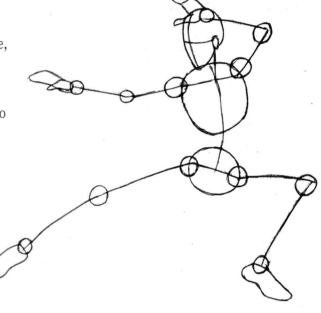

Heroic martial arts characters
are usually in top physical
condition. In martial arts films
and comics, the shirts often
come off when the fight
begins. Get used to drawing
your characters with broad
shoulders and chiseled
physiques.

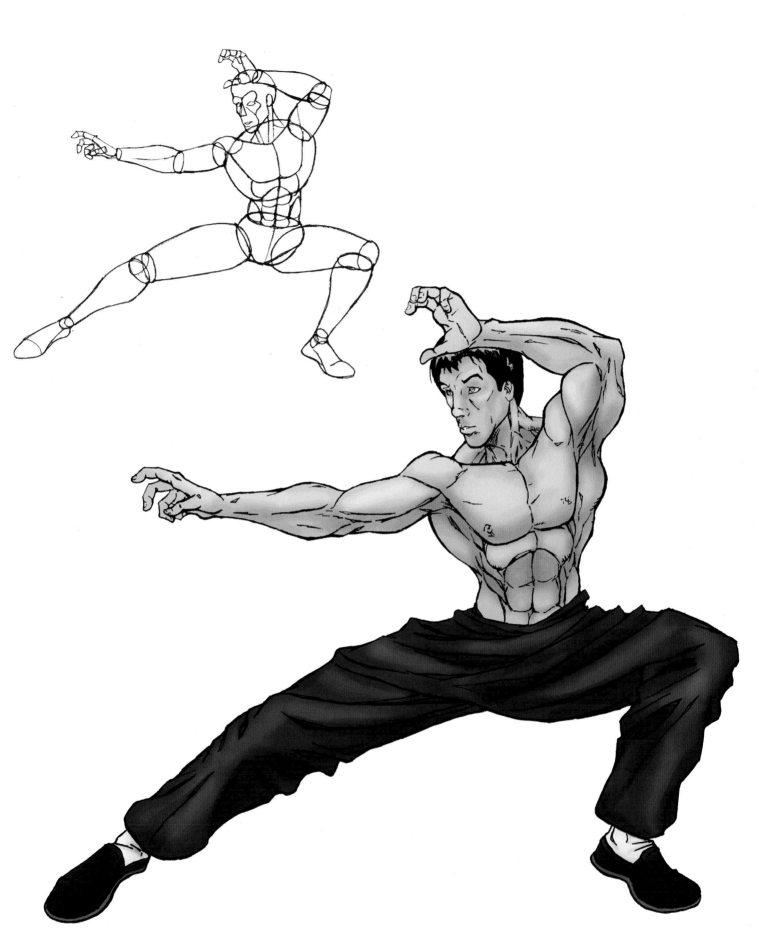

THE INNOVATOR

Jun Fan—better known by his adopted Western name, Bruce Lee—established a new school of martial arts called jeet kune do, which means The Way of the Intercepting Fist. (It is also sometimes known as jun fan jeet kune do, after its founder.) Jeet kune do is often thought of as a martial arts philosophy rather than a fighting style per se. Lee had grown dissatisfied with most traditional forms of martial arts and their overreliance on scripted moves. He believed that depending too heavily on memorized *katas* (fighting styles) was like trying to learn to swim while on dry land. He created jeet kune do with the aim of its becoming the ultimate fighting form, because it borrowed the best moves from various fighting styles—including Western styles such as fencing, boxing, wrestling, and savate (French kickboxing), and Eastern styles such as judo, karate, and wing chun (a Southern style of Chinese kung fu)—and then boiled them down to their rawest, most effective form.

A key principle of jeet kune do is to become like "an empty cup, able to be filled"—in other words, to be flexible enough to adapt to whatever situation you find yourself in. ("Absorb what is useful; disregard that which is useless" is a popular Bruce Lee quote.) Jeet kune do fighters don't adhere to one martial arts form or favor a particular stance; at any given moment, their fighting style is usually a work in progress—a mix of all the latest moves they are assimilating into their own, unique kind of martial arts practice.

Characters using jeet kune do moves are fun to draw. As always, start with a simple line drawing or stickman figure. Once you are comfortable with the position and size of your drawing, you can start to build your character's anatomy on top of it.

African-American Martial Arts Heroes

Martial arts exist in virtually every part of the world and are practiced by nearly every culture and ethnic group. You should therefore avoid drawing characters belonging to only one race. The sharing of fighting skills freely between cultures is a relatively recent phenomenon, however. In ancient times, martial arts secrets would be tightly guarded to keep rival forces at a disadvantage. The tearing down of cultural walls and the bringing together of martial arts masters with students from different ethnic backgrounds have helped to foster a greater sense of family within the martial arts community.

When African-American karate champion Jim Kelly teamed up with Bruce Lee in the 1973 film *Enter the Dragon* one more racial stereotype was torn down. Kelly's character, Williams, was a hero-warrior perfecting his fighting skills while pursuing a path to enlightenment. Kelly went on to star in the 1974 kung fu/blaxploitation classic *Black Belt Jones,* and thanks to his pioneering career, other black martial artists/actors were given a high-kicking leg up in Hollywood—helping to prove that the martial arts know no racial, sexual, or cultural boundaries.

One of those black actor-athletes was Kareem Abdul-Jabbar. Famous for his "skyhook" jump shot, this basketball star was also a student of Bruce Lee's and of Lee's jeet kune do martial arts style. Abdul-Jabbar filmed an electrifying fight scene with Bruce Lee for the 1978 film *Game of Death.* Sadly, Lee died during the movie's production, and this scene is one of the few redeeming moments in the film, which was completed with stand-ins for Lee.

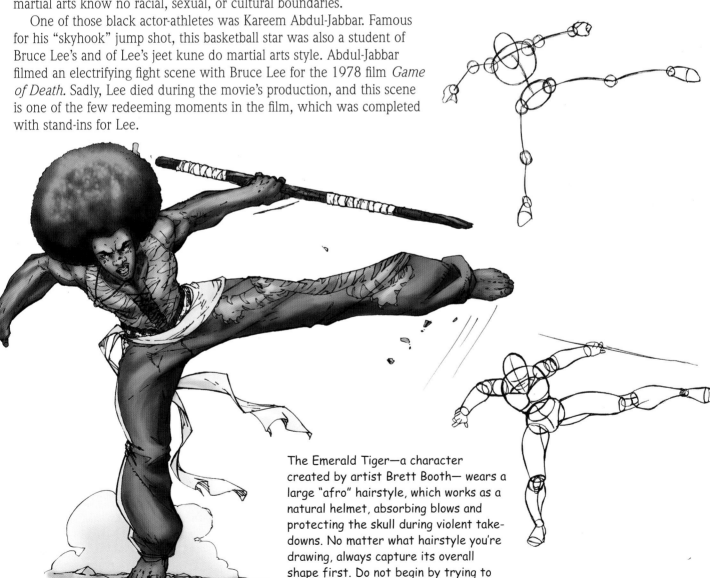

The Emerald Tiger—a character created by artist Brett Booth— wears a large "afro" hairstyle, which works as a natural helmet, absorbing blows and protecting the skull during violent take-downs. No matter what hairstyle you're drawing, always capture its overall shape first. Do not begin by trying to draw individual strands of hair.

SHAOLIN MONKS

The Shaolin order of Buddhist monks dates back to the fifth century, when the Shaolin Temple was founded in the Chinese province of Henan. Sometime in the sixth century, an Indian Buddhist priest named Bodhidharma—called Tamo in Chinese—paid a visit to the Emperor of the Middle Kingdom, and while in China he met with his fellow monks at Shaolin. He noticed that the monks there, who spent all their time hunched over tables translating ancient texts, lacked the physical conditioning necessary for Buddhist meditation. So Tamo introduced them to a series of eighteen exercises derived from Indian hatha yoga and based on the natural movements of wild animals.

Working from the moves Tamo had taught them, the monks developed their own distinctive, stylized martial arts form, which has come to be known as Shaolin kung fu.

Shaolin monks are some of the best fighters to ever walk the earth, but the highest goal of their training is not to overpower foes but rather to master themselves. The monks undergo rigorous training routines to gain control over their bodies, minds, and spirits. They believe enlightenment comes to those who achieve total mastery over their own being.

MULAN

The men seem to have their valiant martial accomplishments forever recorded in the annals of time, but what about the ladies? Enter Mulan. Disney may have given her worldwide fame, but Mulan (whose name translates as Magnolia Flower) was the heroine of a popular Chinese bedtime story and a female role model way before Walt got hold of her. The poem describing Mulan's exploits first appeared sometime in the seventh century, during the Tang Dynasty. As the poem tells the story, an invasion from the north forces the emperor to draft the eldest son from every family in his kingdom for military service. Since Mulan's family does not have an eligible son, tradition dictates that her elderly father will have to serve instead. To protect her aged father from harm, Mulan joins the emperor's militia disguised as a man. The poem recounts Mulan's several courageous acts of service during a ten-year campaign against the northern invaders.

Mulan is reported to have been a master swordswoman, an excellent archer on horseback, and unbeatable in hand-to-hand combat. When the Chinese were finally victorious, Mulan revealed her true identity and then returned to her family. At first this surprised her fellow soldiers, but they soon realized that, though valor favors no gender when there's a battle to be fought, men and women have very different roles in society during times of peace.

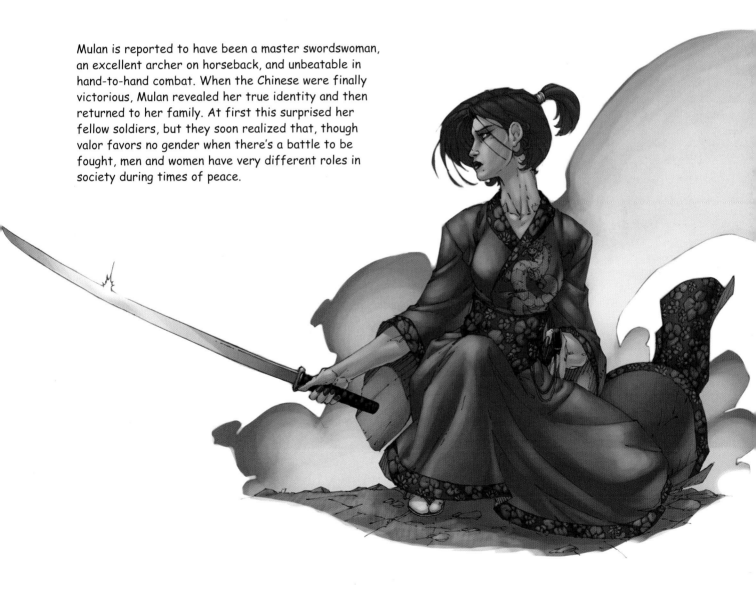

SUPERHERO MARTIAL ARTISTS

The martial arts provide fertile ground for the creation of superheroes—offering ordinary, non-superpowered people the opportunity to play in the big leagues with the metahumans. If you think about it, Batman is really just a modern-day ninja with high-tech gadgetry. Marvel Comics' popular hero Master of Kung Fu is just a regular guy who happens to have mastered the martial arts. With a lot of hard work and discipline, an average Joe can hang out with guys like Superman and Spider-Man—while making the world a better place, to boot. What's not to love?

In the West superheroes tend to fly around and do things like shooting lasers from their eyes. In the East, superheroes have historically incorporated elements from the martial arts into their powers and action, as we've seen from imported Japanese cartoon series like *Ultraman* and *Mighty Morphin' Power Rangers.* (Ultraman did have genuine superpowers: For instance, he could transform himself from ordinary human size to a towering giant capable of wrestling with huge, city-destroying monsters.)

Superhero-type characters usually dress in form-fitting clothes made of fabric similar to spandex. These kinds of outfits are perfect for honing your anatomy skills, since you're basically drawing a nude figure and then applying bright colors to the bare forms.

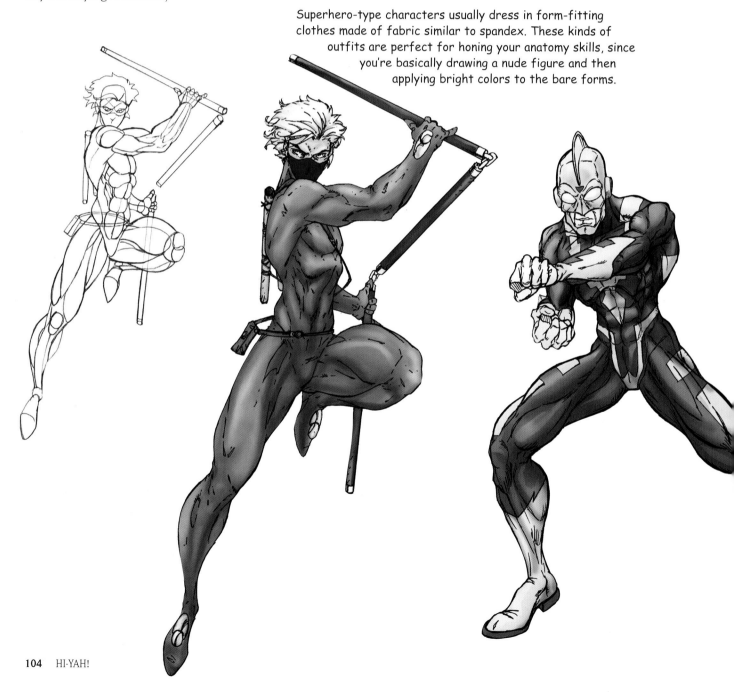

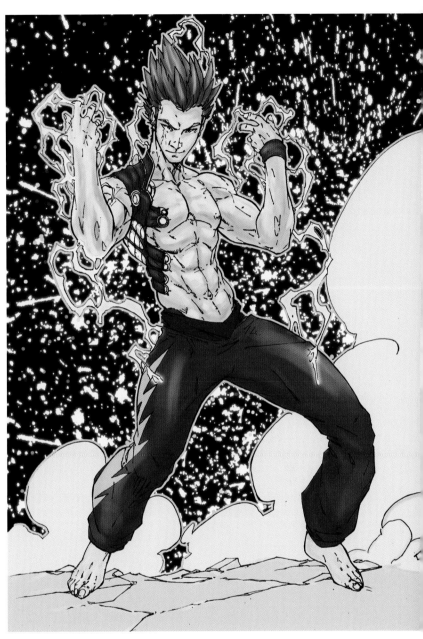

▲ Some martial arts heroes have reached the upper echelon of all-time martial arts masters and are able to transcend what is humanly possible. By focusing their *ki,* they are able to affect their surroundings supernaturally or to manifest visible energy fields as they perform their moves.

◄ *Sentai* is the Japanese word for "task force," but it has also become the name for a genre of television shows featuring brightly costumed superheroes. Typically, the shows center around a group of young friends who secretly transmute into gifted martial arts experts, complete with cheesy, form-fitting spandex suits. Each week, they dispatch some B-movie-type monster with an impressive display of fanciful kicks and pyrotechnics. Uberman here looks like he would fit right in among a bunch of creature-karate-ing do-gooders. When creating characters in this vein, there's no limit to the wondrous powers—flying, growing, shrinking—you can give them. The possibilities are limited only by your imagination.

Sometimes the good guy is a bad boy. A recurring character in martial arts tales is the cocky, loudmouth individual who has achieved near-mastery of his discipline but who is taken down a peg or two because of his arrogance. These characters make great comic foils for the main hero and always have something humorous to say. This particular fellow seems to have quite an electrifying personality. Even standing still, his pose screams energy and oozes self-confidence. The spiky pineapple hairdo is a dead giveaway he has a shocking amount of charisma.

THE BIG, THE BAD, AND THE UGLY

When two tigers fight, one is certain to be maimed, and one to die.

Master Funakoshi

THE MARTIAL ARTS TRANSFORM the human body into a living weapon. Unfortunately, martial arts techniques are as easily learned by those with nefarious aims as by those whose intentions are noble. As long as there is corruption in the human heart, there will be those who distort martial arts practice into a means of personal gain rather than a path for bettering themselves. This chapter is dedicated to the bad guys—as well as to some fighters who aren't necessarily bad but sure are big and ugly!

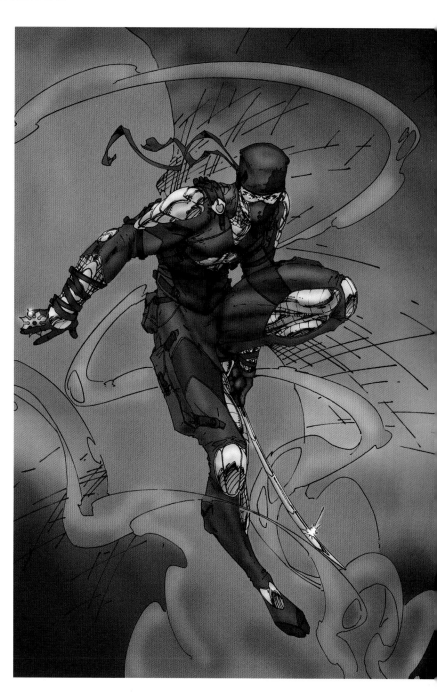

Ninjas practiced the arts of camouflage, concealment, horsemanship, explosives, and poison.

THE DARK SAMURAI

A samurai warrior viewed his life as a path to enlightenment. To deviate from that path invited terrible retribution from supernatural forces. In Japanese stories, the dark samurai is usually a warrior who has fallen from grace; the story begins with his tormenting the hero, but by the end of the tale the valiant and noble deeds of the hero have won the dark one over, and he is given one last chance at redemption. This theme was incorporated into the *Star Wars* movies with great success. Audiences thrilled to the adventures of Anakin Skywalker—a noble Jedi warrior (clearly based on the samurai model) who falls and yet redeems himself with the help of his son.

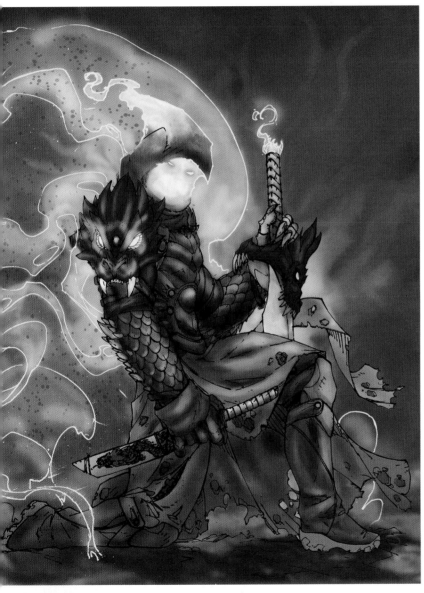

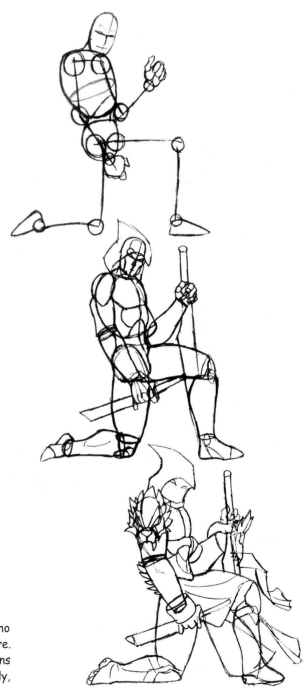

It looks like this guy made a wrong turn a long, long, time ago. Even a character as complex as this dark samurai is no match for the artist who patiently builds his character according to the simple steps laid out here. First, start with the "matchstick" figure, refining it until the proportions are correct. Then add the simple cylindrical masses to the frame. Finally, erase the guidelines and add details such as weapons and armor.

NINJAS

Ninja warriors arose during Japan's feudal period, when missions of espionage and assassination were often carried out against warlords ensconced in their fortresses. Ninjas were recruited from Japan's lower classes, who because they did not have access to samurai training or specialized weapons, learned to make do with the everyday implements available to them.

Ninjas also deviated from the traditions of honorable combat and adopted a "by any means necessary" mentality to accomplish their missions. They were looked down on for their unconventional fighting style—known as ninjitsu—and for their reliance on stealth and misdirection and their reluctance to face opponents out in the open. It was only in the 1970s, when the cult of the ninja started to infiltrate popular culture, that they received iconic status as a clan of expert warriors to be respected and feared.

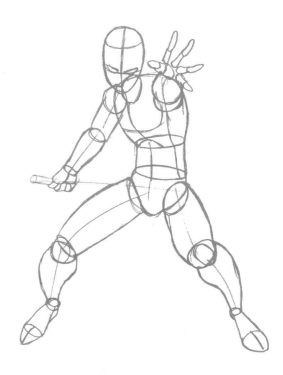

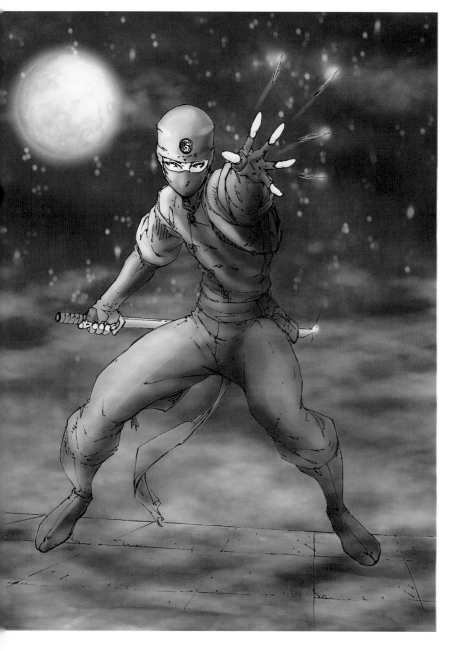

Although ninjitsu does incorporate various linear and circular emptyhand (that is, weaponless) techniques, much of the ninjas' success stemmed from their use of swords, daggers, blow guns, weighted chains, and throwing stars.

Unsavory Types

Martial arts villains include some pretty sleazy characters. There are the sadistic young toughs who attack in packs because they lack the skill and courage to face an opponent alone. And then there are the evil-doing "masters" who rely on their age (and general nastiness) to inspire fear in their underlings. What an unsavory bunch.

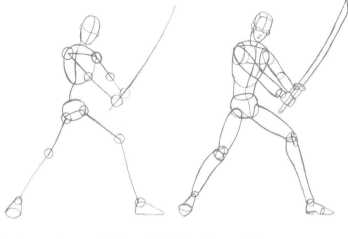

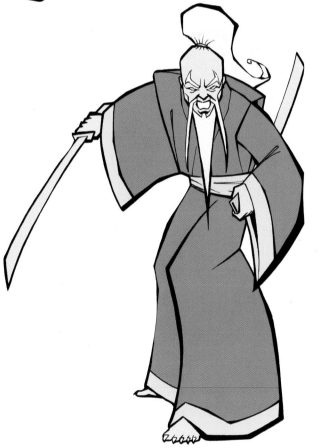

You know the type. He's not disciplined enough to master an art, but he likes to rough people up with the help of a group of friends. He's the underling—the lowest rung on the martial arts ladder. All bark and very little bite, he's the perfect target for your heroic characters to test out some new tooth-loosening kicks on.

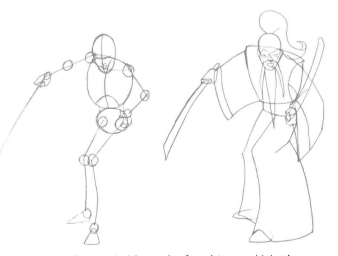

The underling probably works for this guy. He's the mastermind behind some wicked goings-on. The old man probably has one or two martial arts tricks left up his sleeve to impress new recruits, but he's basically running his organization on brains, not brawn.

FLAMBOYANT VILLAINS

Why do some villains seem to spend more time designing their costumes than thinking through their wicked plans? If the guy below spent one-tenth of the time on his evil plot that he took to assemble all those straps and armor, he'd probably have a higher success rate in executing his schemes of world conquest.

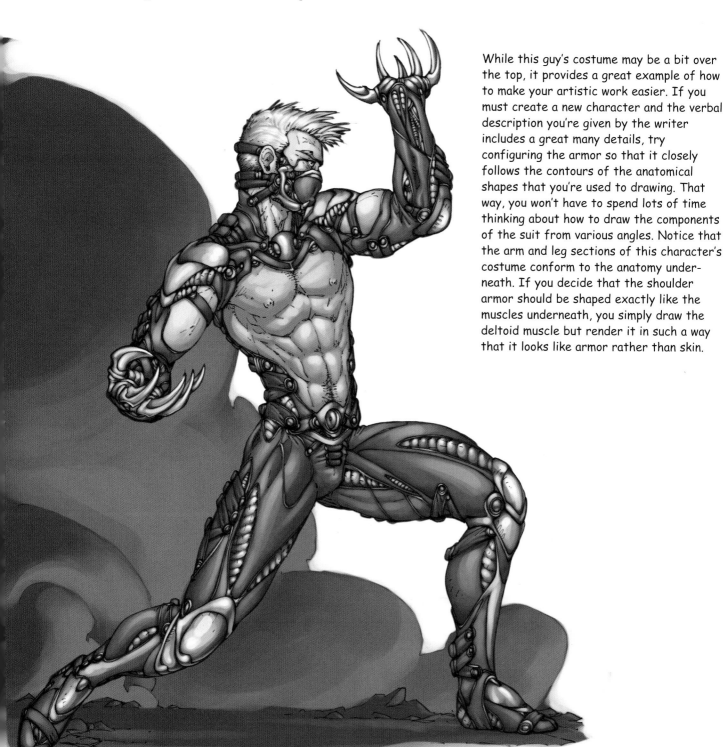

While this guy's costume may be a bit over the top, it provides a great example of how to make your artistic work easier. If you must create a new character and the verbal description you're given by the writer includes a great many details, try configuring the armor so that it closely follows the contours of the anatomical shapes that you're used to drawing. That way, you won't have to spend lots of time thinking about how to draw the components of the suit from various angles. Notice that the arm and leg sections of this character's costume conform to the anatomy underneath. If you decide that the shoulder armor should be shaped exactly like the muscles underneath, you simply draw the deltoid muscle but render it in such a way that it looks like armor rather than skin.

STONE NINJAS

Characters made of living rock or metal are common in martial arts comics and video games. The combination of impervious skin and daunting fighting abilities makes for a formidable foe. Typically, a character like this makes the protagonist's life miserable; he will have the upper hand for the first few rounds of the battle. But soon enough the hero will discover his Achilles' heel, and then this guy is rubble. The bigger they come, the harder they fall.

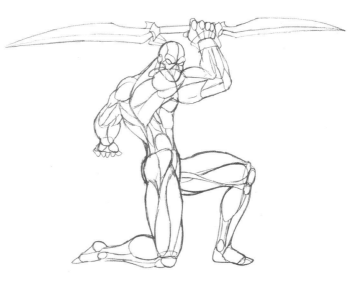

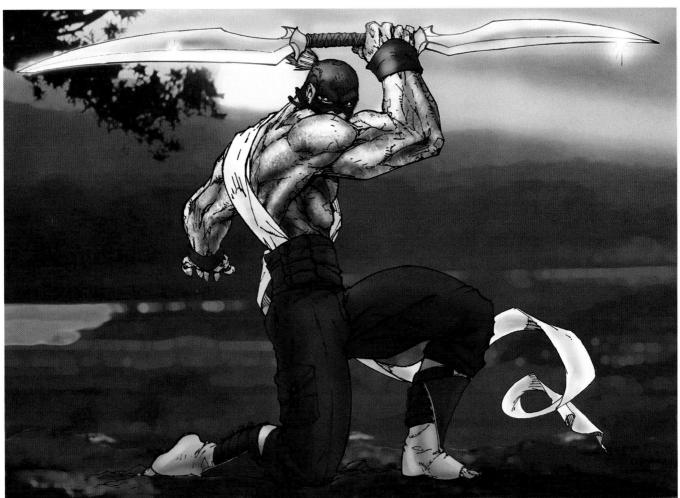

If this guy were in a video game he would definitely be a "boss battle"—the guy you have to defeat at the end of one level before you can move on to the next. When drawing a character like this, do everything you would do for a normal character—just make all his muscles bigger! A common trick is to draw a huge character with a slightly smaller-than-normal head so that his size looks even more massive.

ANTHROPOMORPHIC CHARACTERS

Anthropomorphic characters had their heyday when the Teenage Mutant Ninja Turtles appeared on the scene in the 1980s. The Turtles were not the first half-human/half-animal martial arts characters, but they sure have become the most popular. The Japanese comics form known as manga often features hybrid characters; sometimes these are mutants, but more often they are victims of some unlucky bewitching. They are usually given a task to perform to regain their human form. This popular genre has experienced an surge in popularity with the "Bloody Roar" fighting games on the various PlayStation platforms.

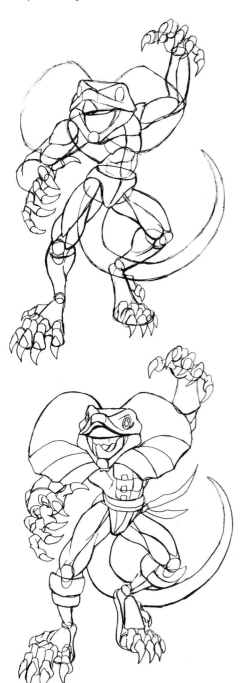

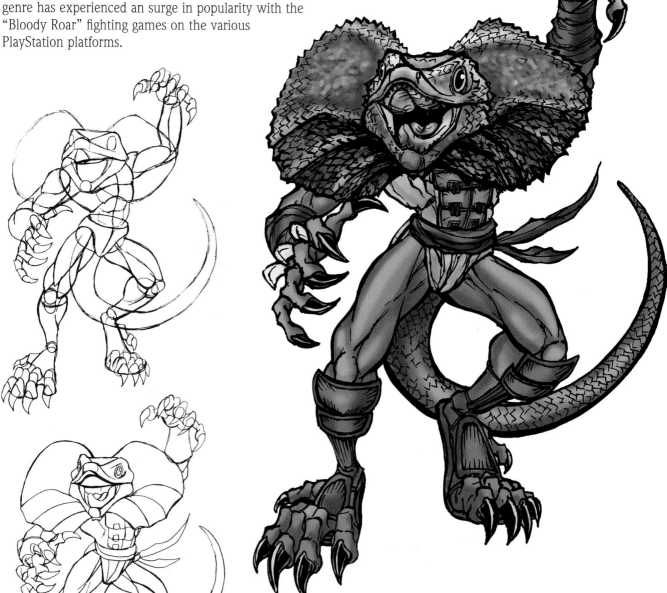

Even though his anatomy is half-human and half-reptilian, you still use the same basic steps to draw this scaly guy. You can see that his claws are just enlarged, angular hands and that his feet have elongated insteps. I used an old *National Geographic* magazine for photo reference. The wonderful world of nature offers fertile material for an endless supply of animal-man kung fu creations, and there is no shame in using photos to draw creatures more accurately.

Some anthropomorphic characters are good, some are bad—and some hit the lottery and are big, bad, *and* ugly. Remember: it is sometimes an effective storytelling technique to have a character's appearance be at odds with his or her moral orientation.

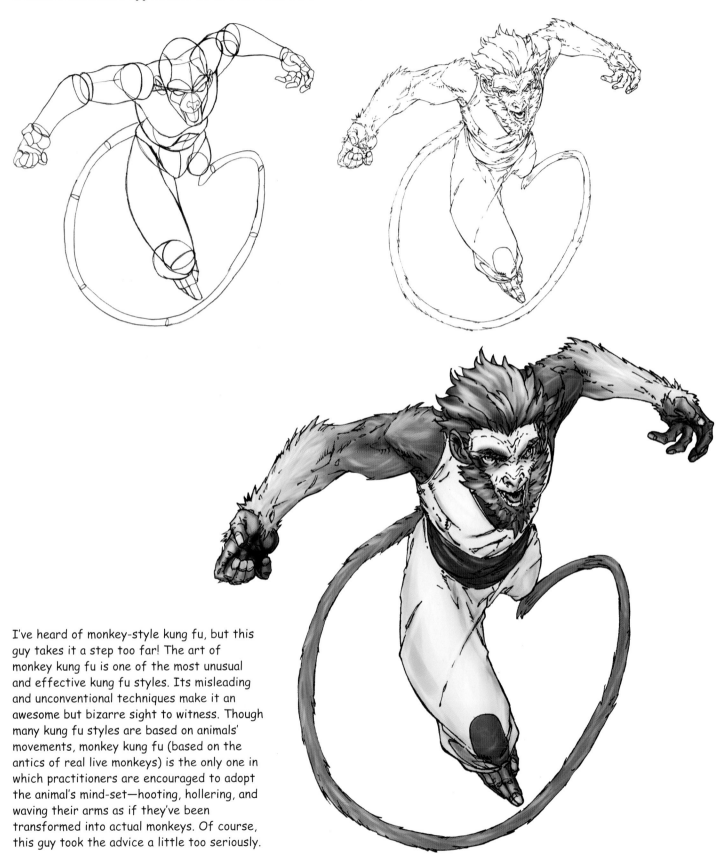

I've heard of monkey-style kung fu, but this guy takes it a step too far! The art of monkey kung fu is one of the most unusual and effective kung fu styles. Its misleading and unconventional techniques make it an awesome but bizarre sight to witness. Though many kung fu styles are based on animals' movements, monkey kung fu (based on the antics of real live monkeys) is the only one in which practitioners are encouraged to adopt the animal's mind-set—hooting, hollering, and waving their arms as if they've been transformed into actual monkeys. Of course, this guy took the advice a little too seriously.

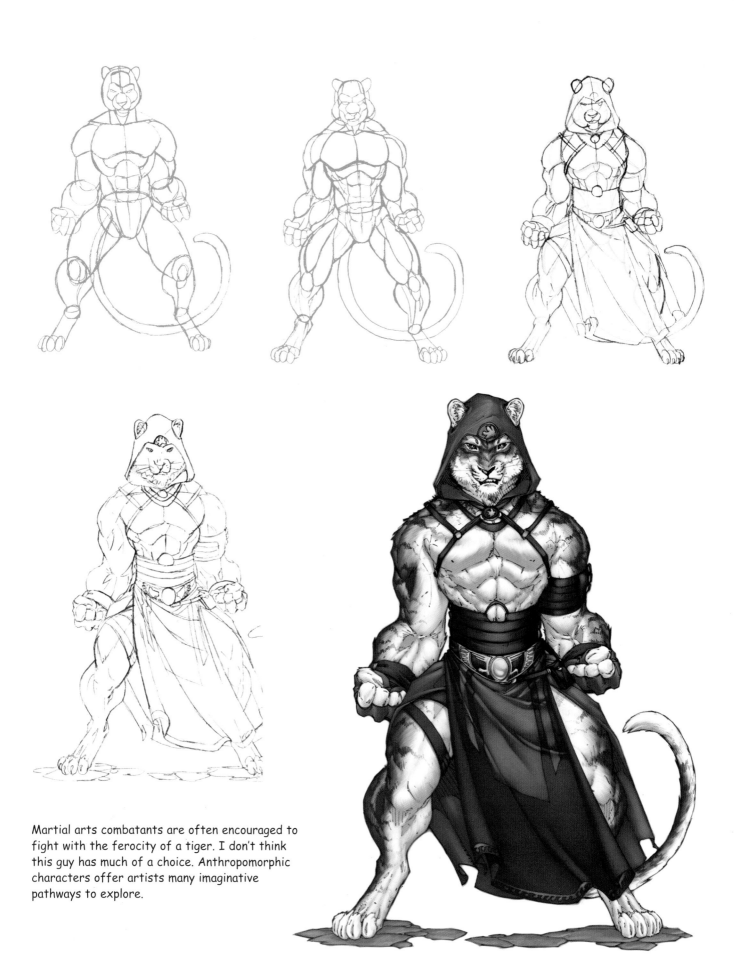

Martial arts combatants are often encouraged to fight with the ferocity of a tiger. I don't think this guy has much of a choice. Anthropomorphic characters offer artists many imaginative pathways to explore.

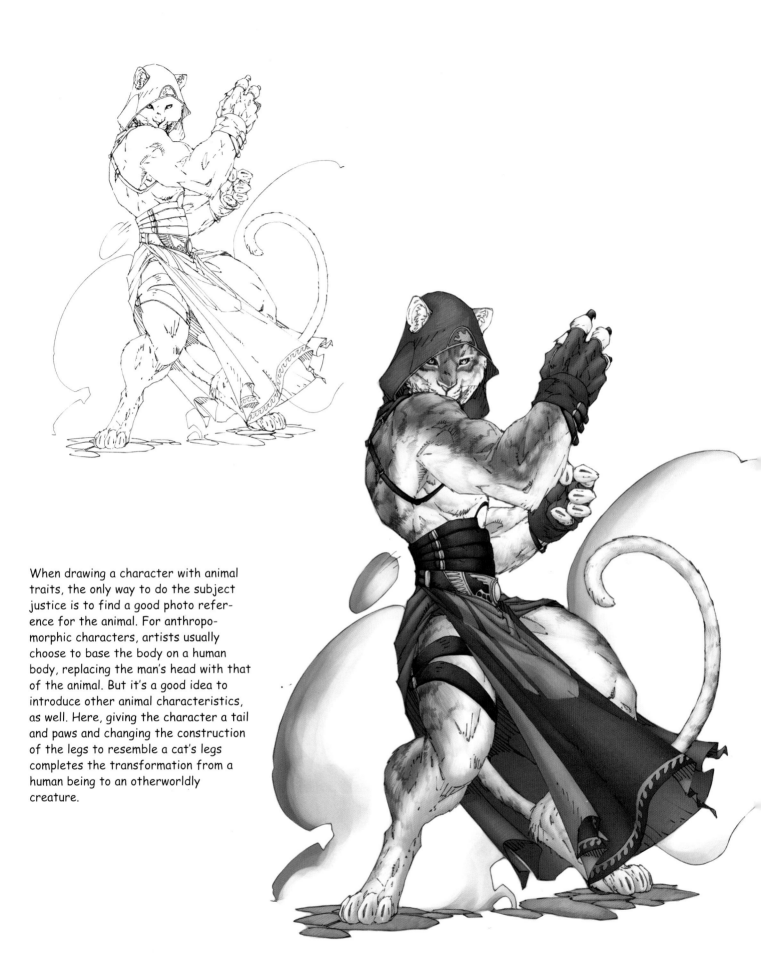

When drawing a character with animal traits, the only way to do the subject justice is to find a good photo reference for the animal. For anthropomorphic characters, artists usually choose to base the body on a human body, replacing the man's head with that of the animal. But it's a good idea to introduce other animal characteristics, as well. Here, giving the character a tail and paws and changing the construction of the legs to resemble a cat's legs completes the transformation from a human being to an otherworldly creature.

SUMO WRESTLERS

Sumo wrestling is the most popular spectator sport in Japan, and sumo meets are surrounded with many complex and sacred rituals. The general term for martial arts in Japan is *budō* (which roughly translates as the Way of the Warrior), and for the Japanese, sumo is a *gendai budō*—a modern martial art. Sumo-wrestler characters aren't necessarily evil, but they certainly can be scary—which is why I've included them in this chapter.

In each sumo match, two huge, loincloth-clad wrestlers (called *rikishi*) face off on a circular mat. Each attempts to push the other off the mat or to execute a trip or throw that will result in some part of the opponent's body (other than his feet) touching the mat.

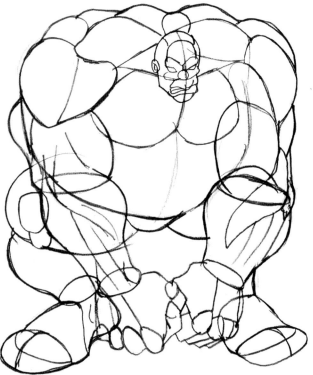

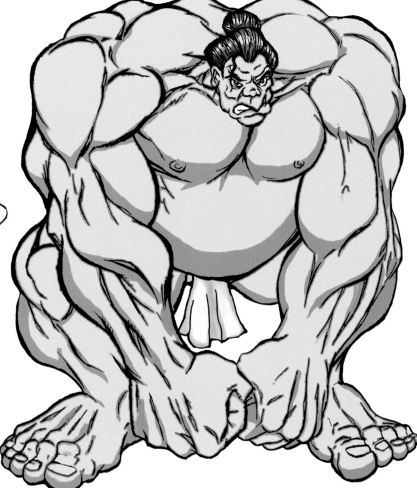

Artists working on video games and anime films often portray their sumo characters as more muscular than their real-world counterparts actually are. You still need to draw the same basic human forms during the construction steps, but the chest will be greatly exaggerated. Another good tip is to keep the head small. The smaller the head, the greater the perception of girth will be.

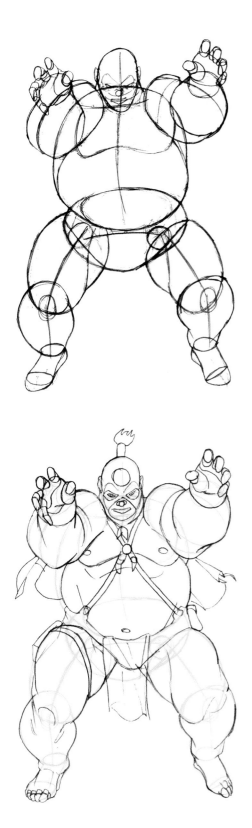

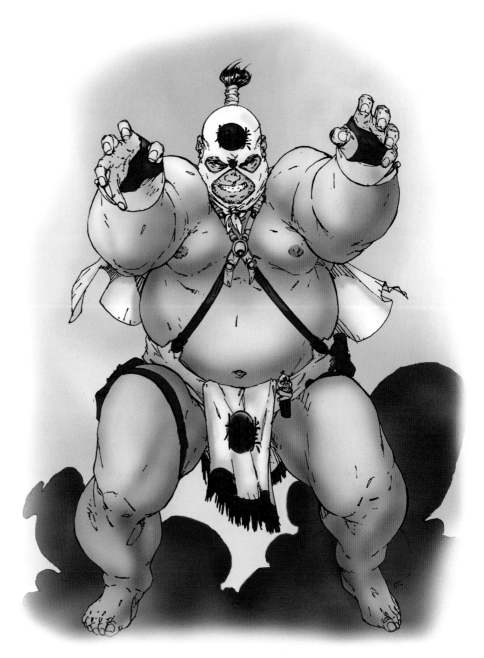

Don't let all that fat fool you. You can construct this flabby fellow using the same basic construction steps you'd use for those of a leaner persuasion. Just remember to keep your forms round. When it comes time to render the final anatomy, remember that your marks are not describing hard muscle but soft fat. Keep horizontal marks to a minimum; by using vertical lines, you will create the appearance of drooping flesh.

BEAUTIFUL BUT DEADLY

Be sure to tell them it was a girl that beat you.

Anonymous

THE MARTIAL ARTS AREN'T ABOUT SHEER BRUTE STRENGTH.
One of the advantages of using martial arts techniques for fighting
is that they rely on the principles of physics to multiply the momentum
and mass directed against an opponent, meaning that skillful female
martial arts fighters can often triumph over male fighters who are
physically stronger. Women tend to have a lower center of gravity,
which not only adds a degree of finesse to everyday activities like
walking but also translates into a slinkier execution of martial arts
moves. This lower center of gravity also gives women greater stability
for kicking moves, because the fulcrum of most kicks is centered in the
lower hips.

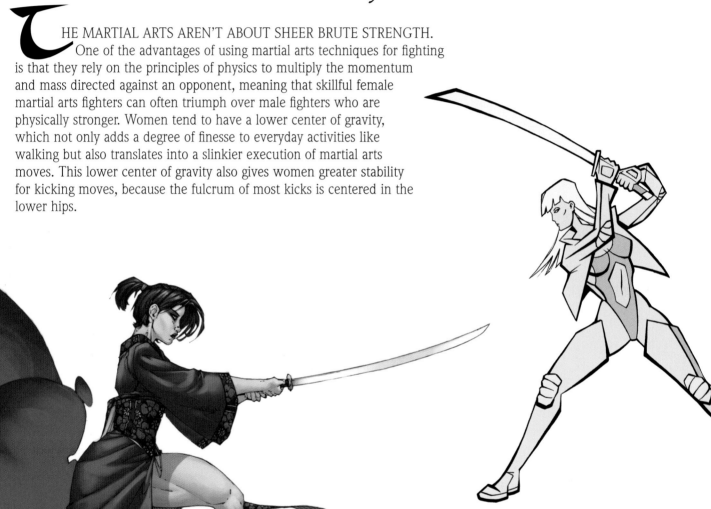

Women tend to be better dancers than men,
capable of effortlessly gliding across a ballroom.
Now, imagine a dance routine performed by a gal
holding a razor-sharp sword, and you'll begin to
understand the allure of female sword fighters.
Whereas men often choose a frontal mode of
attack, women are more likely to leap about
during a confrontation, often with catlike agility.
The characters portrayed here represent just a
few of the sword-wielding women who abound in
martial arts pop culture.

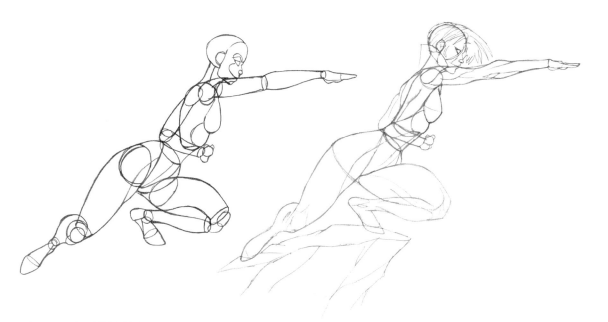

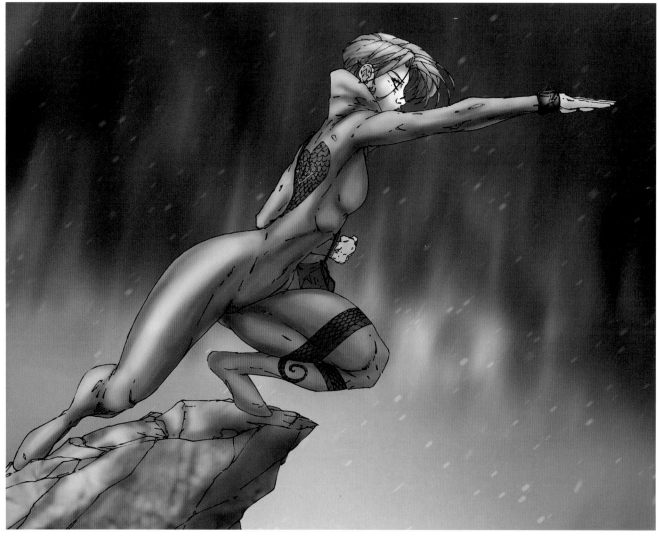

Skintight body suits are popular outfits for female fighters. Not only does the form-fitting clothing allow freedom of movement; it also provides an alluring distraction to male adversaries.

LEAPING LADIES, CROUCHING WOMEN

Female characters are more effective leapers than men, since their lower center of gravity gives them a more accurate trajectory. Arms extended to the side, even with weapons in hand, will stabilize a jumper's descent.

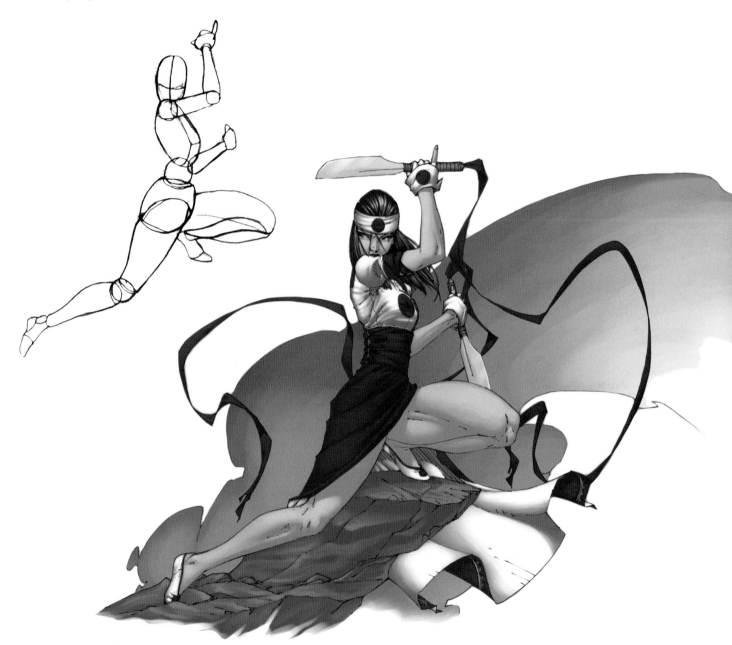

A nimble fighter may prefer to launch her attacks from a crouched position, since it is nearly impossible to topple an attacker whose center of gravity is only a few feet off the ground. By the way, the streamers on the handles of this assassin's blades are more than mere decoration. When a streamer-bedecked sword—or especially a pair of swords—is twirled in a complex routine, the flourish of color and the obscuring of the blades give the sword-wielder a significant advantage.

KITSUNE

Kitsune is the Japanese word for "fox," and kitsune are among the best-known characters in Japanese folklore. These are not run-of-the-mill, break-into-the-chicken-coop foxes, however. They're magical beings whose powers include human-to-animal transformation and the casting of illusions. Today, kitsune often appear in children's books, comics, TV shows, and movies.

Kitsune are usually portrayed as mischievous, impish rogues whose aim is to cause human beings trouble. Occasionally, though, they are envisioned as wicked and genuinely dangerous spirits intent on increasing human woe. These furry tricksters take on many foxlike forms, but they love to disguise themselves as beautiful young maidens.

FEMALE KUNG FU FIGHTERS

The Chinese term *kung fu* can be translated to mean either "well done" or "human effort." Traditionally, kung fu encompassed both armed combat (with swords, spears, bows and arrows, quarterstaffs, and so on) and unarmed fighting, but most American practitioners of kung fu focus only on the unarmed-combat styles. Kung fu is classified into two basic styles, known as Northern and Southern. (These two styles are further subcategorized into *external* and *internal* styles. External styles focus on the physical techniques for overpowering an enemy; internal styles, which are more defensive in nature, concentrate on developing the fighter's ingenuity in "thinking out" an opponent's moves in advance.)

Northern kung fu, which originated in the area of China north of the Yangtze River, favors kick moves performed from kneeling, standing, or jumping positions. Punches (delivered with a closed fist or the palm of the hand) are also used, but they're not as abundant as in the Southern style.

Southern kung fu, sometimes thought of as a boxing style, is very hand-oriented and features several high-speed chops and punches. Blows are fired off from a firm stance in which the legs are spread and bent at a 90-degree angle, which concentrates most of the body's weight on the front foot. Defensive moves include deflecting or grappling techniques performed at a close range.

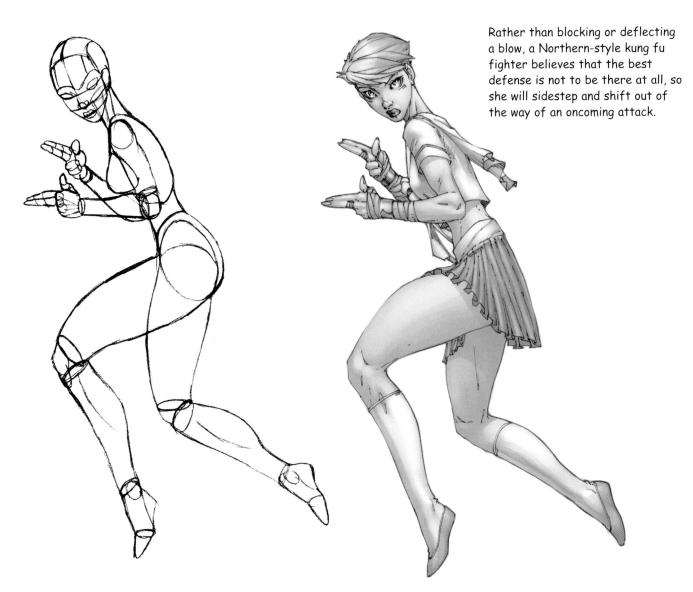

Rather than blocking or deflecting a blow, a Northern-style kung fu fighter believes that the best defense is not to be there at all, so she will sidestep and shift out of the way of an oncoming attack.

CYBER CHICKS

Killer female cyborgs are popular characters in martial arts–themed science fiction comics. I guess there's just something about these automatons' beautiful curves and deadly power that's extremely titillating.

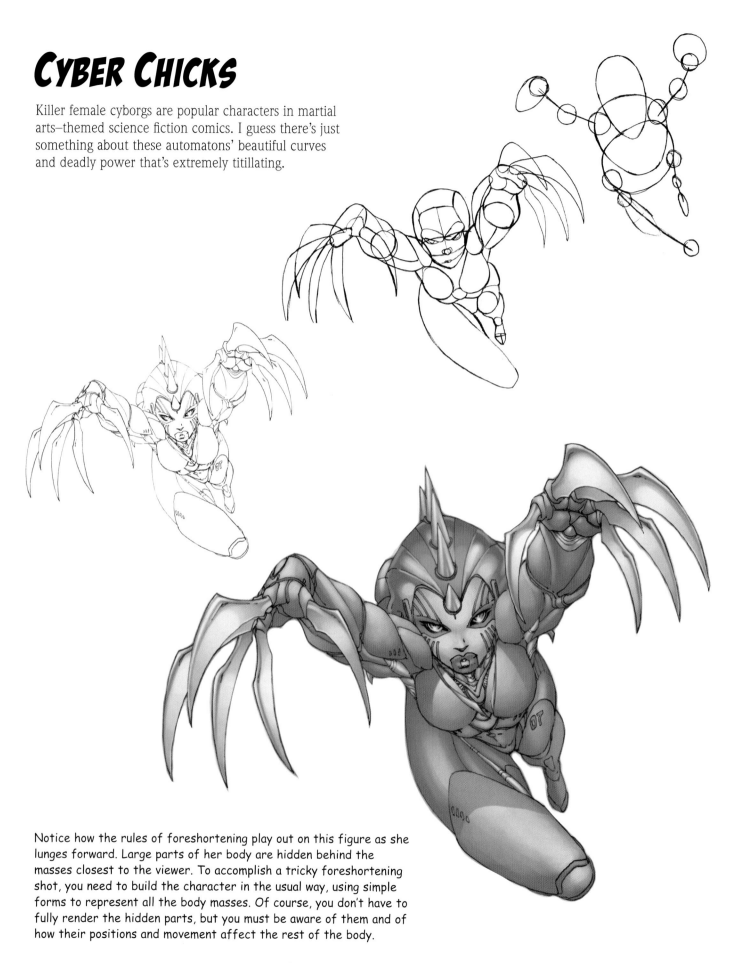

Notice how the rules of foreshortening play out on this figure as she lunges forward. Large parts of her body are hidden behind the masses closest to the viewer. To accomplish a tricky foreshortening shot, you need to build the character in the usual way, using simple forms to represent all the body masses. Of course, you don't have to fully render the hidden parts, but you must be aware of them and of how their positions and movement affect the rest of the body.

BAD GIRLS

Even though this "Goth" character's defiant attitude may be hard as nails, you still want to draw her using supple and curvy lines. What really defines this femme fatale as a bad girl (spelled *g-rrr!-l*) is her clothes. Underneath the leather and spikes is the same soft daddy's-girl physique you would use for a more blissful character; it's the costume that marks her as a delinquent from the Pep Club.

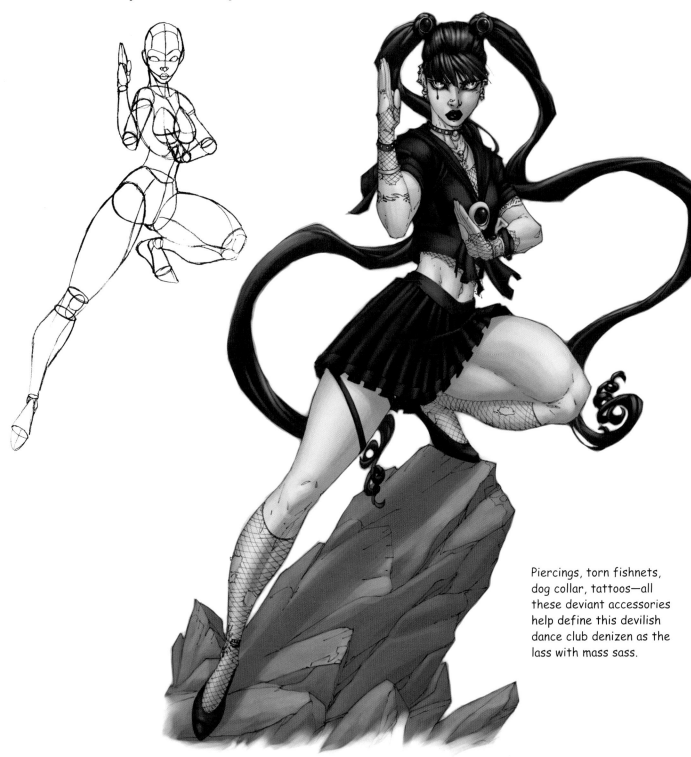

Piercings, torn fishnets, dog collar, tattoos—all these deviant accessories help define this devilish dance club denizen as the lass with mass sass.

FEMALE NINJAS

Kunoichi is the Japanese term for a female ninja. Historically, female ninjas relied more on skills of espionage and emotional manipulation than on face-to-face combat to achieve their goals. Mistresses of deception, kunoichi learned to maximize their feminine charms, granting them access to powerful political figures. Once the required information had been extracted, the ninja would assassinate her startled victim while the taste of her kiss was still fresh on his lips. Although they excelled at psychological warfare, kunoichi were also expected to be formidable hand-to-hand combatants; their fighting techniques were modified to focus on their womanly dexterity rather than on brute strength.

Because a woman carrying a long sword would have been highly suspicious, female ninjas relied mainly on short-bladed weapons or other small armaments that could be easily hidden in their clothes.

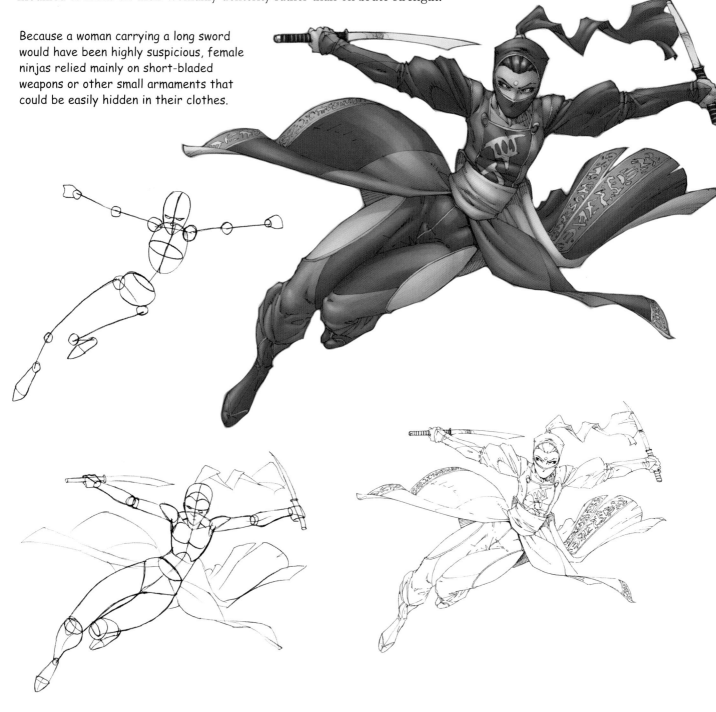

SENTAI

Sentai is the Japanese word for "task force." Originating during World War II, it literally means "fighting squadron," but nowadays the term is used to refer to the garishly costumed superhero teams that dominate children's television shows in Japan. Full of pyrotechnics and other special effects, the shows feature live-action characters who perform exaggerated, cartoonish martial arts moves.

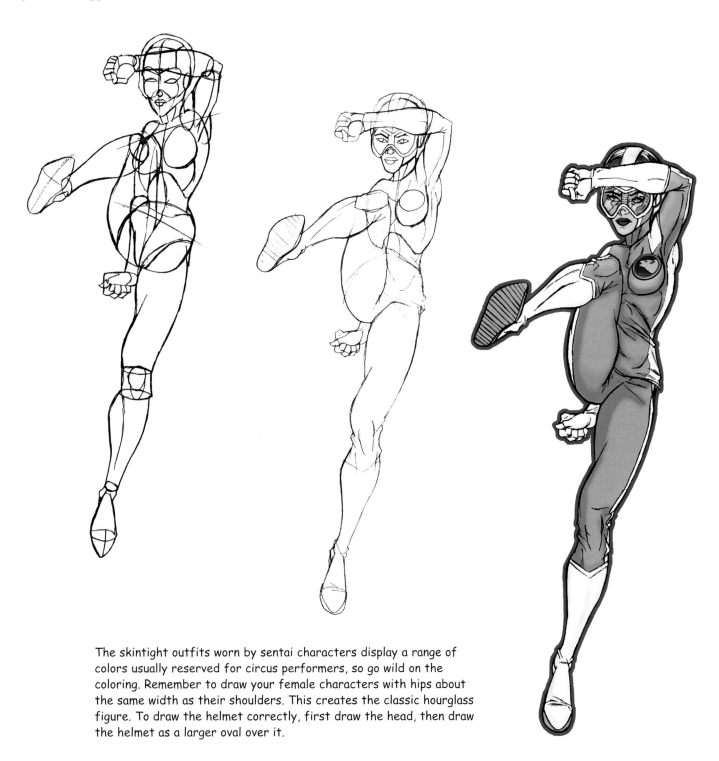

The skintight outfits worn by sentai characters display a range of colors usually reserved for circus performers, so go wild on the coloring. Remember to draw your female characters with hips about the same width as their shoulders. This creates the classic hourglass figure. To draw the helmet correctly, first draw the head, then draw the helmet as a larger oval over it.

FIGHT CLUB

*When two opponents of equal
strength and technique fight it off, it
is what is in their heart and how they
use their mind that will decide who
will win.*

Bruce Hyland,
National Australian Karate Federation coach

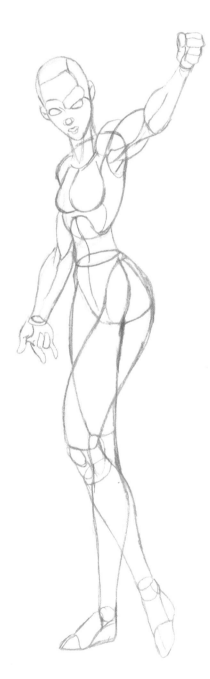

EVENTUALLY, EVERY MARTIAL ARTS STUDENT MUST PUT WHAT HE or she has learned to the ultimate test by facing another fighter. The same is true for people learning to draw martial arts characters—but don't worry, you won't receive any bumps or bruises during these exercises. The goal of this chapter is to help you compose interesting scenes of confrontation.

In reality, fights are often over in seconds. They begin with a flourish of kicks and punches and end when one fighter is unable or unwilling to continue. Anyone who has witnessed a few martial arts battles knows how hard it can be to accurately describe what happened—who hit whom, when he hit him, and exactly how many blows were landed. As an illustrator, your job is to slow the action down, depicting the crucial moments of the conflict by "freezing the frame."

In comics the fight scenes are usually the highlight of the story since they have the most action. For this reason, they are often given a much higher number of panels or pages than might be warranted by the amount of "real time" they occupy. For example, two brawlers may exchange threats for several minutes before engaging in a five-second tussle, but the name-calling and bickering will most likely receive a single panel while the actual battle will sprawl over several pages, probably including a two-page spread. It is crucial that you learn to look at action in the same way a movie director does, and that you frame each of your shots for maximum impact.

Not only do you need to draw dynamic poses for your fighters, but you also need to create a pleasing path for the viewer's eye to travel as it takes in all the information the picture conveys. A camera sees all of an image at once, but we human beings process visual information in chunks. We start at one point and then move to the next logical point. This is easy when you're reading a page of text, because you've been taught to start at the left and move to the right, line by line. But in a picture there is no one inherent path for the eye to move along. That path must be created by the artist. For fight scenes—which can be naturally chaotic—it is important to design a path into your composition, giving the viewer's eye cues as to where to look first, second, third, and so on. The examples in this chapter show how to create dynamic compositions while maintaining a clear center of focus and a definite path for the eye.

Adding Oomph

In the exercises in the "Disciplined Bodies" chapter, I showed you how to break the figure down into simple parts and to construct a figure one step at a time. When you're drawing fight scenes, however, you also need to keep the bigger picture in mind and to visualize the overall directions of the figures involved. In a fight, it's usually a fist or foot that's being propelled at an opponent. Think of the extended arm or leg as an arrow that's pulling the rest of the body along, and of the hand or foot as the arrow's point, indicating the direction of the character's momentum. To add extra oomph to a blow, make sure that other masses of the body appear to be moving in the same direction—and take note of the fact that the character absorbing the blow has a momentum of his own.

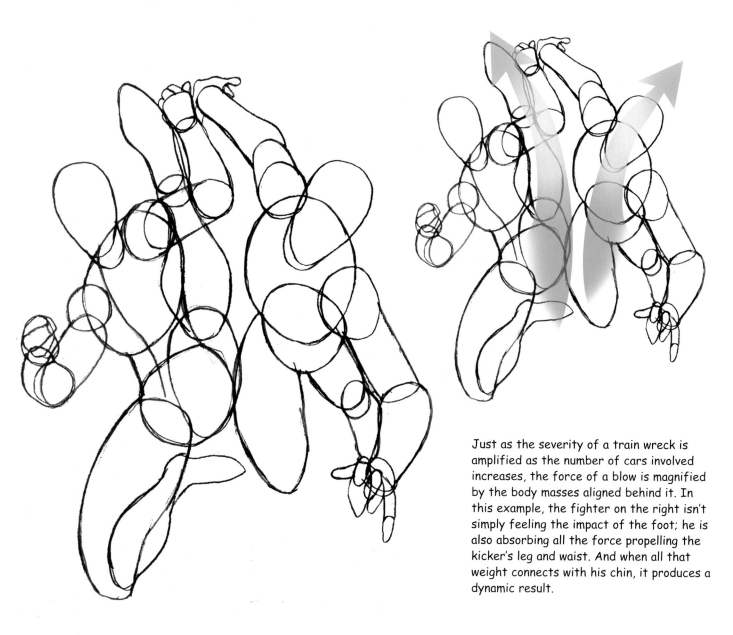

Just as the severity of a train wreck is amplified as the number of cars involved increases, the force of a blow is magnified by the body masses aligned behind it. In this example, the fighter on the right isn't simply feeling the impact of the foot; he is also absorbing all the force propelling the kicker's leg and waist. And when all that weight connects with his chin, it produces a dynamic result.

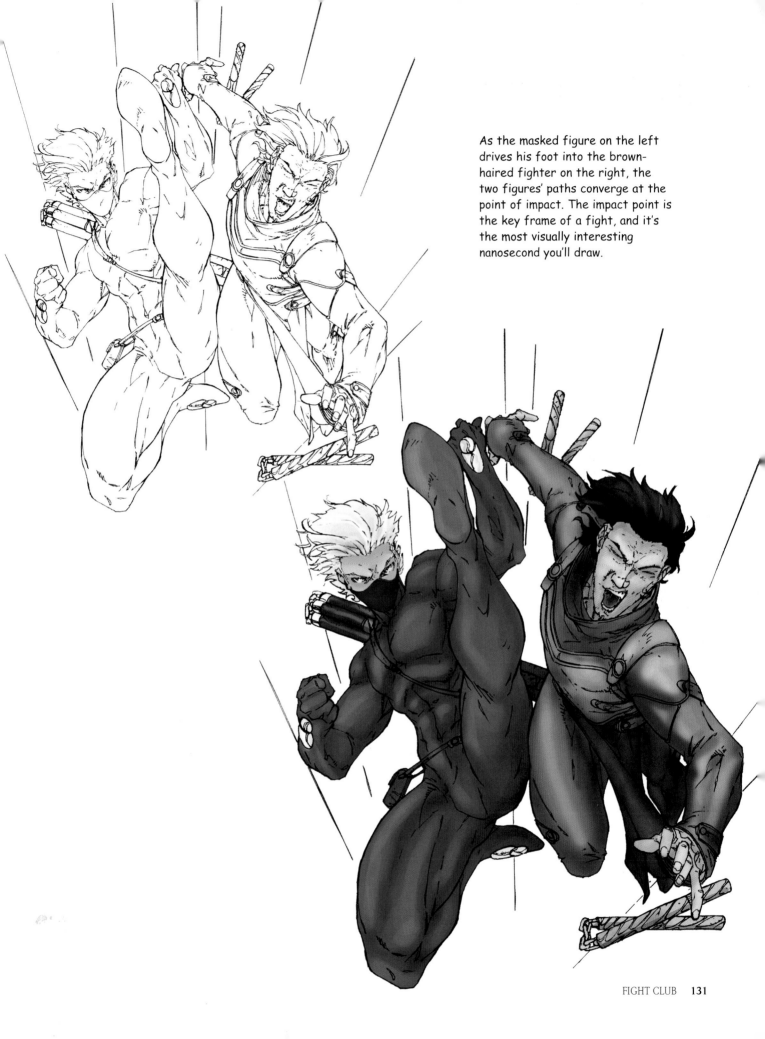

As the masked figure on the left drives his foot into the brown-haired fighter on the right, the two figures' paths converge at the point of impact. The impact point is the key frame of a fight, and it's the most visually interesting nanosecond you'll draw.

FIGHTS WITH WEAPONS

When weapons are thrown into the mix, the job of composing a scene that isn't visually confusing can become a battle in and of itself. Not only do you have all those legs and arms to position, but you must also factor in the placement of the weapons. Usually, the center of attention will be where the figures connect or overlap. When fighters are armed, the weapons become extensions of the figures' bodies, and the relationship of one weapon to the other will be the strongest draw on the viewer's eye.

In the figures on these pages you can almost hear the *ka-zing!* of the blades as they ricochet off each other. The character on the left has just delivered an offensive slash toward the female character's head, while she has parried with a defensive block. Artist Brett Booth has laid this scene out so that the meeting point of the swords is the central focus, but all the secondary elements needed to convey the mood are here, as well. The intensity of the fight is mirrored in the woman's eyes. Her pose is intended to absorb the brunt of the blow. Meanwhile, the figure on the left lunges forward, and the momentum of his entire body fuels his sword strike.

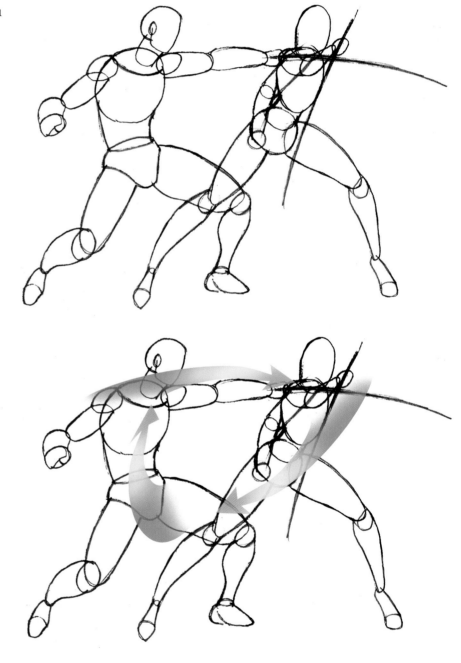

Can you see the path that Brett wants the viewer's eye to follow in this composition? From the center of attention (the point of contact between the two swords), the eye will naturally look for long lines or arcs. These create the visual direction, and an artist using them is telling the viewer's eye, "Go this way." The woman's sword and the alignment of her body lead the viewer's eye downward to the male fighter's knee, which in turn directs the viewer's eye to travel up his body and then back down his arm to his sword. The entire path is basically circular—and this is a common technique for ensuring that the eye stays within the frame. In some instances, you will want to lead the viewer's eye to the next panel rather than closing the compositional path, but for fight scenes like this one you should maintain a tight path for the eye to follow.

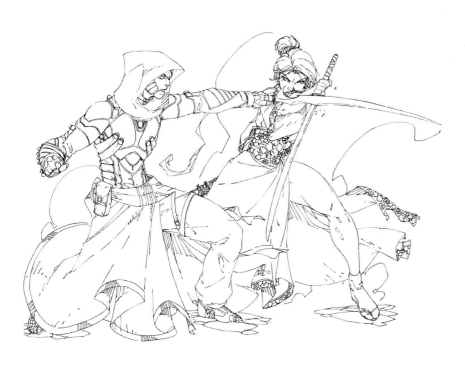

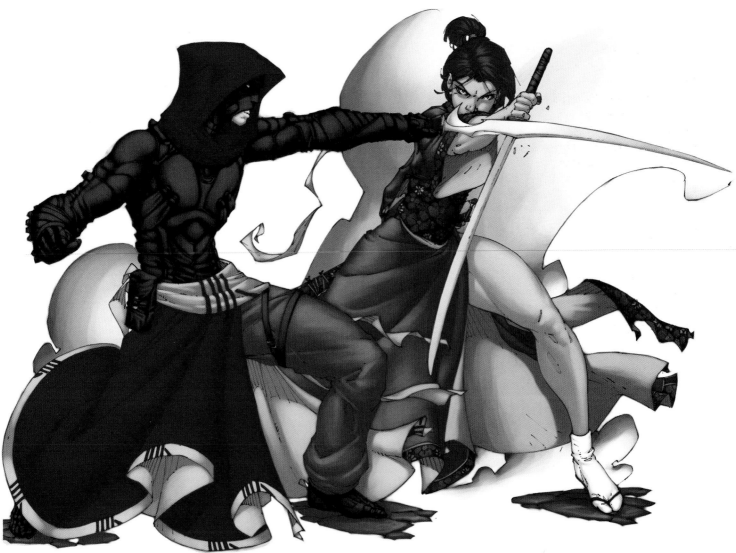

MULTI-CHARACTER BATTLES

So how do you handle a fight scene that includes more than two characters or characters of varying sizes? In this composition, master penciler Brett Booth has created a figure eight–shaped path for the viewer's eye. Large elements in a drawing snatch a viewer's attention, and you aren't going to find an element much larger than this sumo wrestler!

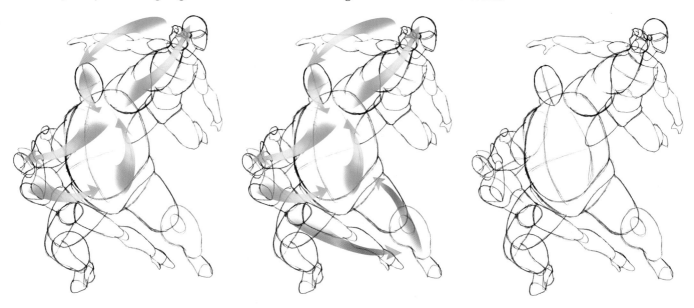

Using the sumo guy's outstretched arms, Brett has designed a path that travels around all three figures and crosses back on itself. A closed path like this keeps the center of attention where the action is. Of course, the eye will eventually move around the rest of the picture, taking in every area of the drawing. An experienced draftsman will therefore incorporate a secondary path so that the eye also hits important supplemental elements of the drawing. This secondary path is represented by the blue arrows in the second version above. Notice how the secondary path feeds back into the primary path, and how all the elements work together to create a pleasing composition.

TELLING THE STORY

Karate is a form of martial arts in which people who have had years and years of training can, using only their hands and feet, make some of the worst movies in the history of the world.

Dave Barry

I THINK WHAT THE HUMORIST DAVE BARRY IS REFERRING TO IN THE QUOTE above is the lackluster way some martial arts moviemakers combine awesome fighting moves with boring characterization and unimaginative story ideas. We've all watched kung fu flicks and found ourselves constantly tempted to fast-forward to the fight scenes. Martial arts are cool, and I love to see some of the crazy moves that people come up with, but for a movie, comic, or video game to really work it has to have a satisfying story. There has to be more to the plot than "the good guy beats up the bad guy."

The comic book page opposite and all the other pages reproduced in this chapter come from an issue of *Tool & Die*, published by Samson Comics. Pencils are provided by Brett Booth, colors by Andrew Dalhouse.

The first page of this story begins with a bird's-eye view of a group of fortified buildings deep in the mountains of China. The next panel is similar, but the buildings are seen from closer up, which helps pull the reader into the story. We then move inside one of the buildings and see some sort of ancient ritual already in progress. Using a mystic crystal, a secret order of martial arts monks is preparing to select its next champion. The crystal reveals a warrior deep in meditation.

What can we learn from this page? Artist Brett Booth has masterfully woven a web of intrigue that draws the reader in. By starting with the faraway view of the monastery, he gives us enough information about the setting for us to get a rough idea of where the story takes place. By moving progressively closer to the characters, the artist invites the viewer to enter the story and suspend disbelief. The details of the buildings, the furniture, and the characters' clothing all work together to create a coherent environment. This is one of the first ingredients of a successful narrative: a fully realized setting. This does *not* mean that the imaginary world has to be 100-percent realistic. (That would eliminate 99.9 percent of all comic books!) It does, however, mean that the creators of the imaginary world—the writers and artists who are telling the tale—have to take their creation seriously enough to incorporate details that breathe life into the fantasy.

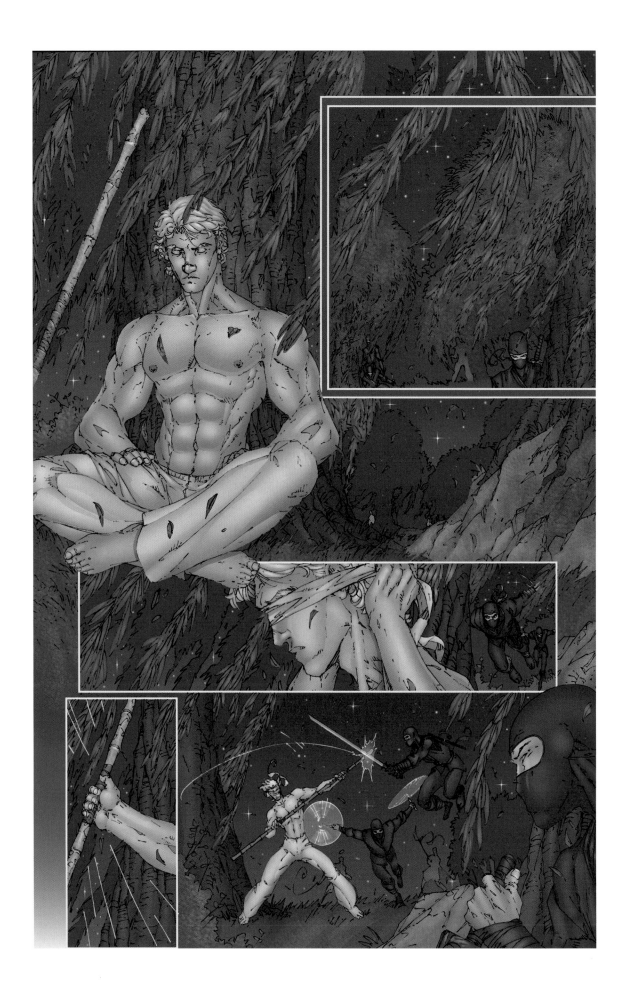

This page—the next in the sequence—creates a smooth transition from the previous page by repeating the last image shown there, though at a larger scale and in a much more detailed way. This clues the reader in on the fact that we have now moved to a new setting. Penciler Brett Booth has taken the time to draw every last leaf of the weeping willows surrounding the mysterious young warrior. When the ninjas appear in the next panel we know a fight is coming. So what does our hero do? He dons a blindfold, grabs his *bo* staff, and prepares to do battle.

This page establishes tension, another key component of great storytelling. Without tension, a reader will feel no need to continue with the story. The blindfold is a great device for the writer to use to stack the odds against the hero. No one takes on half a dozen ninjas, let alone blindfolded!

Here is the same page before Andrew Dalhouse laid down his vibrant colors. You can see how much of the storytelling weight is placed on the penciler's shoulders. But artist Brett Booth is more than up to the challenge.

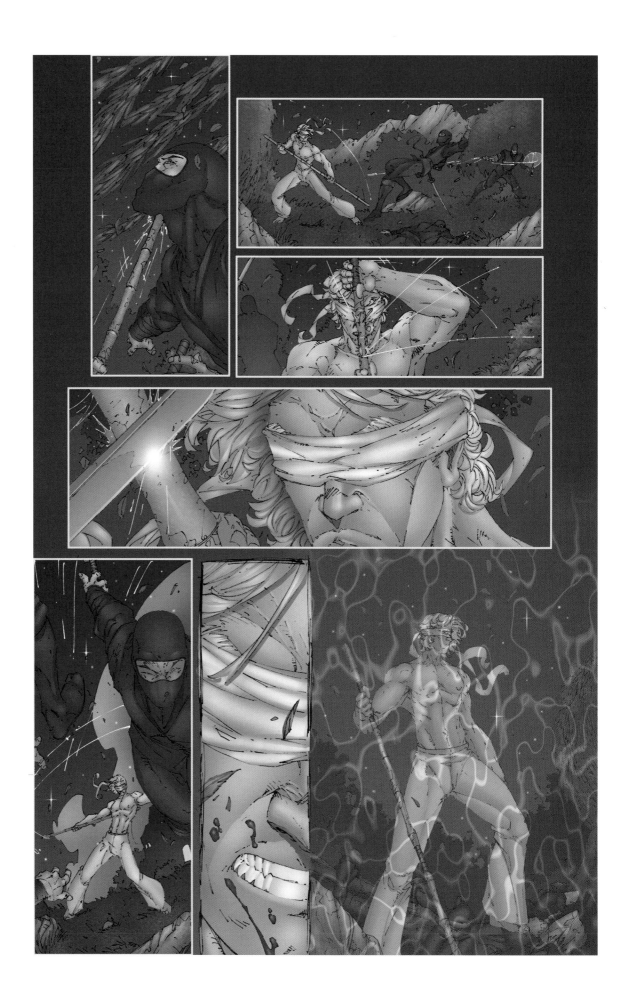

With this page, we get into the heart of the battle. The crucial thing about this page is the variety of the panels. Penciler Brett Booth keeps the action moving by drawing energetic figures, but he also shakes things up with the many varied angles.

And here is the same page sans color. The artwork has a consistency that helps hold the reader's attention. The backgrounds are fully rendered, and the costumes are drawn believably.

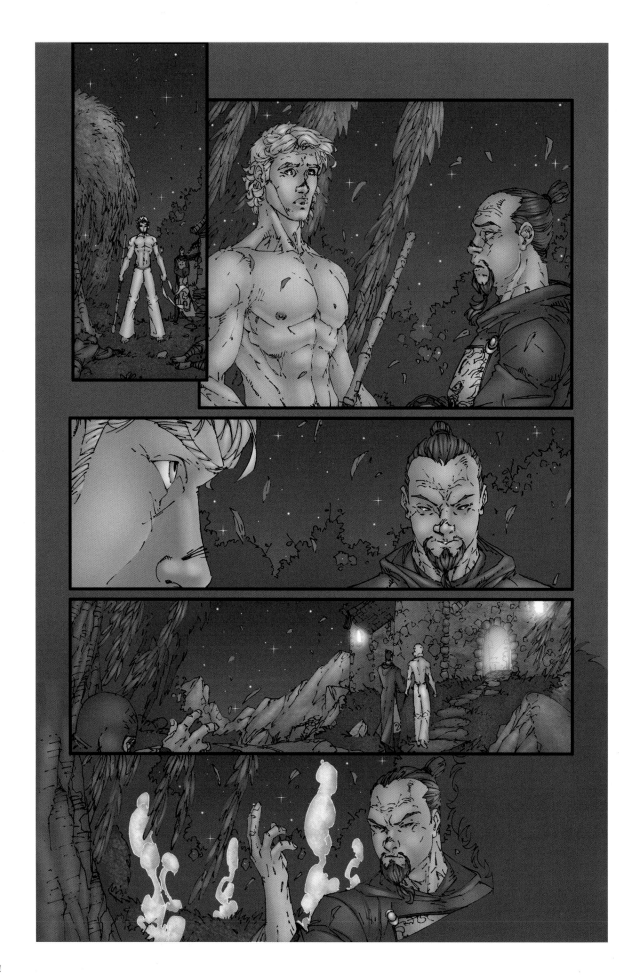

On the final page of the sequence, the hero meets the mystic monk from the first page, who invites him into the fortress to share his true calling with him and to tell him how he can be of service to the monk's supernatural order. This is a wonderful way to begin a story that, though it is steeped in martial arts, does not depend entirely on fight scenes to carry the narrative. The characters, setting, and details all add up to an intriguing glimpse into a magical world—and leave the reader wanting to know more.

If you look back over this sequence, you'll see how the things I've talked about throughout this book have come into play in creating it. If the artist didn't have a firm grip on anatomy, action, clothing, weapons, and techniques for drawing martial arts battles, the narrative would just fall apart.

That brings us to the end of this book. I've done my best to teach you some key moves, but your further training in the art of martial arts comics is up to you.

Be diligent. As one martial arts master has said, "Of those who start tae kwon do training, only about 5 percent stick with it until they achieve black-belt rank. Then, perhaps 80 percent of those who earn a black stop there." I would imagine that drawing has a similar drop-out rate. Everyone knows someone who can draw a little, but few know an actual artist who chooses to work on his or her craft on a daily basis. It is my hope that this book will help you continue your efforts to be the best artist you can be, for I believe that art offers a doorway to our inner imaginations. Crack your door open, and allow others to see the wonders inside.

By way of encouragement, let me leave you with these words from one of the finest martial artists who ever lived, Bruce Lee:

Art is the way to the absolute and to the essence of human life. The aim of art is not the one-sided promotion of spirit, soul and senses, but the opening of all human capacities—thought, feeling, will—to the life rhythm of the world of nature. So will the voiceless voice be heard and the self be brought into harmony with it.

INDEX